# CURATING
## AT
## THE
## EDGE

# CURATING

THE WILLIAM & BETTYE NOWLIN SERIES
*in Art, History, and Culture of the Western Hemisphere*

# AT THE EDGE

## Artists Respond to the U.S./Mexico Border

Kate Bonansinga

FOREWORD BY LUCY R. LIPPARD

UNIVERSITY OF TEXAS PRESS ⋀⋁ AUSTIN

Requests for permission to reproduce material
from this work should be sent to:
    Permissions
    University of Texas Press
    P.O. Box 7819
    Austin, TX 78713-7819
    http://utpress.utexas.edu/index.php/rp-form

The paper used in this book meets the minimum requirements
of ANSI/NISO Z39.48-1992 (R1997) (Permanence of Paper).♾

Library of Congress Cataloging-in-Publication Data

Bonansinga, Kate.
    Curating at the edge : artists respond to the U.S./Mexico border /
by Kate Bonansinga ; foreword by Lucy Lippard. — First edition.
        pages   cm — (The William and Bettye Nowlin Series in Art,
History, and Culture of the Western Hemisphere)
    Includes bibliographical references and index.
    ISBN 978-0-292-75297-9 (cloth : alk. paper)
    ISBN 978-0-292-75443-0 (pbk. : alk. paper)
1. Artists and museums—Mexican-American Border Region.  2. Art
museum curators—Mexican-American Border Region.  3. Art muse-
ums and community—Mexican-American Border Region.  4. Art and
society—Mexican American Border Region—History—21st century.
I. Title.
    N72.A77B66 2013
    707.5—dc23                                2013004243

The images on pages 19, 37, 38, 41, 42, 43, 48, 60, 62, 76, 78 (top), 79,
82, 83, 84, 88, 96, 98, 99, 101, 102, 103, 106, 113, 118, 145, 147, 148,
169, 179, 182 (bottom), 186, 187, 188, 194, 203, 206, 207, 221, 222, 224,
225, and 227 are © Stanlee and Gerald Rubin Center for the Visual
Arts, courtesy of the University of Texas at El Paso. All other images,
unless otherwise indicated, are courtesy of the artist.

doi:10.7560/752979

# Contents

# Foreword: Curating on the Cutting Edge

*Lucy R. Lippard*

*Curating at the Edge* is an intriguing hybrid, combining a manual on how to create a distinctive university art center with an informed critical text on art reaching across the U.S./Mexican border—and by extension over all borders. This is a book about process and collaboration on many fronts—between curator and artists, artists and artists, university and curators, and cities and nations. "Border as center" is how Kate Bonansinga describes the institutional identity of the Stanlee and Gerald Rubin Center for the Visual Arts at the University of Texas at El Paso. Her searches for art that illuminates and expands that identity, the resulting artists' proposals, and the intricate process of executing the installations are the core of her book. These artworks, each with its own set of problems and triumphs, reflect the shifting social dynamics of the border as it permeates further and further north and south, becoming a local/global nexus with reverberations across many other borders.

El Paso and Juárez are unique in their proximity within the "most populated urban cluster on any border in the world." Sharing a population of around 1.4 million, they are separated only by the Rio Grande. Until around 2009, they were intimate sister cities. Then Juárez, thanks to rampaging drug cartels, official corruption, and ineffective governmental policies, was labeled the world's most dangerous city, while El Paso remains one of the safest cities of its size in the world. Given this tragic contrast, the Rubin Center's ongoing collaboration with the Universidad Autónoma de Ciudad Juárez (UACJ)—even

when that beleaguered city was out-of-bounds to those UTEP students living in El Paso—surely meant a great deal to everyone on both sides of the river. In 2009, Tijuana-based Tania Candiani illuminated this relationship with *Battle-ground*, a performance on the hillside next to the art center. Students with helmets and weapons made from domestic objects (a sad reversal of "swords into ploughshares") chose to be either Warriors or Defenders, protecting Juárez from Juárez. Originally planned to play across the border, it was live-streamed to Juárez and projected in the Rubin galleries.

The connection between curating and place, on the model of California's groundbreaking Border Arts Workshop and inSITE, is one of the lessons this book has to offer. Nearly 80 percent of the UTEP student body is Mexican American; most belong to the first generation in their families to attend college. One thing that stands out about the artists and curators discussed here is their respect for these students. The art shown at the Rubin is as complex and challenging as anything exhibited in far better-funded and more prestigious institutions. Although the Rubin also presents smaller and more conventional art exhibitions, the choice of commissioned installations as the focus was a daring one. Even hanging neatly framed and delivered works can be a touchy business; installation art is far more complicated. For the artist it offers a way to try something new, complex, temporary, and sometimes place-specific. For the hosting institution it offers all kinds of out-of-the-box learning possibilities. For audiences and faculties unaccustomed to contemporary art, it offers new and brain-stretching experiences. For the students, it means regular participation in the construction of the innovative artworks, according to the Rubin's mission: to become a laboratory for experimentation where "visiting artists would be the researchers and UTEP students would be their assistants."

For the curator, it provides innumerable headaches. Bonansinga candidly discusses the evolution of an impressive number of very disparate works—the aesthetic, financial, academic, and marketing decisions made over the decade in which she forged first the Rubin Center itself (when it opened in 2004 she was its only full-time employee) and then its remarkable exhibition program. She makes the challenges sound easy, admitting mistakes and disappointments, but the attentive reader can see between the lines. There are inevitably minor clashes as the curator tries to keep peace between project and budget, possibility and impossibility, while pursuing a shared vision of the completed work. Accounts of last minute mind-changing are common, throwing the best-laid plans into disarray. On the unpredictably organic growth of the SIMPARCH collective, Bonansinga remarks wryly: "More people, more talent, and more chaos."

Above all, Bonansinga trusts artists—the mark of a good curator. She is open, flexible, and follows her hunches. Amazingly, there are no disasters. Most of the artists selected for commissions were already nationally or internationally known. Only one, Adrian Esparza, was born and raised in El Paso (and resides there still), and one other (Margarita Cabrera, not shown at the Rubin, but accorded prime space in the book) is currently El Paso–based. The few Anglos are or have been residents of border states. Perhaps most surprising, given the potentially controversial subjects and images routinely selected for the Rubin, is that the UTEP administration trusted Bonansinga, supporting her stated intention to create "spectacular exhibitions [by living artists], with minimal resources." Partnerships like that between the curator and UTEP president Diana Natalicio are rare.

The Rubin's program is remarkable in its consistent challenges to the status quo and its consistent ventures into social and political issues illuminated by "cutting edge" contemporary art. The titles of works presented at the Rubin and elsewhere by Alejandro Almanza Pereda reflect the risk-taking flavor of the program itself: *Just Give Me a Place to Stand, The Heaviest Baggage for the Traveler is the Empty One, The Fan and the Shit, Andiamo, Stand Clear*. Pereda's works are sometimes weighty and sometimes precarious, with floating furniture and fluorescent pillars, reflecting the tensions of a life lived across borders. Construction and destruction are recurring themes. In *Lines of Division*, Mexico City–based Enrique Ježik, after abandoning a plan to exhibit the rubble of a demolished Mexican maquiladora, turned to political mapping in a raw, even brutal, installation including plywood panels outlining contested borders around the world. He executed the final piece with a chainsaw at the opening.

"By building, we are destroying," observes Tijuana-based ERRE (Marcos Ramírez), whose hard-hitting and visually powerful work includes a two-headed Trojan horse on the border, a slum shanty transported to official central Tijuana, and a billboard aimed at U.S. border vigilantes. He focuses on walls as icons of social injustice, dubious development, and cultural misunderstandings. His four-part installation at the Rubin was ironically titled *To Whom It May Concern: War Notes*. Among his targets are U.S. bombings in Afghanistan. When a similarly aimed work was censored in Pennsylvania, he demanded, "Are people outraged because a Mexican artist has bothered to highlight this history? Or do I perceive an underlying shame?"

The subjects of violence and betrayal are unavoidable in this context. The artists commissioned by the Rubin deal directly and indirectly with violence against women, *Narquitecto* tunnels under the wall, desperate attempts to live

in a skewed economy, and the layers of social injustice found on both sides of the wall. Women's labor, women's bodies, and protection of the family and the domestic sphere in the midst of crisis are Tania Candiani's themes. And Liz Cohen (daughter of Colombian immigrants) defies gender roles and the male gaze by offering a flirtatious persona in bikini and high heels while she works in an auto body shop and builds her own hybrid car—the Trabantimino, a cross between the German Trabant and Chevy El Camino. New Mexican (now New Yorker) Nicola Lopez, in the *Claiming Space* exhibition, showed abstract installations of woodcut-printed and metal-entwined Mylar, evoking the twists and turns of thoughtless urban planning and roads that "don't get you anywhere . . ." "One lives within the local depending upon how one participates in globalization," says anthropologist Néstor García Canclini, with regard to the work of Julio César Morales, whose *Informal Economy Vendor #2* shattered an image of a Mexican street vendor into pieces across the wall.

Bonansinga and her many collaborators for the most part reject "identity politics" in favor of showing "how identity is shifting in a globalized world." The "established stereotypes of Latino art"—what has been called the "ethnographic look—virgins and bloody hearts, etc."—are notably absent, although it must be said that these images remain significant to many artists in the border states and their possibilities have not yet been exhausted. Similar themes are incorporated into the Rubin installations by artists skilled in doing what the art world does best—having it both ways: the formal use of meaningful local materials leading to both personal and political interpretations. Adrian Esparza's *Unknitting* pieces, for instance, stem from his childhood familiarity with crafts, too often considered "low art." As a "high artist," he simultaneously challenges and celebrates tradition by transforming/deconstructing/unraveling striped *serapes* into geometric artworks with social implications. Margarita Cabrera's community-based work, which evolved from soft sculptures of machine parts from the maquiladoras (referring to the Juárez "femicides") and a fabric *Vocho* from the Puebla Volkswagen plant, is now often presented as the product of a folk art cottage industry called Florezca. Her fired clay replica of a tractor covered with flowers, birds, and butterflies (*Arbol de la Vida*) raises issues of aesthetic authorship and international trade relations, while at the same time empowering individual artisans and immigrants.

In 2010 the Rubin faced what Bonansinga called "a moral dilemma"—an invitation to take part in a series of events marking the bicentennial of Mexico's independence from Spain and the centennial of the Mexican Revolution at a time when El Paso's sister city was bleeding to death and people were visibly powerless. ("How many revolutions are required to effect change?" asks ERRE.)

Even arriving at a title for the show proved difficult. Kerry Doyle, a colleague at the Rubin, co-curated *Contra Flujo: Independence and Revolution* with Mexican Karla Jasso, and it was indeed "Against the Flow" of nationalist chauvinism. *I-Machinarius* by Marcela Armas was a huge wall piece with rotating cogs that kept in motion an oiled chain forming the outline of Mexico, upside down. A veil of crude oil flowed over it, providing an unveiled criticism of Mexico's human, financial, and natural resources "drained by and into the United States" in a relentless cycle. In the less confrontational but equally significant *Cross Coordinates*, Ivan Abreu, who concentrates on creating "context rather than content" and emphasizes collective over individual experience, invited motley pairs of people to balance a four-foot carpenter's level. The piece was publicly performed in a number of ironic and hopeful circumstances across social and national barriers.

The writer Teddy Cruz contends that "the most dramatic conflict on the border is between the natural and the political." The Rubin has featured several pieces dealing with this subject, among them the Tom Leader Studio's *Snagged*. Initially proposed as a huge structure filled with detritus from the border (evoking the ubiquitous western landscapes of plastic bags caught on barbed wire fences), it then shifted to become a piece about irrigation ditches, drought, erosion control, and Southwest agriculture, described by Bonansinga as a "ghost-like imprint of a section of El Paso's irrigation system . . . death waiting for life." Participating architect Alan Smart described the piece (made of steel and organic cotton) as a comment on the border as a permeable and impermeable membrane, with water as "a metaphor for economic or population flows . . ."

SIMPARCH (Matt Lynch and Steve Badgett) has specialized in funky architectural pieces, augmented by music, sound, and humor, that promote sustainability and often debunk American myths. At the Rubin, after some abrupt changes of direction, they built *Hydromancy*, a version of their "Dirty Water Initiative." A black plastic tank (ubiquitous in Mexico) was erected on the hillside next to the Rubin holding dirty water from the Rio Grande. The water was then purified in three solar stills and piped into the galleries, becoming a "community well or fountain," at which the audience was invited to drink. (The stills were later recycled, given to a nonprofit in Juárez.)

Although the darker side of border relations unavoidably dominates artists' responses at this moment in history, works like these offer a hopeful determination to change. Lights at the end of the tunnel might also bring an end to borders, as suggested by Jay Atherton's and Cy Keener's *Light Lines*, emphasizing "the borderlessness of air and light," through mirrors, shadows,

and the masking of the Rubin's clerestory windows in an act of "understated activism." Similarly, Leo Villareal's *Solar Matrix*—a random field of lights on the nearby hillside, fueled by solar energy and recalling the notorious Marfa Lights—transmitted a mysterious beauty across the landscape.

I have visited the Rubin only once, to see a stairwell installation by my former neighbor, El Paso native Isabella Gonzales. I was impressed. I know of few other institutions that can even approach the quality and commitment of the Rubin, a situation that I hope will continue under its next leader. (Bonansinga left UTEP in July 2012.) This brief foreword can only hint at the breadth and depth of the program over the last decade. But the book does it justice. Read on . . .

# CURATING
# AT
# THE
# EDGE

# Introduction

*Texas, Mexico, Bhutan, and*
*the Origins of the Rubin*

This is a book about some extraordinary artists. I have come to know and respect each of them in my role as a contemporary art curator. It is also a book about curatorial decision making. It is meant for artists, art lovers, museumgoers, students of curatorial practices and museum studies, and anyone else who wants to better understand how contemporary art curators operate. I offer a peek behind the scenes: institutional mission, timing, finances, coordination, personalities, and taste are important considerations in this work. I also interpret and contextualize the artworks discussed, which is an important curatorial task.

## The Beginning

In 1999, I relocated from Portland, Oregon—where I had worked for eight years as a gallery curator and director and as an instructor of art history—to a town just north of El Paso, Texas. I moved from the land of pinot noir to tequila territory, fully aware that I would probably need to reinvent myself professionally and find an entirely new line of work; curatorial posts were, and still are, rare in the El Paso area. I was, and still am, passionate about contemporary art, but I was equally eager to embrace a new life in the grandeur of the American Southwest, at the junction of the United States and Mexico. I was ready and willing to try something different.

But, as it happened, I never faced a career change. In August 2000, I began my new job as gallery director in the Department of Art at the University of Texas at El Paso (UTEP), the only university in a city of about 665,000 people. El Paso is located on the U.S./Mexico border. The half-mile walk from its historic downtown core to downtown Ciudad Juárez is just a stroll across a bridge over the Rio Grande. (In contrast, San Diego and Tijuana are divided by a twenty-mile drive on a superhighway.) Together, El Paso and Juárez, with a population of around 1.4 million, form the largest binational urban environment in the world. Mexican neighborhoods and their mountainous backdrop dominate the expansive vista from the UTEP campus.

At the time, the Department of Art gallery was a one-thousand-square-foot room across the hall from the administrative offices of the Department of Art. It had been in operation since the 1970s, but by the late 1990s, it had become a sleepy establishment. I was charged with energizing and professionalizing it with exhibitions that would infuse new perspectives into the educational art program, which focused on drawing, painting, sculpture, ceramics, metalsmithing, printmaking, and graphic design. The gallery's raison d'être was pedagogical, its location low profile. The budget was about six thousand dollars per year for seven exhibitions, and the entire staff consisted of a ten-hour-per-week student intern and me. My full-time annual salary was thirty-nine thousand dollars. Still, I was able to attract recognized, high-quality artists such as Margo Sawyer, Jean Lowe, and Stefan Sagmeister, and private collections that included prints by Kiki Smith, Robert Longo, and Liliana Porter, among others.

This mode of operating presented great advantages. There was the challenge and satisfaction of creating spectacular exhibitions with minimal resources. There was the opportunity to build formative and trusting relationships with many members of the art faculty. And there was the reward of curating exhibits that not only fulfilled the gallery's mission of serving the needs of the department but also captured the attention of a diverse, widespread audience from two countries.

After about a year, I felt the need to expand my reach by expanding my audience. I was convinced that the gallery could be better and more strongly integrated with the university's teaching and research missions, as well as with the borderland community. We were the only contemporary art space with a progressive programmatic agenda for a radius of hundreds of miles. It seemed to me that the gallery should draw much more traffic. So I made an appointment to introduce myself to the president of UTEP, Diana Natalicio. I thought she might have some ideas about how to do that.

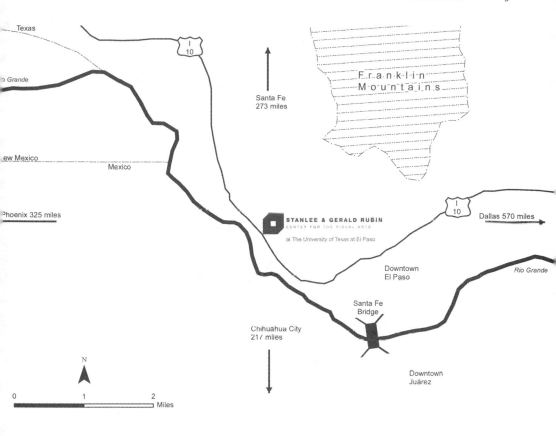

*Binational, Tristate Area of El Paso, Texas.* Map by Rebecca Martin.
Courtesy of Geography Lab, New Mexico State University.

Dr. Natalicio began her academic career at UTEP in 1971 as a visiting assistant professor in the Department of Languages and Linguistics and worked her way up the ranks to be named president in 1988. Highly energetic, articulate, and personable, she favors "walking meetings" because she enjoys fresh air and exercise. At our first conference, it became clear that she and I shared a fondness for midwestern professional baseball (she is a native of St. Louis and I was raised in Cincinnati) and a commitment to developing the talent pool in the underappreciated borderlands by attracting new perspectives and developing existing capacity. Under her leadership, the demographic of the UTEP student body—nearly 80 percent Mexican American and primarily first-generation college students—came to reflect that of El Paso, and the university's institutional research agenda came to focus on the U.S./Mexico border.

By the time we met, the president had already noticed the new level of expertise behind the Department of Art gallery. Some of the art faculty and the dean of the College of Liberal Arts had mentioned it to her, and she also visited a few of the exhibitions. We talked about possible strategies for the gallery to serve other departments and colleges and a wider audience. However, the space was not suitable for presidential-level donor events because it was small, difficult to find, and aesthetically unimpressive.

In summer of 2002, Dr. Natalicio telephoned to tell me about a meeting with representatives from the Houston Endowment. They told Dr. Natalicio that they were interested in supporting the restoration and renovation of Seamon Hall, the last of the five buildings that made up the original campus, which was constructed between 1914 and 1928. Situated between the Fox Fine Arts Center (where the Department of Art is located) and Sun Bowl Stadium (the football field and best-known campus landmark), it had fallen into disuse in the early 1980s when the geology department relocated to a larger building. Seamon Hall, Dr. Natalicio thought, might be an ideal location for an art museum.

"Are you willing to work with me on this project?" she asked. "Without a doubt," I responded. By summer 2003, she had raised the two million dollars required to gut and renovate the building to make it suitable for the exhibition of art. My role in that fund-raising process was to inspire confidence in her and in the donors that the project would be in good hands. The funding came from the Houston Endowment, the Brown Foundation, and UTEP alumni Stanlee and Gerald Rubin. Gerald is founder, chairman, president, and CEO of Helen of Troy Ltd., a publicly traded personal care products firm with headquarters in El Paso. The Rubins generously donated one million dollars to the project, and the building was named in their honor.

In the months that followed, local architect Frederic Dalbin redesigned the interior with the guidance of a committee of university facilities services personnel and me. Construction began in fall 2003. The exterior was not to be changed since distinctive Bhutanese-style architecture defines the UTEP campus. Instituted in 1917 with the first campus building, this motif was inspired by Kathleen Worrell, wife of the first dean of the college, who read an article about the South Asian country of Bhutan in a 1914 issue of *National Geographic*. The Himalayas, as photographed by Jean Claude White, reminded Worrell of El Paso's Franklin Mountains. The Bhutanese style became the college's architectural identity, and, with few exceptions, every UTEP building follows this design. The results are magnificent. Nestled in the foothills of the Franklins, with buildings that cross or incorporate many arroyos, the campus seems part

of the desert landscape, rising organically from it. It elevates above Juárez and Interstate 10, the main east/west route that connects Los Angeles, California, to Jacksonville, Florida. To motorists and Juárenses, UTEP looks like Shangri-La.

## What's in a Name?

In spring 2003, administrators and faculty, including myself, decided that the Department of Art gallery would move its operations to the new facility. The gallery's mission of exhibiting art by living artists under the advisement of faculty would remain intact. Three factors contributed to the decision to name the new enterprise the "Stanlee and Gerald Rubin Center for the Visual Arts," instead of "Rubin University Art Museum" or "Rubin Contemporary Art Museum" or "Rubin University Gallery" or some other such title.

First, one of Dr. Natalicio's intentions in designating the new building as a visual arts center was to create an elegant and welcoming venue for the university and broader communities. However, another equally important goal was to alleviate some of the space pressures in the Department of Art. All of the art history and art appreciation classes were taught in a classroom in Fox Fine Arts Center with pull-down screens, a jury-rigged projection system, and plastic chairs. We decided to move this component of the departmental curriculum to the new building by creating an auditorium there. It would be occupied with classes every day from morning until late afternoon and, on most days, into the evening. The auditorium would also serve as the venue for public presentations in conjunction with the exhibitions by artists, curators, and scholars. The building would house galleries that would serve as laboratories for creating art and as exhibition space open to the public.

At the time, I was fully aware of the museum world's ongoing transitional state, which focused on re-identifying museums as loci of learning and enjoyment rather than dusty browseable storerooms for objects from the past. In 2011, Mexican architect and critic Fernanda Canales stated, "The museum, synonym for both petrified scenery and tourist circus, increasingly seeks to be known as a place where everything is possible. From trunk or shop window to experimental laboratory, and now public space, art centers have undergone unprecedented exploitation."[1] Here Canales argues that "museum" and "center" are both versatile organizations. Still, "center" captures the multiuse character of the facility better than the term "museum," just as "visual" is a better choice than "contemporary" for the UTEP facility inasmuch as art history would be taught in the classroom and, from time to time, exhibitions would include historical art that informs contemporary art practice.

Second, UTEP had never systematically collected art. The few artworks that came to the university via donations from alumni and students were primarily housed in the library or were on loan to one of the many offices on campus through the Art on Campus program. To create a university art museum with the intention of building, caring for, interpreting, and presenting a collection, which is one of the important roles of most university art museums, would have required an acquisitions budget and a larger building. At 2½ stories and 14,000 square feet, the building was a perfect size for a small contemporary art museum or large university gallery: about 3,700 square feet of gallery space, an 1,800-square-foot auditorium, and 10,500 square feet total for preparation room, offices, kitchen, custodial facilities, hallway, and entry spaces and storage.[2] There simply was neither the space nor the funds to collect art. So "center" seemed an appropriate descriptor: the scale of the structure and of the budget in part determined the identity of the new enterprise.

Even though we would be a non-collecting institution, we were committed to maintaining museum standards for our facility, our exhibitions, and related programs. We aspired to the highest quality: the interpretive materials would be well researched and informed but also intellectually accessible. We installed state-of-the-art systems for security and climate control. The building was constructed on a hillside, so the first story is about half the size of the other two. This space serves as the preparation room, from which extends a loading dock. The dock is easily accessed through double doors to the 12' × 12' passenger elevator, which accommodates up to 8,000 pounds. The facility report has passed muster with many prominent museums: we successfully secured loans from the Whitney Museum of American Art, Princeton University Art Museum, and others.

The third factor that determined the label of "center" was precedent. There were several other centers on campus: Center for Inter-American and Border Studies, Center for Environmental Resource Management, Center for Effective Teaching and Learning, and Center for Civic Engagement, to name a few. All of them combine teaching, research, and outreach, as would the art enterprise we were creating.

The Stanlee and Gerald Rubin Center for the Visual Arts opened in September 2004. The full moniker is on the signage and the stationery. But within the first year of operations the center came to be called by a name that was shorter, easier to remember, and tinged with affection: the Rubin.

## Shaping a Curatorial Identity

As the reconstruction of the building progressed, I established how the enterprise would distinguish itself from other contemporary art museums and university art galleries. By uprooting gallery operations from the Department of Art and transplanting them into the new facility, we were able to expand an existing program that invited nationally recognized artists to campus to exhibit, lecture, and interact with students.

UTEP students tend to be economically underprivileged with limited resources for travel, so the university brought the art and artists to them. The Rubin would continue to do this. Thus, it would support the needs of the teaching mission of the university and the Department of Art, but also fulfill the equally important research mission by supporting artists in the incubation of new ideas and new art. The building had the physical presence and scale suitable for commissioned artworks. We would be at the very forefront of experimentation in the visual arts—a laboratory where the visiting artists would be the researchers and UTEP students would be their assistants. Through that process, students would come to better understand artistic decision-making from conceptualization to execution. Learning would be dynamic, interactive, and firsthand.

El Paso has many assets, including the mountains, the desert climate, and the hybrid culture. But perhaps its most striking feature is its proximity to Mexico. I set out to locate artists who would take a commission seriously and embrace and respond to place. I scoured art magazines, attended exhibitions, solicited curator colleagues, and drew upon the knowledge that I had developed during my many years of organizing contemporary art exhibits. Organizations such as the Museum of Contemporary Art, San Diego; the Los Angeles County Museum of Art; the Museum of Fine Arts, Houston; the University of Southern California's Fisher Gallery; and insITE, a periodic, binational art event in San Diego / Tijuana had created exhibitions that focused on the U.S. / Mexico border. I thought about how the Rubin might follow their lead but also distinguish itself. Meaningful university student involvement in the shaping of the exhibitions, serving as a nexus for cross-disciplinary discussions and learning, and consistent community engagement with art and artists became my goals.

I also looked to these precedents for potential artists. Deciding which artists to invite to exhibit would be the first step toward distinguishing the Rubin as an important and innovative venue. The list of names consisted of artists who had one or more of the following traits: a familiarity with the geographic territory, a proven track record of addressing the U.S. / Mexico border in their art,

an interest in borders and boundaries, and a high level of ambition that translates to an upward career trajectory.[3] Most of the commissioned works were new media, sculpture, and performance. The thought-provoking and visually arresting exhibitions that resulted from some of their endeavors unfold in the following pages of this book.

During those early years the Rubin not only commissioned and exhibited artwork, it also hosted many medium-specific group exhibits of noncommissioned graphic design, metalsmithing, ceramics, printmaking, and painting. For these group exhibitions, we borrowed pre-existing works of art from the owners—usually the artist, but sometimes a collector or a museum. For each of these exhibitions, the Rubin staff, together with Department of Art faculty, developed a central unifying idea for the show, typically based on what we saw as an important trend in art making. Sometimes we packaged and toured these exhibits to other institutions, which brought them to new and different audiences. *Hanging in Balance: 42 Contemporary Necklaces*; *Equilibrium: Body as Site*; *Multiplicity: Contemporary Ceramic Sculpture*; and *Up Against the Wall: Posters of Social Protest* are examples. Whereas the commissioned works entailed the astute selection of artists, the group exhibitions demanded the considered selection of objects. Together, these types of exhibits formed a vibrant mixture that exemplified two methodologies for contemporary art curatorial practice.

## The Logistics

This ambitious curatorial vision required significant financial and human resources. Deeply invested in the success of the Rubin, UTEP was a benevolent "parent" that provided infrastructure, including staff salaries, custodial services, utilities, administrative support, and some funding for exhibitions and programs. The integration of the exhibitions and associated programming into the teaching and research mission of the university was part of my strategy for ensuring that the relationship remained positive and that the institution continued to support the success of the Rubin and vice-versa. For example, I taught a class in exhibition practices during the early formative years, applying the concept of the Rubin as laboratory. The university administrators recognized that this initiative supported UTEP teaching and research missions and helped it to grow.

When the Rubin opened its doors in September 2004, I was the only full-time employee. As of fall 2011, the staff had grown to include a full-time assistant director, who also served as associate curator; a preparator, who also served as registrar; and an administrative assistant, plus several part-time

student interns. By this time, UTEP's annual financial commitment was approximately $565,000 annually. About 48 percent of that was indirect costs, such as UTEP administrative staff salaries and benefits, utilities, fine art insurance, and physical plant and administrative overhead.

In addition to the programming budget that the university provided, I located other sources of support, including grants from public agencies and private foundations, gifts from individuals, and institutional collaborations. This additional funding served as a tool for validation, marketing, and audience building, as well as for raising requisite monetary support for programs. Most of the grant applications underwent peer review, so to merit one was also to earn the imprimatur of the field. Income from these applications averaged about $55,000 per year during my eight years as director. In order to encourage individual giving, I established a Director's Circle, a group of nine individuals who served as connectors between the Rubin and the broader community. In addition, the Rubin regularly collaborated with other institutions with the goal of sharing resources and audiences. We developed alliances, for example, with the El Paso Museum of Art, the Consulate General of Mexico in El Paso, Universidad Autónoma de Ciudad Juárez (Autonomous University of the City of Juárez), New Mexico State University, and myriad UTEP departments.

A growing audience for contemporary art in El Paso and the region was the ultimate return on our investment in the development and realization of the exhibitions. As the only university in El Paso, the institution takes its responsibility to the community seriously. The Rubin followed this example and made public outreach a priority. A carefully selected and developed exhibition was the primary draw: if the content was something people wanted to see, attendance flourished. Because the commissioned art addressed the audience's time and place, it created a point of entry for them. Once they were hooked in, they were willing to tackle the challenge of grasping the art's meaning and nuances.

In addition to this curatorial intent of audience building, we opened the galleries for an array of beyond-campus outreach programs that focused primarily on high school students because we found this age group to be intellectually curious and open to the possibilities that contemporary art presents. We actively encouraged high school teachers to bring their classes and facilitated in-depth discussions and hands-on exercises related to whatever exhibition was on view. (Many UTEP art majors' first meaningful experience of the university was during a high school tour of the Rubin.) This was in addition to on-campus outreach to departments and programs that might benefit from guided tours or focused instruction and discussion about the exhibits. Our goal was for our visitors to leave with new perspectives, their thoughts stimulated.

The galleries host a month-long annual juried UTEP student art exhibition in April each year. We structured our exhibition calendar around this show and usually launched new exhibits four times a year: January, April, May, and September. This loosely followed the cycle of the academic semesters: spring, summer, and fall exhibitions, plus the student show. The Rubin has three gallery spaces of varying sizes. The 550-square-foot Project Space is on the ground floor, where visitors enter the building, between the auditorium and the administrative offices. The L Gallery (so named because of its shape) is 1,100 square feet and the Rubin Gallery is 1,800 square feet, and both occupy the next floor up. Some exhibitions encompass all three spaces. More often there are two exhibitions (one that bridges the Rubin and the L and another in the Project Space) or three exhibitions (one in each gallery) on view at a given time. We average nine exhibitions each year. Between 2005 and 2011, I organized more than sixty exhibitions for the Rubin. Most were accompanied by original research published in an exhibition catalogue. The direct cost for each single artist exhibition ranged from five thousand to forty thousand dollars; the direct cost of a small group (four to eight artists) exhibition was usually somewhere between twenty-five thousand to forty thousand dollars.[4] The exhibitions discussed in the following pages are among those that I am proudest of, but all fed and expanded my perspectives on art and artists.

## The Structure and Intent of This Book

This is a book about twelve exhibitions at the Rubin and the decisions behind those exhibitions. Most of the decisions related to which artists to exhibit and how to make their artwork come alive for an audience. The story is told in the first person; I take ownership of my own experience and speak with authority only about why I did what I did and what factors influenced my actions. My goal was to generate the meaningful creation, exhibition, and reception of challenging visual art. As the founding director of a small museum, I was invested in its success and in how it affected the people around it. Thus, in part this book is about the steps that I took to ensure institutional success and impact.

This is not an academic book about the U.S./Mexico border. I am neither a specialist about this political demarcation nor a native of this region. I am instead an outsider from the Midwest via the Northwest who brought a new perspective and appreciation to El Paso. This is not a survey of curatorial practice, but I hope the experiences conveyed in the following pages contribute to that field of study.

*Curating at the Edge* is a series of case studies of exhibitions that I identified and curated as cogent and worthwhile responses to the El Paso/Juárez region during the first decade of the twenty-first century. Some of those responses directly and specifically addressed the subject matter at hand. Others were enigmatic. Many tackled feminism, land use, identity, self-preservation, natural resources, destruction and its ultimate transformation, and the politics of power. Some of the artworks were abstract and required sustained engagement to decode and comprehend. Many of them were ironic and subversive. All of them sensitively considered the time and place in a manner that transcended both constraints.

When I first began work at UTEP in 2000, I thought nothing of crossing into Juárez for a meal, shopping, or sightseeing. It was one of the great advantages of living in El Paso: in an afternoon, I could travel abroad and back. By 2009, Juárez had been identified as the world's most dangerous city due to the escalation of drug trafficking from south to north and gun trafficking in the other direction. Felipe Calderón was elected president of Mexico in 2006, and his administration declared war on drug cartels. The cartels responded to this crackdown with increased brutality: between 2006 and mid-2011, forty-five thousand people had died in Mexico due to drug-related violence. Between 2006 and 2008, the U.S. government fortified the border fence, a huge steel structure that scarred the land and tore us apart from our southern neighbor.

Calderón's administration began near the start of the period covered in the following pages. The border became increasingly important at an international level, making the periphery that is our national boundary central to discourse. My goal was to make the Rubin central to art world discussions as well, though that world has become increasingly decentralized. By means of its support of this objective, the university and the city of El Paso contributed to that decentralization.

In order to effectively convey how one curatorial decision led to the next and how the sociopolitical climate of the border shifted, I organized the book chronologically in twelve chapters, one artist or artist team per chapter. Chapter 1 covers Alejandro Almanza Pereda, a UTEP student who exhibited in the first annual student art exhibition to take place at the Rubin in spring 2005. Chapter 2 discusses *To Whom it May Concern, War Notes* by Marcos Ramírez ERRE in fall 2005, one year after the building's inauguration. Chapter 3 recalls the 2007 *Hydromancy* by artists' collective SIMPARCH, which centered on solar stills positioned on the hillside to the north of the Rubin and addressed the preciousness of water. One of only two group exhibitions that this book addresses, *Claiming Space: Mexican Americans in U.S. Cities*, the subject of Chapter 5,

is from 2008, though its incubation began in 2002. Chapter 6, *No Room for Baggage*, focuses on artist Liz Cohen, who reconstructed a German Trabant to be a Ford El Camino in an expression of optimistic transformation. Tania Candiani's concern with women's work is applied to political tensions on the U.S./Mexico border in her 2009 exhibition *Battleground*, described in Chapter 8. Chapter 9 revisits *Snagged*, 2009, by landscape architecture firm Tom Leader Studio, which addressed agriculture as industry in the border region. Chapter 10 focuses on two artists, Ivan Abreu and Marcela Armas, who were part of an eight-person exhibition titled *Against the Flow: Independence and Revolution* that took place in 2010 in both El Paso and Juárez.

Chapter 11 covers Enrique Ježik who in 2011 portrayed political borders as aggressive and random demarcations and expressions of power. This was a time when the violence in Juárez and northern Mexico continued to escalate, after many years on an upward trend. Finally, Chapter 12 focuses on *Light Lines* by Atherton|Keener, which was on view during summer 2011. *Light Lines* countered Ježik's approach by offering a quiet reprieve from the current harsh border reality. Although each chapter is meant to be self-contained and meaningful on its own, each also connects to the others and creates a crescendo of the body of exhibitions that came together to form a curatorial program during the institution's first seven years.

Chapter 7 discusses Margarita Cabrera, the only artist featured in this book whose work was not exhibited at the Rubin. Not to include her would seem an oversight because the art she created between 2001 and 2011 directly addresses many of the issues that formed the core of my curatorial practice at the Rubin, specifically the U.S./Mexico border as a place of importance. During those years, Cabrera and I were both invested in generating an international audience for art about regional concerns that have broader implications and in focusing on building momentum in a creative pursuit. (Cabrera's pursuit was art making. Mine was shaping and sustaining an institution.) Plus, Cabrera is one of only two artists featured here who is based in El Paso. The other is Adrian Esparza (Chapter 4), who was showcased in the group exhibition *Unknitting: Challenging Textile Traditions*. Esparza is the only artist discussed here who was born and raised in El Paso. He returned after graduate school and closely identifies with the border as his home and source of identity. Both Cabrera and Esparza earned global attention in the first decade of the twenty-first century. As the Rubin matured, so did their artistic careers. I wanted to include Cabrera and Esparza as homage to the dynamic binational urban environment of El Paso/Juárez. It is in part what made this book possible.

# Alejandro Almanza Pereda

*Just Give Me
a Place to
Stand*
2004

The room is rough, with a concrete floor, exposed brick walls, dark steel posts, and a raw wood ceiling—relatively standard fare when it comes to exhibition spaces for contemporary art. It is one of the galleries in the Soap Factory, a historic soap manufacturing plant that was repurposed to be an art exhibition venue in Minneapolis, Minnesota. What makes it unusual is that the furniture there seems inexplicably to float. Tables, a desk, fluorescent and incandescent lightbulbs, a lamp, an upended couch, lumber, cinder blocks, and draped extension cords are suspended in space and appear to be disconnected from the stability of the floor. This is Alejandro Almanza Pereda's architectural-scale sculpture ironically titled *Just Give Me a Place to Stand* (2007). To walk around and inside it is to walk through a seemingly precarious landscape that is secure only if each of the sculpture's units collaborates and balances with all of the others. *Just Give Me a Place to Stand* is one of Almanza Pereda's attempts to locate firm ground and moments of light-filled hope in a decentered world, a recurring theme in his art. *Untitled (Chest of Drawers)* (2006) is another example of this. The ideas of balance, electricity, and containment underlie much of his artistic output.

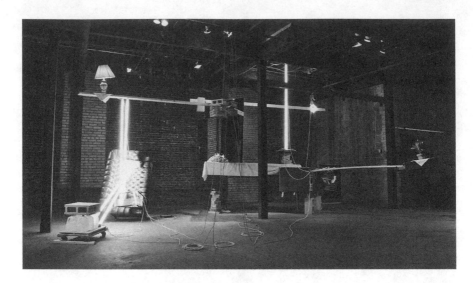

Alejandro Almanza Pereda, *Just Give Me a Place to Stand*, 2007. Lumber, doilies, water gallons, cinder blocks, fluorescent lightbulbs, fish tank, vase, water, air pump, sofa, lamp, dollies, milk crate, fused lightbulbs, mirrors, concrete, tables, bricks, tabletop, cushion, plate, magazines, desk, plant. Dimensions variable.

## Art and Hazard

At the time of this writing, Almanza Pereda, at the age of thirty-six, has been the subject of four solo exhibitions in New York City: *The Heaviest Baggage for the Traveler is the Empty One* (Magnan Metz Gallery, 2010); *The Fan and The Shit* (Magnan Projects, 2008); *Andamio (Temporary Frameworks)* (Art in General, 2007); and *Stand Clear* (Magnan Emrich, 2006). He also has gallery representation in Berlin. Each of his New York exhibits earned thoughtful reviews. *The Fan and The Shit* was accompanied by a seventy-four-page, full-color publication that included commentary by Eleanor Heartney, Elizabeth Grady, and José Luis Cortés Santander, all well-respected art commentators. This level and amount of recognition is notable for such a young artist.

When I contacted Almanza Pereda via Skype in October 2010, he was in Bogotá preparing for ArtBo, an international contemporary art fair. The New York gallery Magnan Metz had rented a studio for him and hired two assistants. Almanza Pereda showed the fatigue of participating in the global art circuit

*Facing:* Alejandro Almanza Pereda, *Untitled (Chest of Drawers)*, 2006. Lumber, chest of drawers, table, fish tanks, water, doilies, carpet, cinder blocks, electrical cable, lamp, bedsheets, vase, plant. Dimensions variable.

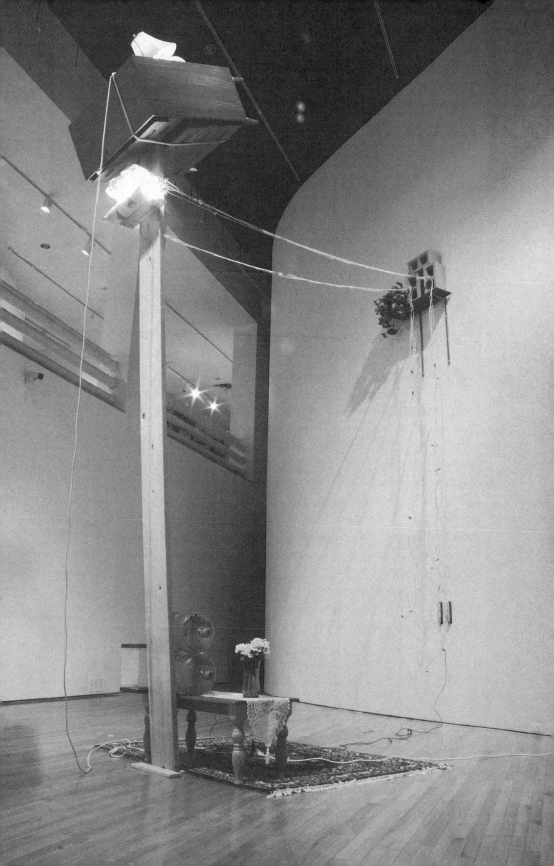

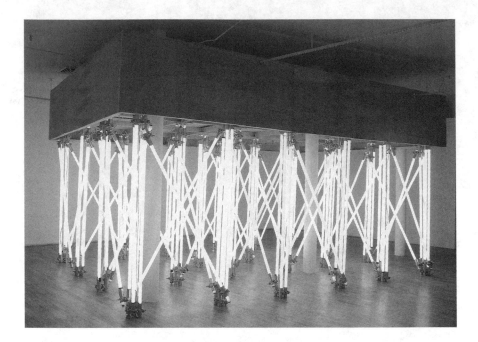

Alejandro Almanza Pereda, *Andamio*, 2007. Fluorescent lightbulbs,
forged steel clamps, ballasts, wood. Dimensions variable.

and had only a few minutes to talk. "I'm really tired. I have been traveling like
crazy. . . . I feel the need to be back in Mexico City . . . when you get invited to
a place and you have a month to do things . . . the piece is done one day before
the opening. . . . It is nicer to see the piece done and reflect on that and then
show it."[1] The artist seemed to need some time to think, to find his center, and
strike a balance, an urge that his sculpture conveys. It is off center and seem-
ingly hazardous.

Almanza Pereda was born in Mexico City and raised there and in Juárez.
I first met him in 2002 when he was a twenty-five-year-old undergraduate art
student at UTEP with a dark ponytail and a wiry frame, wearing a T-shirt and
working constantly with frenetic energy. The Department of Art hosts an an-
nual student art exhibition each year and Almanza Pereda swept the prizes for
all of them during his years in the Department of Art.[2] Since his graduation in
2005, I have tracked his progress via published reviews and his website and kept
in touch via e-mail and occasional Skype conversations.

Almanza Pereda would be a good fit for the Rubin. Though there is an an-
nual alumni exhibition in the smallish Project Space in conjunction with the
annual student art exhibition, my instinct is that Almanza Pereda has already

professionally outgrown that opportunity. Plus, his art is large scale and needs more room than the Project Space offers. In addition, he may need more time to develop because his current work is still closely linked to his student investigations, which were exhibited with great impact throughout the city of El Paso. *Untitled (Desk)* (2005), for example, was one of the student show award winners. In it lies the conceptual and physical focus of *Just Give Me A Place to Stand*: the tension at the tipping point between stability and catastrophe, construction and destruction, protection and exposure, suspension and weight. Theories developed by Maurice Merleau-Ponty and Jacques Lacan, which I touch upon later in this chapter, pull broader meaning from Almanza Pereda's explorations of moments of change.

## Inner Tubes, Cinder Blocks, and Lightbulbs

Many of Almanza Pereda's most ambitious projects in El Paso occupied and transformed underused spaces, both on and off campus. For his untitled entry into the 2002 student art exhibition, he darkened the sculpture foundry in the sculpture studios of the UTEP Department of Art by masking its huge windows and then hanging about a dozen paper globes of varying sizes from the ceiling, some low, some high. Each had a lightbulb inside, a glowing point of light. The next year, Almanza Pereda moved beyond the Department of Art for his site-based sculpture: UTEP's Seamon Hall, the reputedly haunted campus building that had been vacant since the early 1980s when the geologists housed there moved to bigger and more luxurious quarters at the center of campus. Almanza Pereda hacked into Seamon Hall guerilla-style, through a window mistakenly left open. Only the most adventuresome viewers picked through the core samples and antiquated machinery, left behind by the geologists, in order to experience Almanza Pereda's artwork. Two of them were Julie Sasse, juror of the 2003 Annual UTEP Student Art Exhibition and Chief Curator at the Tucson Museum of Art, and me.

It was worth the trouble. Almanza Pereda had connected several inflated black inner tubes of varying sizes and used rough rope to suspend them from the ceiling and to connect each to another, drawn and quartered between the exposed concrete ceiling and posts like a magnificent flayed body in a post-apocalyptic setting. According to the artist, "the inner tube piece was totally about the tension of the material, it was really a formal piece, it was voluptuous . . . of course, every material you use may have political connotations. They were truck inner tubes . . ." that reference the most prevalent mode of commercial commerce across the border at El Paso/Juárez. Eighteen months

later, after a complete interior redesign, Seamon Hall became the Rubin. Almanza Pereda's untitled work had unwittingly set precedent for the building to be the contemporary art venue that it is today. He represents the type of talented and ambitious art student who is also a member of the galleries' core audience.

Almanza Pereda had purchased the used inner tubes in Juárez and remembers "they had wire around them so they were already about tension." At the time, he was living in Juárez and commuting across the Rio Grande to attend classes each day. Inner tubes became the material for several subsequent works. Almanza Pereda was artist-in-residence at the prestigious Skowhegan School of Painting and Sculpture during summer 2004. "The artists and critics there suggested the sculptures were about people crossing the river with those inner tubes and things like that," he said. "But, to be sincere, I wasn't talking about that, I was talking about a more sculptural approach." Almanza Pereda's concern with formal and material qualities continues today, but, for the most part, he does not work with raw material, preferring instead to combine found or purchased elements. For example, many of the elements in *Just Give Me a Place to Stand* were abandoned in the basement of the Soap Factory, used cast-offs that no one wanted.

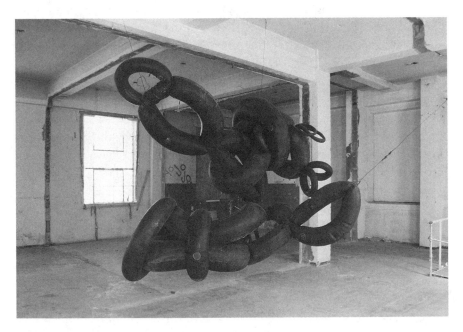

Alejandro Almanza Pereda, *Untitled*, 2003. Previously used inner tubes. Dimensions variable.

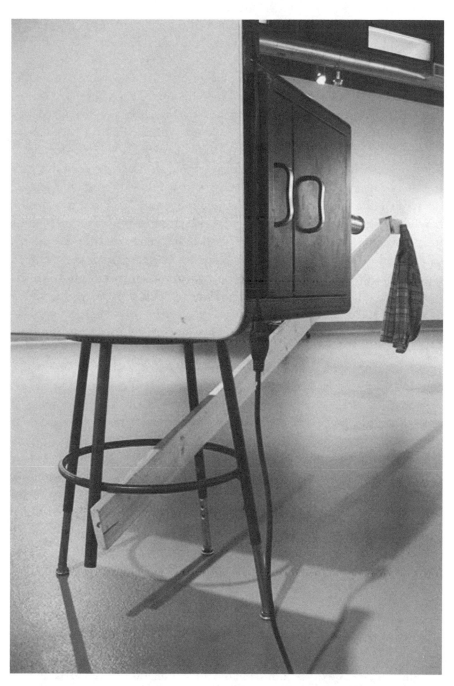

Alejandro Almanza Pereda, *Untitled (Desk)*, 2005. Desk, stool (missing one leg), lumber, TV, dolly, extension cord, jacket, cigarettes, and coins. Dimensions variable.

Though Almanza Pereda is interested in the inherent materiality of his media, the everyday use and meaning of the individual found-object components of his sculptures—such as Persian-style rugs, ladders, fans, lumber, lamps, and potted plants—add another layer to his investigations. For example, his use of Middle Eastern carpets might be interpreted as a comment on the lack of balance or logic in the ultraconservative media outlets' vocalized connection between the Islamic faith and terrorism. Art critic Eva Diaz takes a more egalitarian approach in her observation of Almanza Pereda's sculptures: "They ask us why we produce so much we don't need, why we treat this stuff so poorly when we don't need it any longer, why we don't distribute it among ourselves more equally."[3] Plus, seemingly dangerous juxtapositions (a desk perched on top of a ladder, for example) upset our expectations and jolt us from our comfort zone. They make physical the concept of the decentered subject and the decentered viewer, a poststructuralist approach to the human condition as one of fragmented and contradictory desires that spawn dislocation among other equally dislocated individuals. Think of the fragmentation of a Cubist still life versus the stability and centeredness of a Renaissance one: Almanza Pereda's world allies more closely with Cubism. Everything is subjective and in flux.

Cinder blocks and lightbulbs are two of Almanza Pereda's primary media. *Untitled: After Dionysius* (2008) consists of a suspended cinder block, its perforated sides parallel to the floor, the negative spaces receptacles for a tight grouping of glowing incandescent bulbs. The contrast between the solidity of vertical planes of concrete block and the delicacy of the glass bulbs is striking. It was even more pronounced in a similar untitled work that Almanza Pereda executed in 2004. This piece rested on the floor, the fragile bulbs supporting the heavy, durable block. The physics were simple: the aggregate mass of the bulbs carried the weight of the block with ease because they distributed and shared it. It spoke of the power of the collective and of how fragile materials, when properly engineered, can be strong.

### Striking a Balance

During our Skype conversation in fall 2010, I asked the artist a number of questions, including: "Which contemporary artists do you admire?" He responded, "It is difficult to come up with a list . . . any artist can affect you in really amazing and different ways. . . . But definitely for installation there are Sarah Sze, Jessica Stockholder, and Tara Donovan . . . all women and for me the best examples of installation art." This comment indicates that Almanza Pereda

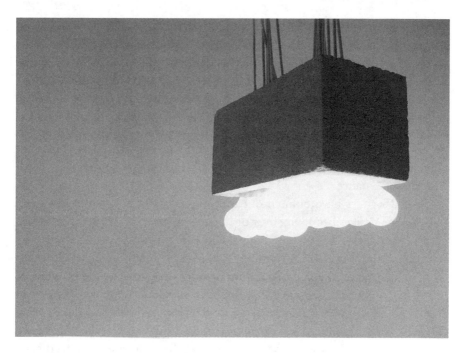

Alejandro Almanza Pereda, *Untitled (After Dionysius)*, 2008. Cinder block, lightbulbs.

sees himself as a practitioner of installation art, the definition of which varies and changes, but the artists he cites shape space with artworks that physically absorb the viewer. Contemporary curatorial critic Claire Bishop explains that "in a work of installation art, the space, and the ensemble of elements within it, are regarded in their entirety as a singular entity. Installation art creates a situation into which the viewer physically enters, and insists that you regard this as a singular totality."[4]

Given Almanza Pereda's self-identification as an installation artist, it seems appropriate to consider phenomenological emotiveness, along with poststructuralist fragmentation, in order to better understand his art. Phenomenologist Maurice Merleau-Ponty, sometimes called the "philosopher of the body," emphasized the pre-cognitive capacities of the physical self. Merleau-Ponty rejected all dualisms that distinguished subjects from objects, particularly Sigmund Freud's distinction between the conscious and the unconscious. He thought instead in terms of lived experience and continuums of existence. Is this not what the best installation art achieves: a complete integration of art, its environment, and the viewer to the point that all three become both subject and object? *Just Give Me a Place to Stand* does this.

Critic and philosopher Arthur Danto dips into phenomenology when describing Sarah Sze's monumental yet delicate assemblages of common objects as having "some antecedent identity in what phenomenologists designate as the Lebenswelt—the world of commonplace objects related to ordinary life."[5] Sze and Almanza Pereda share an interest in juxtaposing everyday furnishings and products to create compelling relationships between these objects and with their surrounding space. But as a general rule, Sze's sculptures are graceful and systemic, employing the power of multiplication, whereas Almanza Pereda's are weighty and seemingly dangerous, exploring the principles of suspension and balance.

Several writers have pointed out that Almanza Pereda's sculptures seem to be on the verge of toppling over or falling apart and consequently connote peril and destruction. Some of the writers tie that to the fear instilled by the destruction of the World Trade Center buildings on September 11, 2001. In 2003, the year after he occupied the sculpture foundry with glowing globes, Almanza Pereda immersed electrified light bulbs in suspended, human-sized, clear plastic sacks filled with water, mixed with white acrylic paint to make it look like milk, and exhibited the sacks in the student union gallery. He darkened the space so that the viewer wandered among these radiant, oversized bladders. UTEP's health and safety commissioner was eating lunch at the union's food court one day, happened upon the gallery, and threatened to shut down the exhibition due to potential hazard. Several art faculty, including me, met with the commissioner that afternoon to vouch for the exhibit's value and for Almanza Pereda's ability to make what is not dangerous look as if it is. He had submerged the bulb only about halfway into the water, so electricity did not connect with liquid. We lobbied to keep the exhibition, and it stayed open for the full week that it was slated to be on view.

## Vitality and Confinement

Others writers attribute Almanza Pereda's expressions not to fear and catastrophe, but to his specific, dual experience in the United States and Mexico. For example, as José Luis Cortés Santander notes, Almanza Pereda "has lived in various cities across Mexico and the United States having spent a third of his life in the latter." Cortés Santander continues:

Historically, coexistence and daily transit between two social realities as different as these two countries has set off high-contrast aesthetics. Though recent generations of bi-national artists have limited their offerings to a

worn-out political literature as common stylistics, Almanza has material-
ized these differences and assimilated them as "what was given him," im-
bibing them firsthand . . . he juxtaposes wire and duct tape, naturalizing
distortions of the security measures at the two places where he works, gen-
erated by his inevitable coexistence over a dislocated border.[6]

This interpretation seems to be in line with what Almanza Pereda has in mind,
especially his emphasis on his border experience. The artist is intrigued by how
people of different cultures perceive safety and danger:

> Every time somebody asks me, how did I start to do art or think about art?
> I think it is totally the border, me living in Juárez and going to UTEP, just
> crossing the border everyday, it was a pretty amazing experience and defi-
> nitely developed my work into focusing on danger, the perception of risk
> and things like that.

About a year earlier, Almanza Pereda stated: "In Mexico City, New York and in
Berlin, it is totally different. That is why I liked living in a border town, because
just one line changes everything."[7]

Occupational Safety and Health Act (OSHA) laws have reduced the tolerance
in this country for conditions of physical peril. Plus, drug-related violence in
Mexico, especially Juárez, has placed that city in a state of alert. Hence, a sense
of relief is part of the experience of crossing north into El Paso, one of the saf-
est cities of its size in the world. In the United States, we have come to expect
security and comfort. Are we, consequently, less vital, less adventuresome and,
overall, less willing to challenge ourselves? Though the middle class is eroding
in this country, with more and more resources concentrated in fewer and fewer
hands, it is still more dominant here than it is in developing countries such as
Mexico. Almanza Pereda crossed from one country to the next on a daily basis
and his sculptures seem to be asking us to ask ourselves: Does our middle-class
comfort impose a fear of its loss that, in turn, controls us?

If the vitality that comes with taking risks is a recurring theme in Almanza
Pereda's work, so is its near opposite: confinement. In his art, these two ideas
interact both physically and conceptually. For example, in *Andamio* (2007), six-
foot-high fluorescent bulbs create a scaffold of support for an enclosed, elevat-
ed wooden container; it is, in many respects, a larger version of the previously
mentioned untitled work from 2004 in which incandescent bulbs supported
a cinder block. The viewer walks beneath the container and looks up at the
underside of its floor, which is the size of a walk-in closet. It sits in a gallery

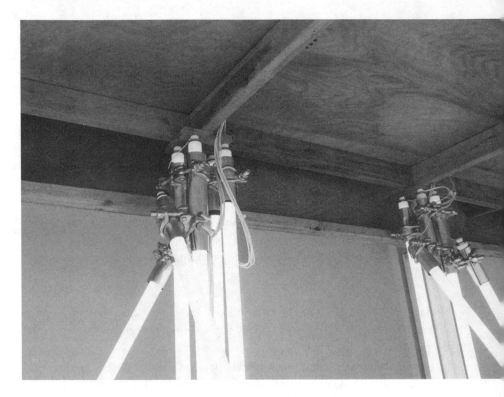

Alejandro Almanza Pereda, *Andamio*, detail, 2007. Fluorescent lightbulbs, forged steel clamps, ballasts, wood. Dimensions variable.

about twice its scale and nearly touches the ceiling, hugging the gallery's vertical columns and engulfing its horizontal pipes of plumbing infrastructure. The gallery surrounds the sculpture that, in turn, surrounds the guts of the gallery in a self-perpetuating, closed system of contained containers. Architecture as containment is an obvious reference, as are materials of the construction trade such as the lightbulb, a fixture of habitation and civilization. The artist states: "I like the structure of a lightbulb. It's a transparent container that releases energy, the light goes through the container . . . a structure that is in a way alive."[8]

## Defying the Dark: Reflecting and Refracting Light

Indeed, most of Almanza Pereda's sculptures include illuminated lightbulbs, and his interest in artificial light raises another dichotomy in his art. Suspicion, fear, and danger associate with darkness; knowledge and clarity connote

illumination. Almanza Pereda's sculptures literally balance these two concepts: there is an optimistic slant to the manner in which he reveals the tenuousness of everyday life. Many other artists who have used light as a medium—such as Robert Irwin and James Turrell—do so with the intention of creating mood and atmosphere by illuminating, and reflecting, the surrounding space.[9] Often the source of light is hidden.

Almanza Pereda, in contrast, employs the bulb for its physical properties. In his hands, the cheap household fixture is exposed and looks like nothing more than itself in part because he dislocates the bulb from its metal fixture and attaches it to another type of connector, which he sources in Mexico and Brazil.[10] But it becomes greater than itself when combined with other objects that balance, challenge, and complement each other: the whole is more than the sum of the parts. *White Carpet* (2004) is a cluster of bulbs arranged in the pattern of a Persian carpet and references the unsupported but widespread connection among Persian carpets, Islam, and terrorism. The glow of Almanza Pereda's bulbs defies the darkness of such ignorance and instead emphasizes the energy resources concentrated in the Middle East.

In addition to bulbs that generate light, Almanza Pereda uses mirrors to reflect light. *Don't Make Light of Something* (2008), for example, is a mirror-encrusted cinder block that brings to mind Damian Hirst's *For the Love of God* (2007), a platinum cast of a human skull encrusted with 8,601 flawless diamonds that cost 14 million British pounds to produce.[11] Almanza Pereda combines the most pedestrian of materials as a counterpoint to Hirst's use of the finest. *Don't Make Light of Something* is suspended, floats above the viewer's head, and threatens to drop. *For the Love of God*, in contrast, rests on a pedestal and under a vitrine and therefore invites reverence. But both works reflect and refract light to create points of brilliance on the surrounding walls, their shadows even more visually commanding than the sculptures themselves.

In Almanza Pereda's *Ahead and Beyond of Everyone's Time, Space and Rhythm* (2009), a disco-ball-sized sphere completely coated in mirror fragments pushes up against and rotates around the edge of a round table, which is draped in white linen and set with fine china. Most of the place settings are clean and untouched; only one has remnants of a meal. Placed as it is, the disco ball makes the table unusable and is also re-identified as a wrecking ball, threatening to destroy this signifier of the upper class. The pedestrian and the popular implied by the ball could easily smash the elitist and the established due to its force and size. Yet, it holds back, intimidated by the status and security insinuated by material possessions. Here the middle class underestimates its power.

Alejandro Almanza Pereda, *Ahead and Beyond of Everyone's Time, Space and Rhythm*, 2009. Table, silverware, chinaware, candles, cutlery, flowers, napkins, vase, tabletop, chandeliers, disco ball.

## Mirrors as Medium and Subject

The use of the mirror as a material in art making has a long history. Jacques Lacan's 1936 essay about the "mirror stage" entered the general discourse surrounding art through the magazine *Screen*, which made frequent references to the essay in the mid-1970s.[12] Lacan reinterpreted Freud and proposed that an infant passes through a stage in which an external image of the body produces a psychic response that gives rise to the mental representation of an *I*. The gestalt of emerging images of selfhood creates an ideal to which the subject perpetually strives, one that is dependent upon external objects and eventually upon linguistic and social relationships. Lacan's philosophy focuses on how an individual's self-development is relative and relational and depends upon the outer world. In *Ahead and Beyond*, Almanza Pereda applies this concept because the way in which a social class understands itself depends upon its

understanding of other classes. Thus, the mirror is not only a formal device that activates space through sparking light, it is also an expression of social and cultural contingency, another way of describing a decentered existence.

Merleau-Ponty also addressed the use of the mirror. He saw it as an important motif in his explorations of vision, its relationship to the body, and its role in the formation of our knowledge of the world. Routledge & Kegan Paul published an English edition of his *Phenomenology of Perception* in 1962, so American artists and critics had access to his important theories on perception about a decade before those of Lacan became more widely available. Art historian Eileen Doyle points out that the use of reflective surfaces in contemporary art arose concurrently with Minimalism: it was not so much central to that artistic movement but grew simultaneously with it, around 1964–1975.

So did the importance of writing about art. For example, Robert Morris arranged his twenty-one-inch *Untitled (Mirrored Cubes)* (1965–1971) into situations where the viewer would be reflected as an embodied component of the gallery space and would then be made more aware of self and surroundings. He then addressed this experience in his 1966 essay, "Notes on Sculpture." Mirrors are central to the work of many other artists such as Dan Graham, Robert Rauschenberg, Robert Smithson, Lucas Samaras, and Michelangelo Pistoletto. In each of these cases, the artist emphasized how the mirrored art object could both facilitate and complicate the viewer's understanding of his/her relationship to inner and outer worlds. Almanza Pereda does this as well, but he also uses the mirror to focus on the properties of light and to address classist tendencies in broader social situations. Almanza Pereda's predecessors and elders tend to focus on the individual experience; Almanza Pereda concentrates on class and social structure.

Almanza Pereda often makes a piece of furniture a focal point in his multicomponent sculptures, balancing it at the end of a piece of lumber, on top of a precarious stack of bricks, on a skateboard, or the like. If the furniture references enclosure, domesticity, and security, then all of these are literally on shaky ground. All his sculptures share one characteristic: although solidly assembled, they seem precarious and use "order to produce an appearance of disorder."[13] They imply risk but are in fact stable. The irony is that this is the exact opposite of the environment during 2006–2008, the years directly preceding the global economic recession, when Almanza Pereda was actively producing art in New York City. At that time, the financial system seemed to be healthy, growing, and safe, but it was in reality crumbling. At the same time, the global economy and Almanza Pereda's sculptures share something

because they both express states of interdependence. Reviewer Izabel I. S. Gass describes Almanza Pereda's works as "infinitely complex force diagrams." If one link is compromised, the entire system will collapse.[14] Consumption depends upon the supply chain, which depends upon the transportation network, which depends upon production, which depends upon consumption, and the cycle continues, with one factor pushing or pulling the others. "Light and electricity are like a great cycle that gives you an idea of time," states the artist.[15] His sculptures are abstractions of our cyclical and dependent situation and how social class connects to economic forces.

## Conclusion

In *Just Give Me a Place to Stand*, *Untitled (Chest of Drawers)*, and most of his other works, Almanza Pereda explores the tension of the decentered human condition, of how one human being depends upon another, social class depends upon economic circumstance, and one society's development depends upon that of other societies, which is especially true on the U.S./Mexico border, where the first and third worlds meet. His art embodies the physical and aesthetic excitement of the built environment by adding to the long lineage of found-object sculpture established by early twentieth-century modernists and expanded upon by recent installation artists. It connotes post-9/11 fearfulness and global economic peril. It draws upon theories of phenomenology and post-structuralism to explore the vulnerability and vitality of interdependence among objects, individuals, and nations. It denies and defies stasis.

# Marcos Ramírez ERRE

*To Whom It May Concern, War Notes*
2005

My introduction to Tijuana-based artist Marcos Ramírez ERRE was through a singular image.[1] *Sculpture* magazine published a review of the art event in-SITE97 that included a photograph of the gigantic *Toy-An Horse y Trojan Horse/ Toy an Horse and Trojan Horse* that ERRE had built directly on the border at the heavily trafficked San Ysidro crossing between San Diego and Tijuana.[2] The story resonated with me so I carried that issue of *Sculpture* along when I moved from Portland to El Paso, and I kept ERRE in the back of my mind when I was programming exhibits for the UTEP Department of Art gallery. I wanted to cultivate a relationship with, and consider showing, just this type of artist: early-midcareer, familiar with the dynamics of the border, and earning well-deserved international attention. Plus, I wanted to expand the repertoire of exhibitors to include artists living in the Americas south of the border. (With few exceptions, we had focused on artists living in the United States.) I thought that ERRE might represent a starting point for this programmatic expansion. These motives eventually led to a solo exhibition at the Rubin that was formative for artist and institution because both regard the U.S./Mexico border as central to contemporary political and philosophical concerns.

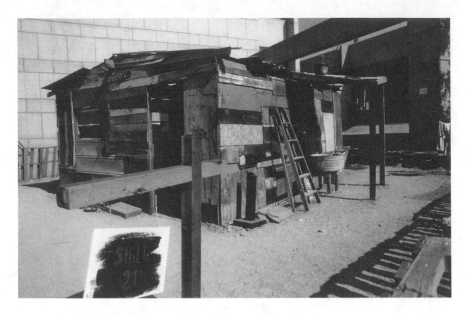

Marcos Ramírez ERRE, *Siglo 21/Century 21*, 1994. Mixed media.
Dimensions variable.

## Of Walls and Borders

INSITE is a periodic, binational art event that addresses the border and the San Diego/Tijuana corridor. Its first iteration was in 1992, precisely when ERRE was launching his career as an artist, and he has participated multiple times over the years.[3] For INSITE94, ERRE brought the border to the literal center of Tijuana when he built *Siglo 21/Century 21*, a replica of a typical, provisional dwelling found in the poor communities along Tijuana's outskirts. He constructed this abode on the formal plaza of Tijuana's Cultural Center in the heart of the city, juxtaposing the monumentality and permanence of Mexico's institutional architecture with the temporality and flexibility of semi-nomadic residential structures. For INSITE94, ERRE built *Toy Horse and Trojan Horse* according to Homer's description of the Trojan horse in the *Iliad*, down to its capacity of thirty people. One head faced Mexico, the other the United States, a physical manifestation of ERRE's double-consciousness as a citizen of both Mexico and the U.S. borderlands.[4]

My hunch that ERRE would be a good choice for an exhibition was reinforced in autumn 2002 when I attended *Mixed Feelings*, a show curated by Michael Dear and Gustavo LeClerc at the Fisher Gallery at

*Facing:* Marcos Ramírez ERRE, *Toy-An Horse y Trojan Horse/Toy Horse and Trojan Horse*, 1997. Metal and wood. 393" × 354" × 156".

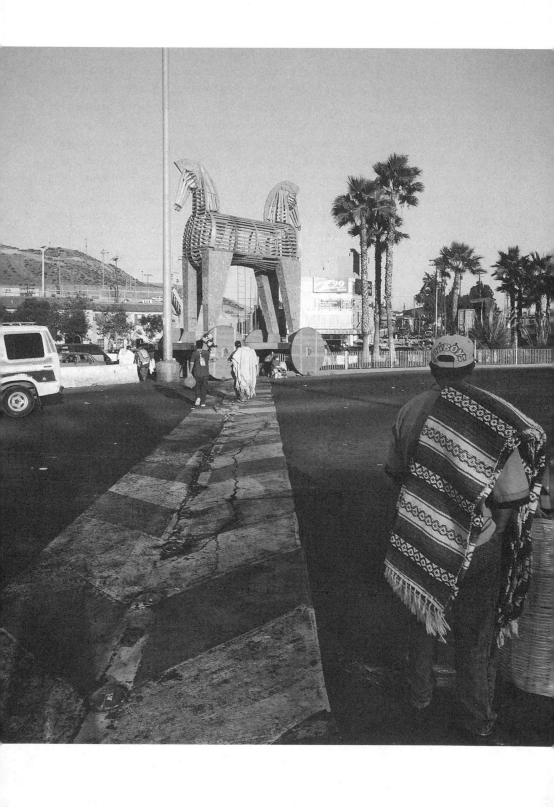

the University of Southern California in Los Angeles that focused on the U.S. / Mexico border. This was about the same time that the idea of, and fund-raising efforts for, the Rubin were under way. For *Mixed Feelings*, ERRE had created *Walls*, a double-sided, eight-foot-high room divider constructed of brick on one side and two-by-six-inch lumber on the other. The brick side was pierced by a portal with a screen conveying video imagery of a Mexican construction crew working in Rosarito, Baja California. Behind it and inserted between two of the lumber two-by-six-inch studs was a second screen with footage of a Mexican crew at a job site in San Diego, California.

The interpersonal dynamics and working styles of the two crews were completely different. The workers on the Mexican site conveyed a more process-oriented approach; they solved problems as they arose. Conversely, the San Diego crew had pre-defined roles; their work style was systematic and their interactions were limited and controlled. ERRE filmed for a day at each site and edited the footage down to eight minutes to highlight the differences between the crews' methods, which point to the tensions and possibilities of border life. I thought that El Pasoans would strongly identify with this piece and decided to pursue a meeting with the artist. *Mixed Feelings* as a whole was formative to my thinking about how artists are responding to the national divide and how UTEP might be instrumental to that response. It reaffirmed my conviction that UTEP could be a dynamic venue for exhibitions of challenging visual expression about the U.S. / Mexico border.

ERRE had employed *Walls'* format and use of materials to highlight cultural difference in a previous work, *Stars and Stripes Forever (An Homage to Jasper Johns)* (2000), which was exhibited in the courtyard at the Whitney Museum of American Art for its 2000 Biennial Exhibition. This "replica" of the American flag was fabricated from sheet metal similar to that used to construct sections of the wall that divides Tijuana from San Diego. ERRE contained a ten-foot-square patch of dirt with four short walls, like curbs, two of cinder block and two of brick. The flag bifurcated the dirt lot. For ERRE, the cinder blocks represented the United States; the bricks, Mexico.

The format of the wall resurfaced in ERRE's *Shangri-La: El Sueño Volatile/ Shangri-La: The Volatile Dream* (2008), which addressed rapid cultural and environmental change in Yunnan, China. A solidly constructed room divider, topped with a decorative Asian roof, housed four plasma screens, two on each side of the structure, in place of windows. On one side were images of the land as experienced "from the house out."[5] On the other side of the wall was footage showing the daily lives of Yunnan residents in their homes. But it also documented the physical construction of a monastery. An older monk looks

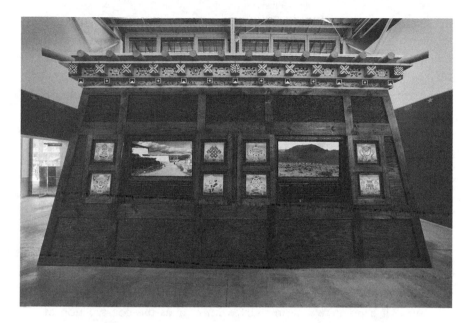

Marcos Ramírez ERRE, *Shangri-La: El Sueño Volatile/Shangri-La: The Volatile Dream*, 2008. Mixed media, decorative wooden detailing created by Tibetan artisans in the region of Shangri-La, Zhongdian, Yunnan Province, China. 144" × 248" × 63.5".

on, attempting to absorb the activity, knowing that new construction represents changing attitudes and the fading of a former way of life—or, as ERRE notes, "By building, we are destroying."⁶ ERRE's interest in the format of the wall may be in part a subliminal recognition of the border wall, or fence, that separates Tijuana from San Diego. In any case, the wall as an imposition to human connection and capability is an important symbol for the artist.

## Meeting ERRE

Soon after I returned from the *Mixed Feelings* show in Los Angeles, I contacted ERRE and scheduled a studio visit. For that trip in 2003, I spent the night in San Diego, parked at San Ysidro, walked across the border, and immediately spotted ERRE waiting for me on the roof of a two-story, cinder block building that he called "Estación Tijuana/Station Tijuana." He was broad-chested and exuded physical strength, smiling most of the time, but with a seriousness of purpose. At Station Tijuana, ERRE constructed his artwork and also hosted exhibitions of art by other artists. It became a nexus for conversations, both organized and informal, among and about artists and their art. As ERRE described

it, Station Tijuana "impacts my work in different ways. Some works in the shows make me question my own practice, others reinforce my position, and others prompt me to find new meaning in my own work."[7] In 2010, ERRE's son Marcos Isaac died in an automobile accident. The artist closed Station Tijuana, vacated the building, and focused on renovating his home in the Colonia Libertad neighborhood of Tijuana, expanding it to be a living/work space for him and his family.

That day in Tijuana when ERRE and I first met, we talked about his art, where it had come from, and where it was going, and, as evening closed in, we ate an excellent meal at a nearby restaurant. That was it. But it was clear to me that the artist was generous, though uncompromising, and a pivotal figure in the art community of Tijuana and beyond. (It was ERRE who connected me to artists Julio César Morales and Tania Candiani, both of whom created memorable artworks for the Rubin in 2008 and 2009, respectively.) That trip was a few months after UTEP President Natalicio had telephoned me about the prospect of the Houston Endowment gift toward what would become the Rubin.

I made it a point to stay in touch with ERRE as the construction of the Rubin took shape. The two largest exhibitions during 2004–2005, the first academic year of programming, did not tackle global or national politics. *Seriously Playful*, by New York–based Paul Henry Ramírez, was a formal exploration of color, form, and sound. The artist executed a site-based painting that visually connected pre-existing canvases of his sexualized abstractions of body parts and fluids to the gallery walls. The work of several jewelry makers, *Hanging in Balance: 42 Contemporary Necklaces* presented one-of-a-kind pectorals that affected the human body's balance and expressed myriad ideas, including thoughts about decay, translucence, and rigidity.

The timing then seemed right to establish our connection to our border audience and policies by making ERRE part of the program. I was not afraid to exhibit controversial art: I had hosted exhibitions by Enrique Chagoya and Joyce Scott and other politically oriented artists when I was managing the gallery in the Department of Art. The only difference was that the Rubin was a higher-profile venue, it was still new on the scene, and it was consequently receiving attention and scrutiny. But I embraced the risk, took the plunge, and offered ERRE an exhibition slated for fall 2005.

### To Whom It May Concern: War Notes

Though ERRE claims the border as his "sphere of action," by that time he was moving away from the specifics of the border experience to focus on political injustice and the aftermath of cultural miscommunication because, in his

words, "in the end human problems are the same whether it is between Mexicans and Americans, Russians and Chinese, or Africans and Europeans."[8] ERRE had no interest in replicating *Walls*. (Though within a few years, in 2008, he returned to the U.S./Mexico border as subject in at least one work and the wall as a sculptural format in another.) I agreed to instead show four other works, one of which was a new commission. ERRE's track record of exhibitions and his identity as a citizen of the border would be enough of a connection to our border location and to the Rubin's curatorial emphasis on art about place. I was determined to focus on the artist's sensibility rather than on the exhibited product of that sensibility. Plus, I did not want to push the artist to return to a piece that he had no interest in re-creating.

Most importantly, I was confident that *To Whom It May Concern: War Notes* (the title that ERRE assigned to the exhibition) would establish a valuable global and historical context for contemporary border relations. War is one possible result of disagreement between governments or cultures. By condemning it and its resulting violence and death, ERRE is, of course, part of a distinguished lineage of artists. Picasso painted *Guernica* in 1937 in response to the bombing of an ancient Basque city by German forces acting on behalf of the Francisco Franco regime during the Spanish Civil War. Of this work, Picasso said, "Painting is not done to decorate apartments. It is an instrument of war for attack and defense against the enemy."[9] This is only one of many examples.

## FOUR PILOTS OF THE APOCALYPSE

*Four Pilots of the Apocalypse*, the conceptual centerpiece of *To Whom It May Concern: War Notes*, consisted of four video projections of excerpts from Hollywood movies about military combat, edited and sequenced by ERRE, who deleted the audio and the scenes that included recognizable actors. The videos were projected from helicopter-shaped sculptures that were suspended from the ceiling. The walls acted as image-filled screens, each only about ten feet away from the helicopter, which was the source of its imagery. The viewer felt compressed—both physically and visually—surrounded by hard-hitting depictions of battles as interpreted first by Hollywood moviemakers and then again by ERRE. The whirring of helicopter blades and music from Richard Wagner's opera, *Twilight of the Gods*, further pervaded the space.

ERRE based *Four Pilots* on the Four Horsemen of the Apocalypse as described in Revelations, the final book of the New Testament. As the story goes, four men, each riding a horse of a different color, appear to the Apostle John. The first horse is white; its rider holds a bow that symbolizes conquest. The second horse is red; its rider grips a sword for war. The third is black and identified by

the scales of famine. The final horse is pale; its rider is death. ERRE first unveiled *Four Pilots* in January 2005 at ARCO, Madrid's annual international contemporary art fair. That year ARCO made international headlines on its opening day when Basque separatists exploded a bomb directly in front of the convention center where the fair was taking place. Destruction as backlash from misunderstanding and perceived oppression characterized the public introduction of *Four Pilots*, immediately actualizing its artistic message.

The El Paso showing was the second in the work's short history and the first in the United States. When ERRE arrived to install the exhibit in late August 2005, we discussed the layout of the show and decided to situate the room that housed *Four Pilots* at the back corner. We wanted the gallery as a whole to have an open and airy feeling, and, placed in the back, *Four Pilots* would then be the final gestalt of the exhibition experience. The ten-foot-square video room consisted of two temporary walls attached to two existing walls. Assisted by the Rubin's newly appointed exhibition installer, ERRE constructed the temporary walls himself, a testament to the artist's construction expertise (he worked for nearly two decades as a carpenter prior to becoming an artist) and his generosity of spirit. He also painted the walls' exteriors in a camouflage pattern.

## LA MULTIPLICACIÓN DE LOS PANES/
## THE MULTIPLICATION OF BREAD

*La Multiplicación de los Panes/The Multiplication of Bread* was the visual centerpiece of *To Whom it May Concern: War Notes* due to its scale and placement. It referenced both a Biblical event (Christ's miraculous feeding of the multitudes with a single piece of bread) and the U.S. intervention in Afghanistan (when the U.S. military dropped humanitarian bundles of food that Afghani civilians confused with undetonated, U.S.-supplied explosives). The focal point of the work was an anonymous and semi-destroyed desert village on the floor below a grid of missile-shaped baguettes. Two light boxes confronted each other at opposite ends of ERRE's model village. One illuminated a photograph of the blue eyes of a pale-skinned boy. The other featured the eyes of a brown-skinned girl who looked like she could be Arab. Both subjects were, in reality, Mexican, further validating ERRE's point that stereotyping based on appearance—or anything else for that matter—is rooted in unfounded prejudice and cruelty. Below each photograph were quotations about the power of love. ERRE paired the girl's photo with a passage from the Koran written in Farsi. The photo of the boy connected to the words of Martin Luther King Jr. The format of these statements resembled eye charts. They became nonfigurative icons of the visionaries whose words they conveyed.[10]

The total direct cost of the exhibition was approximately fifteen thousand dollars. This included the artist's honorarium of two thousand dollars, travel, and lodging; exhibition materials such as sheetrock, paint, and signage; a thirty-two-page exhibition catalogue, including essayists' honoraria, graphic design, and printing; and the cost of shipping the artwork from San Diego to El Paso and back. ERRE took responsibility for trucking the artwork across the border between San Diego and Tijuana.

ERRE's interest in Biblical narratives is obvious in *Four Pilots* and *The Multiplication of Bread*. (He named his second son "Marcos Isaac" after the Old Testament character.) In discussing the two artworks, ERRE states, "The difference between the two pieces is that *Four Pilots* is more charged with despair;

Marcos Ramírez ERRE, *Four Pilots of the Apocalypse*, 2004–2005. Aluminum and wood helicopters, projectors, DVD players, dimensions variable. Photograph by Marty Snortum.

Marcos Ramírez ERRE, *La Multiplicación de los Panes/The Multiplication of the Bread*, 2003. Mixed media installation of light boxes, Persian rug, bread, stones, wood, and sand. Dimensions variable. Photograph by Marty Snortum.

it is really apocalyptical and sad. *The Multiplication of Bread* directly points to specific events in recent history, the result of foreign policy and decisions taken by the American government."[11]

ERRE also fosters a deep interest in mythology. His first son Ulysses is named after the character in Homer's *Odyssey*, the literary work that describes the warrior Ulysses's ten-year-long journey home after the Trojan War. The war ended when the Greeks entered the city of Troy, hidden in the bowels of a huge wooden horse, and took control of the city. ERRE's *Toy an Horse and Trojan Horse* applies this metaphor of unwittingly inviting a foe into secure territory to contemporary border relations. But here the "foe" of Mexico, which is in actuality a trade and business partner to the United States, remained on the Mexican side of the border and did no harm.

ERRE is committed to textual expression and recognizes the power of words. Not only is much of his artwork rooted in Biblical and literary classics of morality, loss, and violence, it also often incorporates text. He quotes artist Joseph Beuys's statement, "In the beginning was the word, and the word is a form," which iterates the aesthetic quality of letters.[12] For example, one of ERRE's ongoing projects is *Crossroads*, a series of signpost sculptures, rectangular and brightly colored, where the text is the image. The works were originally conceived for the international art exhibit, the VII Havana Biennial, in 2000, but

the artist sometimes re-creates them for private and public commissions. They identify the distances of a specific site to places connected with recognizable people, along with a quote by that person. For example, a comment by writer Rainer Maria Rilke—"We live our lives, forever taking leave"—would be paired with the distance between ERRE's sign and the writer's native Prague. For the exhibition *Baja to Vancouver: The West Coast and Contemporary Art* (2004–2005), he produced *Crossroads (Tijuana/San Diego)*, about which Toby Kamps, co-curator of the exhibit, commented: "Appropriating the style of official street signs and tourism markers, Ramírez attempts to chart a complex international psychogeography, using the West Coast as his starting point."[13] Guy Debord, leader of the Situationist International, a group of artists and writers in Paris after World War II, defined the term "psychogeography" as the study of how the geographical environment influences human emotions and behavior. The Situationists created inventive strategies for exploring cities—and for jolting pedestrians into new, visceral awareness—as a method of resistance to the alienation of modern existence. To them, how a place felt determined its impact and meaning.

Indeed, ERRE's signpost sculptures connect politics to place. However, they are geometric in form, primary in color, and cool and graphic in sensibility and therefore privilege the intellectual over the emotive and thinking over feeling. His focus on language opens itself to analysis via semiology, which argues that language is based on a system of relations.[14] I would argue that ERRE's art, including the signposts, allies more with the intellect, with semiotic analysis and with how the written word evokes significance, than it does with the more emotive approach of the Situationists. ERRE's commitment to written narratives and historical events as subjects in his art supports this. Even the title of his exhibition, *To Whom It May Concern: War Notes,* at the Rubin connects to notation and documentation. In any case, several approaches can be applied as tools to unlock meaning in ERRE's art, testament to the flexibility of theory and to the versatility and power of his expression.

## THE READING PROJECT

*The Reading Project*, the third piece in *To Whom It May Concern: War Notes*, was, like *Multiplication of Bread*, critical of U.S. foreign policy. In El Paso, this included a four-by-ten-foot aluminum sign produced for the Rubin exhibition but based on the design for a piece for *Mexico Illuminated*, a citywide exhibition in Reading, Pennsylvania, in 2003. With reflective white letters on a green background and reminiscent of ERRE's *Crossroads*, it was almost identical to

highway exit markers. But rather than identifying the names of the streets connected to the next few off-ramps, *The Reading Project* listed eight cities bombed by the United States, their distances from Reading, and the year of each bombing. Though ERRE won the approval of his sponsors and the Reading Redevelopment Authority to mount a public art piece on a billboard next to the busy Bingaman Street Bridge, *The Reading Project* was censored by the City of Reading. A city councilwoman claimed, "Art is art. But bombing is not Art." ERRE responded to this and other criticism: "The billboard only itemizes events that in their time were celebrated as victories and praised as just causes. Are people outraged because a Mexican artist has bothered to highlight this history? Or do I perceive an underlying shame?"[15]

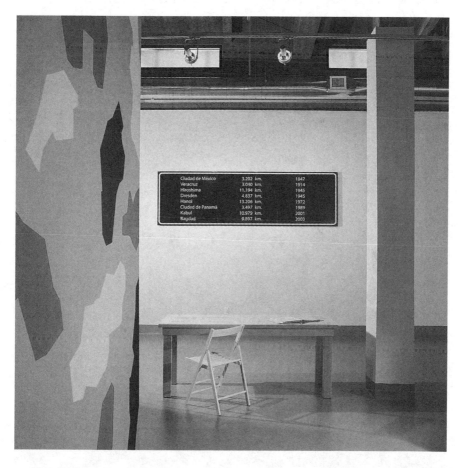

*Facing:* Marcos Ramírez ERRE, *Crossroads (Tijuana/San Diego)*, 2003. Aluminum, automotive paint, wood, vinyl. 144" × 40" × 40". *Above:* Marcos Ramírez ERRE, *The Reading Project, 2003–2005*, 2005. Highway sign: aluminum and paint plus didactic materials. 48" × 120". Photograph by Marty Snortum.

## NEW RULERS

ERRE created *New Rulers*, the fourth and final piece in *To Whom It May Concern: War Notes*, specifically for the Rubin exhibition. The words of Buddha, presented as an eye chart, appeared on a bright yellow background. Four four-foot aluminum rulers stamped with the verbiage "Made in the USA" frame the print. *New Rulers* commented on the United States as today's superpower and its tendency to place materialism before spirituality. Throughout the exhibit were allusions to the significance of the number four (e.g., four pilots, four rulers) and its relationship to symmetry, place, and time: the cardinal points, the seasons of the year, ⅙ of a day. ERRE hired out the production of the print in *New Rulers*, as he does the production of all his eye charts and signs. As he states:

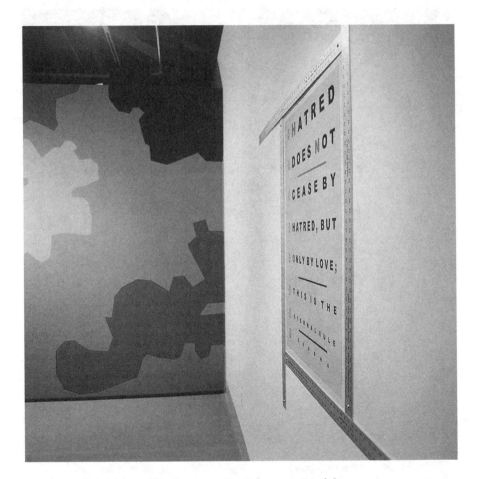

*Above & facing:* Marcos Ramírez ERRE, *New Rulers*, 2005. Lambda print on paper. 59" × 70". Photographs by Marty Snortum.

I have been learning about art as I live and practice . . . and sometimes doing it with other artists . . . and creative people who have designed their creative production on a day-to-day basis. In general, my strategy is to have schematic control of the project and its formal solutions, about 85 to 90 percent of the project. Then I look to find help to solve the other 10 to 15 percent . . . and that is one of the most gratifying parts of the process. I never compromise the conceptual part to exterior participation.[16]

For *New Rulers*, he brought the print from Tijuana and during his time in El Paso formulated the idea of framing it with the measuring devices and established a title for the piece. In this case, the product came first and the concept later.

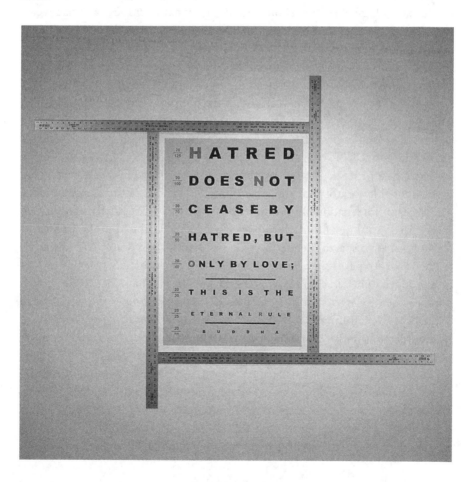

## Back to the Border

ERRE's exhibition was successful because it filled the space pleasingly, conveyed prescient ideas and issues, and left the audience wanting more. In retrospect, the only change I would have made would have been to allocate time and energy to raise the funds to commission a public piece for a prominent site in El Paso in conjunction with the exhibition. Outdoor pieces are some of ERRE's most pointed and effective work. Plus, they reach a broader audience. In 2006, he was able to finally realize a billboard (though not the one he designed for *The Reading Project*) as part of the exhibition *Strange New World* at the Museum of Contemporary Art, San Diego. *The Prejudice Project* was installed on a San Diego highway for about three months and consisted of a photographic image of the back of the head and shoulders of a grey-haired Caucasian male wearing a military jacket and looking into the distant desert. Above him floated the text, DON'T BE A MAN FOR JUST A MINUTE. BE A MAN YOUR WHOLE LIFE. ERRE himself wrote this phrase in hopes that "the people will have a standpoint, a position about the quote."[17] It referred to the Minutemen, the volunteer civilian group that self-mobilized to protect the border from the U.S. side. The Minutemen mounted a response on a billboard less than a mile away that ERRE described as "really straightforward, something like 'stop illegals,' nothing really poetic about it."[18]

During summer 2008, ERRE was a resident at Artpace in San Antonio, "an international laboratory for the creation and advancement of contemporary art."[19] Many internationally prominent artists who have participated in one of Artpace's multiple-month residencies have also exhibited at the Rubin, including Adrian Esparza, Regina José Galindo, and Mark Bradford. During his residency at Artpace, ERRE returned to the subject of the U.S./Mexico border and produced *El Cuerpo del Delito/The Body of Crime*, which focused on how a person's identity may shift due to both the opportunity and the desperation created by the culture of drug trafficking. It also relates to ERRE's conjecture that border culture is expanding both north and south in a "borderization" of both countries: the drug wars affect a far-flung network of cities.[20] The installation included a bullet-riddled black Chevrolet Suburban at the center (its radio playing a *narcocorridos* sound track), a video projection, photographs, various forensic materials, and a graphic representation of the U.S./Mexico border. Mimicking forensic strategies, ERRE asked the viewer to question the role of presumably objective specialists in creating meaning and defining truth.

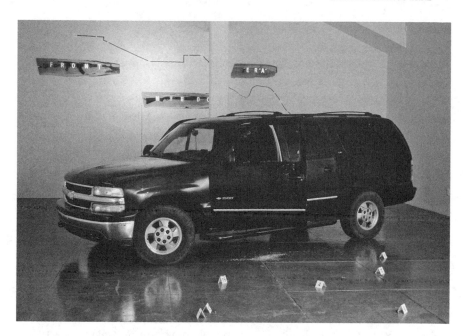

Marcos Ramírez ERRE, *The Body of Crime,* at Artpace, San Antonio, Texas, 2008.
Installation detail. Photograph by Kimberly Aubuchon.

The video element related to the overall work much like the videos used
in *Walls* and *Shangri-la: The Volatile Dream* related to those works. Titled *The
Black Suburban,* the video was a single component of many in the overall in-
stallation and was also core to the narrative of the piece. The video portrayed
the investigation of a fictitious assassination associated with drug cartels in
Mexico; elements of the "crime" were on display in the gallery. The film's nar-
rative explored the moral ambiguity of each of the three characters involved:
the assassin, the policeman, and the victim were all the same person, and all
played by ERRE, in a clear comment on the corruption of the Mexican police
force and on the difficulty of knowing whom to trust. Three mug shots of ERRE
portraying each of these roles were mounted on a mirror that also created a
border around the image. In the bottom border of each was etched a single
word. The victim was labeled "*yo*" (me); the assassin was "*tu*" (you); and the
investigator was "*el*" (him), clearly implicating the viewer as partly responsible
for the corruption. Plus, the viewer's reflection was clear in the border of all
three, "highlighting the masquerade of identity and the instability of truth."[21]

## Focus on Mexico

What was to come after *The Body of Crime*? In early August 2010, I broached this subject with ERRE. I was visiting him at his home in Tijuana and we were sitting face-to-face across a "table" constructed from a piece of plywood laid over two sawhorses. He spoke of social inequality in Mexico. Though he had achieved a high level of recognition as an artist, he was still struggling financially and feeling the pinch of renovating a house without a steady income. ERRE linked his personal financial condition to the North American Free Trade Agreement (NAFTA) of 1994, citing that free trade has led to a major concentration of wealth in the hands of a small group. In 2009, the average monthly salary in Mexico was $372, compared with $379 in China, $961 in Turkey, and $2,955 in the United States.[22] Though wages in Mexico are low, a decent hotel in Juárez costs more than in El Paso. Gasoline is also more expensive in Juárez than in the United States. Gustavo Calderón Rodríguez, a professor of economics at the Autonomous University of the City of Juárez (UACJ), thinks there is a link between low wages and violence in the city. "There cannot be social stability without financial stability . . . people making low wages look to the informal economy and illicit activity like drug distribution."[23] All this was on ERRE's mind.

He was working toward two solo exhibitions slated for spring 2011: a survey of his art at Museo de Arte Carrillo Gil in Mexico City and an exhibit of new work at LAX in Los Angeles. Both would respond to 2010 as the hundredth anniversary of the Mexican Revolution and the two hundredth anniversary of Mexican independence from Spain. The retrospective show would include many of the same works that were featured in the Rubin exhibition, as well as two new works: a signpost for Mexico City and a green highway sign based on the Reading commission. The highway sign would indicate distances to places within Mexico where social rights movements were repressed by the Mexican government in 1911, around the time of the Mexican Revolution. ERRE identifies this as the "other revolution because we are living through a revolt today."[24] The first date on ERRE's sign is 1906, the year of the labor strike at the Cananea copper mine in Sonora, which catapulted Mexico toward the 1911 unrest.

For LAX, the central work was a motorized merry-go-round-like contraption that rotated slowly and was divided into three sections, like a pie chart. The smallest section of the chart was divided from the others with a stainless steel tube to indicate the rich, the next smallest section had a rusted iron

divider for the poor, and the largest section by far was a jury-rigged demarcation of wood and cast-off materials pointing to the miserable. With a huge number of "miserable" and a very small percentage of "rich," the distribution of wealth in Mexico is about the same at the time of this writing as it was in both 1810 (before Mexican independence from Spain) and 1910 (before the Mexican Revolution). In the artwork, the wheel turned constantly, and a digital counter recorded each rotation. The question ERRE asked was, "How many revolutions are required to effect change?" According to the artist:

> The system is corrupted . . . we have a very defective democracy. And a democracy is not always the answer . . . it is very prone to malfunction. We [Mexicans] were not ready for a democracy. We entered democracy upside down . . . without any experience in how to rule. . . . Supposedly it's the best thing that we have, but if democracy was always the best choice, pop music would be the best music in the world.

With these two exhibitions, ERRE shifted his focus from the U.S. government to the Mexican government and its inability to lead its people to greater socioeconomic equality. "I am trying to do my part without putting on my shoulders the weight of the world. I don't have the mind of a politician. . . . I see these things through a poetic vision." *To Whom It May Concern: War Notes* represented a building block in the expression of this overall vision and a step toward ERRE's movement away from, and eventually back to, the U.S./Mexico border as a subject and signifier of more universal human concerns of social and political injustice. The exhibition catalyzed both the artist's career and the Rubin's border-as-center institutional identity. In his artistic practice, ERRE has synthesized text and form to evaluate how personal identity determines belief systems and, by extension, personal truths. Dipping back into history and crossing continents, he has built sculptures, manufactured images, and generated and appropriated texts to bring to our attention the subjectiveness of reality. "For you, your truth is your truth. But the real truth . . . it's hard to get to it."

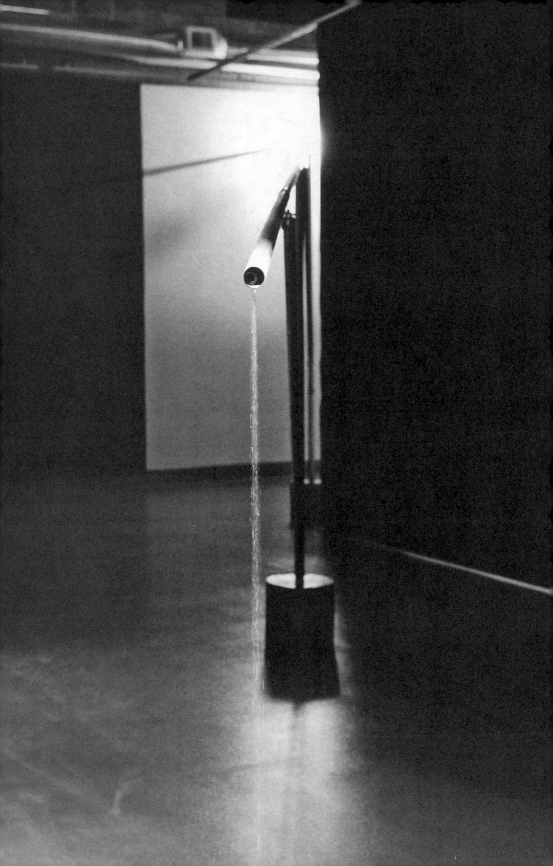

# 3

## SIMPARCH

*Hydromancy*
*2007*

It was June 1999, mid-morning, the day already ablaze, and I was sitting on the front porch of the home of sculptor Rachel Stevens in a downtown neighborhood of Las Cruces, New Mexico, which is about forty-five miles west of El Paso. Las Cruces is sometimes portrayed to be like a picture postcard of the scenic Southwest, but most of the town is grittier. The landscape is dotted with small strip malls. Vacant lots of creosote and mesquite are decorated with plastic bags that become tangled in these desert plants during frequent windstorms.

Stevens's friend Matt Lynch appeared unannounced: tall, gangly, his hair wild and his shorts baggy, skateboarder-style. He introduced himself and took a seat. Stevens emerged from the house, poured cups of coffee, and we all chatted about the weather. I told Lynch that I was planning to move to the area and was looking for a place to live and that Stevens was helping me with that task. I also told him that I was a curator. He was unforthcoming about his professional life, but Stevens told me later that Lynch and fellow artist Steve Badgett had founded the artist's collective SIMPARCH, which conflates the words "simple" and "architecture." Lynch had moved to Las Cruces a few years before with his wife, who had been attracted there by the opportunity to attend graduate school at New Mexico State University. The high desert, small town advantages drew Badgett and

*Facing:* SIMPARCH, *Hydromancy*, 2007. Detail of water coming out of pipeline into the Rubin. Photograph by Marty Snortum.

his girlfriend there. Stevens knew Lynch from their art school days at Syracuse University, and Badgett had been her neighbor when she first moved to Las Cruces. She had introduced the two of them because she recognized that they both liked to, in her words, "build stuff." It was a successful match.

## Art as Gathering Place

In 2000, the year after I met Lynch, SIMPARCH created and exhibited *Free Basin*, an enormous and functional kidney-shaped skate bowl, inspired by Los Angeles skate culture of the 1970s. *Free Basin* earned SIMPARCH international recognition. Since that time, the collective has continued to probe the boundaries of popular culture and amateur engineering to develop projects imbued with social significance. Many are commentaries on the impact of humans on the natural world. They propose solutions but also acknowledge the impossibility of reversing the damage we have caused. Some suggest methods to more equitably distribute scarce resources. Some harness humor. Almost all are of architectural scale and create a platform for something else, something surprising, to happen.

By the time they met, Badgett and Lynch had earned degrees in studio art and were interested in taking their practice outside the studio. Since establishing SIMPARCH, Badgett and Lynch have collaborated on projects that explore environmentally sensitive architecture and the culture of the desert American Southwest and that also provide visual art experiences that reach a broad audience through humor and the use of widely recognizable images and forms. How Badgett and Lynch divide their responsibilities is unclear to me, but their working relationship seems to be without boundaries. They come up with ideas together, they build things together, and they know and understand each other like brothers.

One of SIMPARCH's earliest works is *Hell's Trailer* (1996). It set the stage for things to come, especially the collective's wry comments on the myth of the American frontier. A *bricolage* of hand-painted billboards found in a Route 66 signage graveyard and reconstituted into the form of a travel trailer, the piece is both a parody of the quick-moving, signage-riddled American dream and a reflection on our highway-based family getaways, where an endless string of billboard advertisements scars the natural scenery. Though not fit for the road, the curved form of *Hell's Trailer* allows it to rock with the bodily thrusts of the people who step into its padded interior that is upholstered in camouflage-print fabric. It combines recycled materials and evokes nostalgia for the bygone era of the compact caravan, even as it offers a wry critique of the American

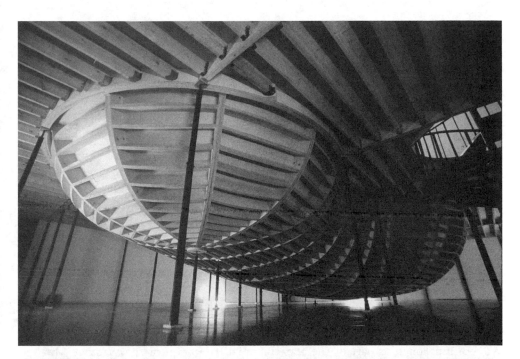

SIMPARCH, *Free Basin*, 2000. Plywood, concrete, steel. 240" × 480" × 600".

myth of leisure on the open road. At the time of this writing, it is on long-term loan in the education gallery, known as the "UnMuseum," at the Cincinnati Contemporary Arts Center.

In 2000—the same year *Free Basin* catapulted SIMPARCH into artistic celebrity—the Renaissance Society in Chicago commissioned the collective to design and construct *SPEC*, a barrel-vaulted tunnel of prefabricated acoustic ceiling panels housing a seventy-two-foot-long bench imbedded with a sub-woofer. Completed in 2001, *SPEC* formed a space intended for community gatherings that would focus the audience's attention on a new piece of electronic music by Kevin Drumm, an experimental electronic composer known for his ambient textural sound landscapes that evoke both human and natural processes and ongoing erosion. By this time, Badgett and Lynch had moved away from the area, but both of them had attended exhibitions that I had curated for the Department of Art gallery, so they understood my curatorial tastes and sensibilities. Like *Free Basin*, *SPEC* set the stage for the creative activity of other people.

SIMPARCH's commitment to creating architectural-scale sculpture as a place for an audience to gather continued with *El Tubo Completo* (2004), which was commissioned as part of the 2004 Biennial Exhibition of the Whitney Museum of American Art. *El Tubo* offered a newly engineered, theater-like space designed to look like a military Quonset hut and scaled to be wedged into the museum's courtyard. Upon entering, viewers alternately experienced an ambient sound landscape by Drumm and *In Order Not to Be Here*, a film by artist Deborah Stratman that examines "suburban lifestyle violence and surveillance . . . with pensive detachment."[1] All of these artworks require some engineering. By putting them forth, SIMPARCH showed itself far ahead of the curve in using DIY (Do It Yourself) art practices that encourage audience participation, social interaction, and the improvement of daily life by means of making things.

## What Came Before

By 2004, the year I invited SIMPARCH to exhibit at the Rubin, the international profile of the collective had skyrocketed. *Free Basin* had been shown at Deitch Projects in New York City, perhaps the most formative gallery in the 1990s and 2000s in terms of presenting art that referenced popular culture. SIMPARCH's work was also featured at Documenta XI, an international art event held every five years in Kassel, Germany. The collective's reputation continued to grow because with each new project SIMPARCH pushed itself to tackle problems new to its repertoire, challenging our understanding of the boundaries and

function of art and its commentary on the human relationship to society and nature. SIMPARCH's interest in uncovering new ways of examining the human impact on the natural environment seemed to me a great fit with the mission of the university. As a state institution situated in the most populated urban cluster on any border in the world, UTEP is involved daily in considering issues of sustainability and distribution of resources. I could not imagine a better university art space to host the collective's next project.

In late 2004, I received a short note from Matt Lynch. SIMPARCH was planning a March 2006 ten-year anniversary party in Las Cruces to commemorate Badgett and Lynch's now celebrated first meeting. They wanted to have an exhibit in conjunction with the party: "We are looking at this as a somewhat leisurely thing . . . ," Lynch wrote, "a collection of ephemera—drawings, images, e-mail, objects. . . ." He thought I might have some ideas of a venue in Las Cruces that could host the show. "In addition," he continued, "a more proper project in El Paso would be great someday."[2] This was the only prompt I needed. In my mind, I began reviewing the possibilities.

A few weeks later, Steve Badgett, prompted by Lynch, stopped by the Rubin when he was passing through the area with a friend. Tall, lanky, and soft-spoken, Badgett, too, expressed an interest in a potential project. Seizing the opportunity, I asked him what SIMPARCH might do if invited to exhibit at our space. He spoke of solar panels and power, saying he wasn't sure exactly what such a project would entail but that he was intrigued by what, in his words, "might happen." In my e-mail to him the next day, I wrote that "we should talk about the possibilities, the budget, what the piece might be and what your needs are."[3] When I didn't hear back, I wrote him again: "I know that it (the project) has something to do with solar panels, but that's about the extent of my understanding . . . can you fill me in on your ideas for this piece?"[4] Badgett responded the same day: "We haven't given this one much thought even though we are extremely interested. . . . But, I think we were talking about the solar-powered, free-standing building for the presentation of . . . ." The four dots suggested that for the artists the precise nature of what was to be presented was still unclear. But I trusted SIMPARCH—and my own instincts—about the rightness of such a project at UTEP.

But I needed more information then and throughout the course of the planning and execution of SIMPARCH's exhibition. Due to the collective nature of SIMPARCH's conceptualization process, the process-oriented group moves toward clarity organically, as they go along. More product-oriented me, though, wanted a sense of clear direction. I wanted to know if the artwork—whatever its final nature—would be installed indoors or out. The landscape surrounding the building is dry, rocky, and almost lunar in character. Directly north of the

building, a barren hillside commands expansive views of Ciudad Juárez and its outskirts. While this hillside is often seen as a wasteland, I felt it was a space of inherent interest to artists. "It has long been said that the desert is monotheistic," claims Guy Debord in his formative essay that inspired the Situationist International,a group of artists who set precedent for some of today's socially engaged contemporary art practices such as those of SIMPARCH.[5] The Rubin hillside certainly evokes the desert in both its earthly and spiritual dimensions.

As things turned out, SIMPARCH became the first in a string of artists to embrace this hillside as a site of rugged beauty with Biblical associations emphasized by its view of pilgrimage site Mount Cristo Rey to the west, a mountain capped by a twenty-nine-foot-high statue of the crucifixion.[6] However, at this stage, though I was intrigued by the possibility of an outdoor work, I also needed to fill the gallery space. As we corresponded over the spring, Badgett brought up the idea of circulating water in the gallery. I asked myself: How? To what end?

## The Project Begins

SIMPARCH had just completed *Dirty Water Initiative* for insITE05. The project consisted of two phases. Phase one was to construct and install a small purification plant as a "public fountain" sited in the pedestrian walkway from San Ysidro to Tijuana at the U.S./Mexico port of entry. Phase two involved the donation of the distillation facilities to *colonias*, or townships, in Tijuana—communities facing ongoing water issues—as a gesture to assist several families in water-challenged communities.

Both phases sought to "stimulate reflection about the problem of water and the importance of researching ecological solutions."[7] A solar still, or distillation unit, of the type in *Dirty Water Initiative*, looks like a desk with a transparent top that reveals a shallow gathering place for yet-to-be-purified water beneath. It uses the energy of the sun to heat the water to the point of vaporization, the same process that forms clouds. The condensation that is formed on the underside of the safety glass "desk top" is pure, drinkable water.

It was not clear at this stage if solar stills would be central to the exhibition. Badgett and Lynch had been toying with the idea of applying solar still technology since 2003 when they began work on *Clean Livin'*, their ongoing project to craft a live/work facility for the Center for Land Use Interpretation artists-in-residence program in Wendover, Utah.[8] The facility allows participating artists and researchers to live on a remote location of Wendover Airfield, the largest WWII airbase in the United States. A seven-hundred-watt solar system

SIMPARCH, *Dirty Water Initiative*, 2005. Stainless steel, glass, silicone,
plastic bottles, hardware. 1008" × 960" × 72" (public component).

supplies electricity to the site. Water is imported fifty-five gallons at a time
via a four-wheeled, two-person bicycle that hauls it from the nearest available
source three miles away.[9] The water is then held in an elevated tank, where it is
pressurized by gravity and heated by the sun. Human and food wastes are com-
posted for making soil in order to cultivate a variety of hardy desert plants and
eventually edible agriculture on this terminal saltscape, where little to nothing
can grow. Wastewater is collected and processed by a gray water system for
re-use on plant life. It can also be made drinkable through solar distillation.

SIMPARCH applied the solar technology that they refined in *Dirty Water Ini-
tiative* to *Clean Livin'*. Critic Polly Ulrich described the project as follows: "With
its emphasis on the social power of art, *Clean Livin'* descends directly from
Joseph Beuys' definition of art as 'social sculpture,' that is, art as a process of
compressing action, thought, and discussion into aesthetic material in order to
reshape the world."[10]

In his discussions with me, Badgett spoke about how *Clean Livin'* refer-
enced the notion that inhabiting an abandoned site makes physical the claim
by theoreticians Gilles Deleuze and Felix Guattari that "it is always on the

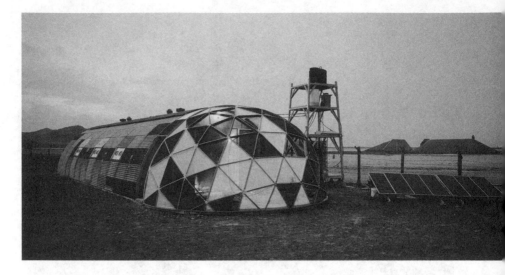

SIMPARCH, *Clean Livin'*, 2003–ongoing. Quonset hut plus surrounding structures, historic building, conventional and alternative building materials, found objects. 120" × 240" × 576".

most deterritorialized element reterritorialization takes place."[11] Badgett excerpted this concept from *A Thousand Plateaus*, where the two philosophers offer a strategy for overcoming all the internal constraints that society forces upon us in order to reorganize ourselves in new ways—including cultivating a nomadic mode of existence and a new, dynamic quality of being. *Clean Livin'* supports this radical shift in the understanding of selfhood proposed by Deleuze and Guattari. The human carbon footprint can be temporarily reduced when the conscious use of resources and the body's own metabolic energy alter the expectations of daily living. By addressing the hope for sustainability, *Clean Livin'* also remembers the myth of the frontier. In addition, it reacts to previous examples of communal living and recent experimental environments such as Biosphere II and Paolo Solari's *Arcosanti*.

## Solar Stills and Water

Solar stills had clearly emerged in SIMPARCH's work as an important tool to apply their vision for a better and more sustainable world. Badgett was eager to propel the success of *Dirty Water Initiative* to the Rubin. He said that if I was still committed, SIMPARCH was eager to move forward. I assured him that I was and again asked about the location (inside or out) and the estimated expense.

I received no clear response to either. It was late spring 2006 and I needed a show for the following January. In terms of planning a museum exhibition, I was down to the wire.

I followed my instincts based on my trust in SIMPARCH and on the success of their previous projects, took the plunge, and scheduled the show, subconsciously aware that the next months might be filled with some drama related to last-minute decisions. The ideas and physical components of the commission only came together very close to the opening of the exhibition. Not until mid-December 2006 did SIMPARCH settle upon a final shape for the piece. They would install on the hillside a tank of dirty water from the Rio Grande River and three solar stills that would render that water pure. (The stills would be created by New Mexico State University's Institute for Energy and the Environment in Las Cruces, commissioned and paid for by the Rubin at a total cost of about thirteen hundred dollars.) We would then drip the water via a temporary aqueduct into the gallery where people would be invited to take a drink. The piece would reference the community well or fountain where, before the time of modern plumbing, people would gather to socialize as much as to obtain liquid sustenance. What else would be in the gallery remained to be determined. Even a month before the slated opening it was a high-wire proposition, in part, I told myself, because of the improvisational requirements of a project inspired by the constantly shifting natural environment.

SIMPARCH, solar still relocated in 2007 from *Hydromancy* to Anapra, Juárez, Mexico. Photograph by Steve Badgett.

Badgett and I settled upon *Hydromancy* as the title for the exhibition. The derivation of the word is Greek: *hydro* means water and *manteia* means divination. *Hydromancy* was a method of making decisions or predicting the future by means of water, including its color, ebb, and flow, and how it responds to agitation. The title and the concept for the piece were partly inspired by *H2O and the Waters of Forgetfulness* by Austrian philosopher Ivan Illich, who urged post-industrial society to critically assess the role of technology in everyday life. Badgett was a fan and had read Illich closely as he prepared *Dirty Water Initiative*. In his treatise on water, Illich reflects on the difference between water as a compound or commodity, in need of treatment and in the service of technology, and water as a substance with a sacred role in ceremonies, such as baptism. Debord's interpretation of the desert as monotheistic also connects to this idea of water as holy. From the holy rivers of India to Mecca's sacred well to the River Jordan, water is held sacred all over the world. Creation stories from ancient Egypt, Africa, and the Amazon reference water as the fount of life.[12] Accordingly, SIMPARCH's installation invited an engagement with water that would recall all its meanings to our daily existence and our systems of belief. *Hydromancy* was to be more akin to the quasi-scientific approach taken with *Clean Livin'* and *Dirty Water Initiative* than to SIMPARCH's more formal (but equally populist) works such as *Free Basin*.

The image that announced *Hydromancy* to our audience and to the media was a photograph of a nineteenth-century fountain in Tijuana of the Greek goddess Diana shooting a bow and arrow. The image's connection to Illich's thinking was tangential, and its connection to what *Hydromancy* came to be was even more obscure. It was therefore not ideal in our a-picture-equals-a-thousand-words-oriented art industry and society. However, no other objects or images existed at the time the press releases were circulated, and none of us had a better solution. And the picture of the fountain was more suitable than a photograph of the empty hillside or the gallery, if only because those conveyed too little of the project's intentions. The fountain, at least, had the advantage of being, in Badgett's words, "an odd reference to water as a metaphor—the fountain being an anachronism"[13] and thus a somewhat ironic commentary on issues of water and community.

By then I had also corresponded with UTEP's Department of Geology to ensure that our intended location for the stills would not interrupt the functioning of Kidd Seismological Observatory, which had equipment located at both the base and the top of the hill. I had also secured campus approval to install an outdoor sculpture for a couple of months and to temporarily replace one of the Rubin's clerestory windows with a piece of ⅜-inch plywood, which

would be penetrated by the aqueduct's pipe. The university's health and safety commissioner was also on board for the serving of the water to the public: INSITE had not been comfortable with the general public drinking water from SIMPARCH's solar stills in Tijuana, so SIMPARCH was particularly interested in achieving that interactive aspect in El Paso, and so was I. We were fortunate to be part of a campus community in which progressive projects such as *Hydromancy* were seen as supporting the university's research mission.

## The Collective Experience

By this time, Lynch and Badgett had decided to take advantage of the skills of three fellow artists in the execution of the piece. Though there are exceptions, this is typical of SIMPARCH's process.[14] Their projects are simply too large in scope and scale for two people to achieve, and both Lynch and Badgett enjoy working as members of a larger team. For *Hydromancy*, SIMPARCH invited Chris Vorhees, Ryan Hennel, and Steve Rowell to participate: more people, more talent, and more chaos. Rowell would provide a sound component to the installation and be credited in the exhibition title as a creative partner. Vorhees and Hennel would help build the physical structure of the piece, but their names would not be listed in the title because their conceptual contributions would be more intertwined with those of Badgett and Lynch. Honoraria, travel, and lodging for each of the five artists; construction materials required to execute the piece; equipment, including solar stills and audio; and printed exhibition catalogue brought the direct costs of the exhibition to approximately twenty-five thousand dollars.

By necessity, the ideas and technical details came together quickly. The exhibition was slated to open only a week after the artists arrived and nearly everything was yet to be worked out. The group went to Juárez to purchase a black plastic water tank—ubiquitous in Mexico—to be the holding tank for the Rio Grande water at the top of the hillside. There would be enough water to last for the eight-week run of the exhibit. A stand would elevate the tank on the hillside sufficiently to allow gravity to carry the water down the pipe, through the solar stills, and into the building. After entering the building, the pipe connected to a flexible tube, descended several inches, pierced the sheetrock, and connected to another stainless steel pipe, so that it appeared to enter the building as a seamless, straight pipe. The area where the pipe butted up against the sheetrock was bathed in harsh light, creating a minimalist point of luminosity as the vista view from the doorway to the gallery. To the visitors' left, a twelve-foot-high "wall" of industrial felt, stitched together by a team of

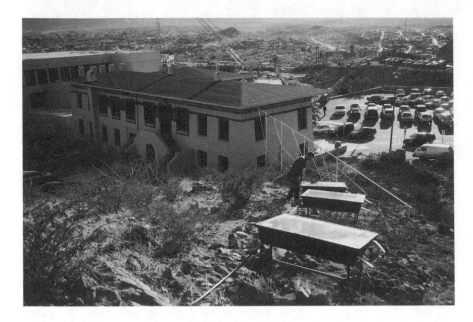

SIMPARCH, *Hydromancy*, 2007. Detail of water distillers and
pipeline to the Rubin. Photograph by Marty Snortum.

UTEP students under the guidance of SIMPARCH, served as a sound-dampening
screen; the most active components of the piece were on its opposite side. On
the wall to the right, a cup dispenser invited visitors to drink the water. Only
after rounding the corner of the felt wall did visitors see the "fountain."

While all this was being figured out, composer Steve Rowell walked the Rio
Grande, tracing the land boundary between the United States and Mexico. As
he did so, he recorded sounds from both sides of the border. He then mixed
sounds of the engineered water process with these field recordings, creating an
audio overlay for *Hydromancy* that metaphorically dissolved the physical walls
of the gallery to reveal an acoustic interpretation of the landscape beyond.
Four speakers were hung from the ceiling on the same side of the felt wall as
the "fountain." The sounds of the United States emanated from the two speak-
ers on the east side of the room and those of Mexico from the two speakers
located on the west side, the direction of the border. Through the visitors'
objective experience and ability to perceive minute differences in stereo sound,
this sound track had the effect of reducing and distilling the division between
the two nations.

We discussed how to collect the water as it dripped from the pipe. The shape and size of the basin would hold meaning: a vessel that was formal and at waist height might reference a baptismal font, a bucket shape and size would bring to mind work and utility, a table with a bowl shape would relate to eating and sustenance. In the end, SIMPARCH asked if it would be acceptable to simply let the water pool on the floor. "The cleanest water possible," Lynch said, "no chance of residue or staining." This was an unorthodox method of collecting, or not collecting, dripping water that could potentially damage the building. The Rubin's floor is sealed concrete with a baseboard, so it would function like something of a bathtub. But what if there was too much water? Or what if a visitor were to slip? I pondered, but quickly. At this point, it was the day before the exhibition was to open and there was not enough time to solicit the university's health and safety department formally for a decision. Again, more lead time from the artists would have made my job easier. There was some tension.

Within the hour that strain dissipated. I risked reprimand on the part of the university to support the artists because their idea drove home the conceptual basis of the piece. The clean water, which required human ingenuity and energy to create, lay in a puddle, unused and wasted. SIMPARCH spot-lit the puddle from several angles, its reflection bouncing onto the gallery wall where it shimmered, ever in motion. Twelve-inch diameter concrete disks on the floor became stepping-stones that also affected the form of the puddle. On the night of the opening reception, we were all exhausted, but visitors were wowed. Early in the evening, when the sun was still shining and the fountain still dripping, people made their way across the stepping-stones and filled their paper cups to drink. One couple kissed across the top of the pipe.

Over the ensuing weeks, the puddle shifted in form and size, substance rather than commodity, spreading at the audience's feet. Cloudy days resulted in very little distillation, whereas sunny days produced a regular stream and a large puddle, but, as it turned out, it never seeped outside of the gallery or even under the felt curtain. Unpredictable weather conditions meant that we were forced to relinquish control of the water's flow and accumulation. At the end of each day, we mopped the floor, beginning each morning renewed and aware of the cycle of days. Near the time of the closing of the exhibition, we hosted a panel discussion with Badgett and several environmentalists from Israel and Jordan, who had been invited to UTEP by its Center for Environmental Resource Management. Our local news anchor moderated. The auditorium was packed.

SIMPARCH, *Hydromancy*, gallery view of pipeline in
the Rubin, 2007. Photograph by Marty Snortum.

## Limited Resource

Author David Gissen claims that stagnant pools of water represent society's
vulnerabilities and so contemporary architects consequently design spaces
that emphasize movement and flow. He continues, "the puddle, the trickle or
the leak has the capacity to represent social life in a more vulnerable, naked,
and self-reflective state . . . for a new type of socionatural interaction."[15] *Hydro-
mancy* achieved this level of self-reflection: the puddles literally reflected light
and image and metaphorically connected visitors to the truth about water's
scarcity and value.

El Pasoans use on average twice as much water per day as their southern
neighbors. In Juárez, water is provided without restriction to large *maquilado-
ras*, while many *colonias* in the periphery of both cities have little or no access
to drinkable water for daily needs.[16] Across the globe, some 1.2 billion people
lack access to clean water. Twice that number have no sanitation, and most of
the world will not have enough water within thirty years.[17] It is often distribut-
ed unfairly or used as a tool to exercise or demonstrate economic and political
power. For example, in 2006, Botswana's High Court ruled that the bushmen

had the right to live on their ancestral lands. But this does them little good because the government denies them water by closing off the crucial Mothomelo borehole. Nearby tourists enjoy swimming pools while many bushmen die of thirst.[18]

In the industrialized world, we have come to expect water to be clean and drinkable; yet, we pollute it with all manner of human and industrial waste. SIMPARCH's *Hydromancy* acknowledged the Rio Grande as the physical boundary between the United States and Mexico, the place where "the first and third world come together so dramatically."[19] At the same time, the piece recognized the river as a life source that has been made almost entirely inaccessible in El Paso because of a series of fences, canals, irrigation diversions, and barriers erected to prevent northward migration. It thus addressed concerns that are regional and global, environmental and political, while creating a space that was beautiful, ever changing, and participatory.

## Post-Hydromancy

Recent works by SIMPARCH have tended to strike a more humorous note on such serious themes. For example, *Exhausted* (2009) featured a reclined, fifty-foot-long Godzilla, its "skin" fabricated from green shade fabric of the type used in greenhouses to moderate light. Visitors entered the belly of the beast where five tiny speakers emitted intermittent rumblings composed by frequent SIMPARCH collaborator Kevin Drumm. Godzilla literally embraced the architecture, his tail wrapped around a support column in the gallery at Open Satellite, a residency program for contemporary art in Bellevue, Washington, where SIMPARCH created *Exhausted*. Just as Illich's writings formed a literary cornerstone for *Hydromancy*, Chon Noriega's "Godzilla and the Japanese Nightmare: when *Them!* is U.S." inspired *Exhausted*.[20] Noriega notes that the Japanese Godzilla often protects Tokyo and battles aggressive forces. The Japanese are consequently sympathetic to him. American audiences, on the other hand, cast him as attacker, in part due to expectations of aggression arising from the U.S. superpower status and proactive military presence worldwide. "With *Exhausted*," writes exhibition curator Abigail Guay, "SIMPARCH addresses these motivations by embodying a population fatigued and bankrupted by a decade of aggressive foreign policy and fear."[21]

In 2010, SIMPARCH earned a federal Art in Architecture commission for art at a border station in Tornillo, Texas, to be administered by the U.S. General Services Administration (GSA). The initial proposal was *Independent Truck*, a

sixty-five-foot-tall wind turbine in the form of a full-scale tractor-trailer rig turned on end, its cab piercing the sky. This obelisk-like sculpture was designed to turn in the wind. "The work functions on multiple levels," stated Badgett at the presentation meeting attended by U.S. Customs and Border Protection (CBP) clients, the GSA overseers, and a few art and architecture advisors, including me, ". . . as a specifically engineered gesture that is playful and also brings attention to the truck as an icon of unhindered economic freedom and as a standardized mode of transport that is unique and that is manned by individuals whose livelihoods depend upon the exchange of goods across this border."[22] In the end, the GSA found the sculpture unacceptable: too big, too risky, too much unresolved engineering, not enough of a budget to execute it correctly. But its brilliance and humor and potential success at responding to the demands of the site and at capturing the imagination of the public struck me as worth discussing here as a possible next stage in SIMPARCH's artistic evolution.

The piece was intended to play to its audience. It would be truckers moving to and fro across the border who would see this homage to trucks. SIMPARCH predicted that the fatigue and ennui that ensued while idling at a border inspection line would be assuaged by the visual pleasure of watching this "wind turbine" in action. It was to be an artwork experienced primarily by rig operators from a distance and through a windshield, marking their crossing from one country to another and the role that they play in our economic life. This new SIMPARCH work was designed to recall other public projects that function as spectacular objects, transforming the familiar into the larger than life. These include Lawrence Argent's towering red rabbit in the San Jose Airport, Armando Muñoz Garcia's *La Mona*, a fifty-five-foot-tall female colossus (which serves as the artist's home) in Tijuana, Mexico; Claus Oldenburg's oversized sculptures of everyday objects such as erasers and toilets; and Jeff Koons's proposal for a life-sized train locomotive sculpture for the Los Angeles County Museum of Art.

By choosing the tractor-trailer as the subject, SIMPARCH questioned and celebrated the truck as *the* ubiquitous element at border ports of entry. As Badgett noted, "trucks are reviled by some because of traffic and oil consumption, but we're all dependent on this form of commerce; it's our system, our economy."[23] The piece would have become both a complex reflection on our methods of commerce (and their impacts on human and natural environments) and an arresting three-dimensional image.

With *Exhausted* and the conceptual drawing for this new public commission, SIMPARCH seemed to be turning toward more image-based, representational expressions. Yet the team explained that this is neither an intentional

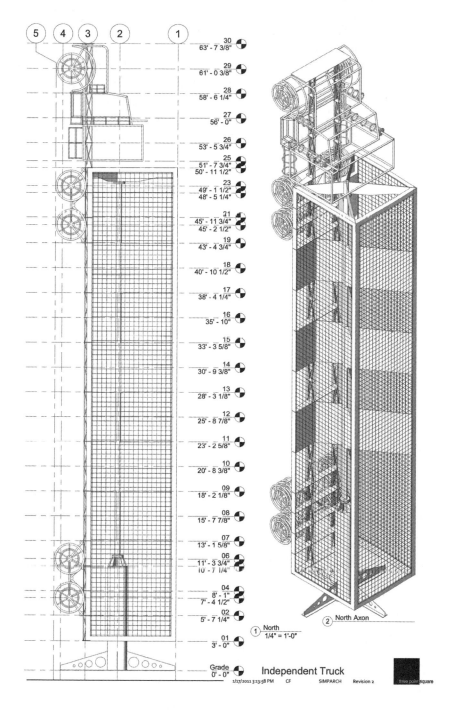

SIMPARCH, *Independent Truck Drawing*, CAD of proposed sculpture for General Services Administration commission for Tornillo, Texas, Land Port of Entry, 2010.

nor a long-term shift, but rather a result of achieving satisfactory solutions for these two specific projects. The two recent works also share the important characteristics of those that preceded them in SIMPARCH's oeuvre, first, because they harness the unique characteristics of a given space or place to address a subject that is of local and global concern and, second, because they playfully and subtly critique the status quo. *Hydromancy* had all of these traits and achieved success because of them.

# 4

## Adrian Esparza

*Unknitting: Challenging Textile Traditions*
*2008*

I met Adrian Esparza in 2002, two years after his return to El Paso from the Los Angeles area, where he had earned a Master of Fine Arts degree at California Institute of the Arts. He is large in stature, soft spoken, and thoughtful, with a wide face and gentle manner. "Growing up in El Paso, I had little exposure to historical art," he told me later.[1] "My first exposure was through craft. Early memories include manipulating Popsicle sticks, carving balsa wood . . . seeing my mother sew. . . . Craft laid the foundation for the formal issues that I would later learn in school."[2] His commitment to the honoring of the ordinary and to the hybridization and dynamism inherent to the U.S./Mexico border made him a connecting force between two simultaneous but seemingly disparate exhibitions at the Rubin, *In the Weave: Bhutanese Textiles and National Identity* and *Unknitting: Challenging Textile Traditions*. Long before these exhibitions opened, a symbiotic series of events transpired to make them possible and successful. After they closed, it became clear to me that they shared the underlying concept of self-preservation through transformation.

### Serapes: Unraveling Old Forms into New

Sculptor Willie Ray Parish introduced me to Esparza and his art. The Dallas Museum of Art invited Parish and me to be part of an advisory committee for *Come Forward: Emerging Art in Texas*, a 2003 exhibition of promising new artists in Texas. Our eight-person committee assembled in fall 2001 for a daylong

meeting in Dallas. Each of us presented images of the work of young artists living in our respective cities that we believed to be worthy of exhibition. I championed Nicole Antebi and Dave Ford, among others. Parish presented Esparza, who had earned his Bachelor of Fine Arts at UTEP and had been Parish's student.

A few months later, the exhibit's co-curators Lane Relyea and Suzanne Weaver visited El Paso to meet with some of the artists recommended by Parish and me. Relyea had been a teacher at California Institute of the Arts and knew Esparza. But Weaver and I were meeting him for the first time, and both she and I were taken with his artwork. Ultimately, Esparza was the only El Paso–based artist selected for the eleven-artist exhibition.

The Dallas show proved to be formative for Esparza. He created *Here and There* (2002), his first deconstructed *serape* (blanket). Striped and brightly colored, Mexican *serapes* are traditionally made of wool or cotton. However, Esparza uses the cheap acrylic ones that are more prevalent these days. Although still associated with Mexico, they are often manufactured in India and China. It is a globalized product that, like many others, such as chopsticks and Hello Kitty, has a localized identity. Esparza's repertoire is vast and includes abstract patterns rendered in black textile paint on bedsheets and pillowcases, white ceramic sculptures that are constructed assemblages of components cast from hobbyist molds, painted reproductions of wood grain, and framed, patterned assemblages of colorful, square pieces of chewing gum.[3] But over the years it has been the *serapes* that have captured the attention of curators. Weaver and Relyea exhibited painted bedsheets and pillowcases, ceramic sculptures, and *Here and There* in the Dallas show.

*Here and There* consisted of a blue, yellow, and red *serape* that the artist purchased at the open-air market in Juárez and two strips of cheap wood, each about one inch wide and six feet high and tacked to the wall vertically, approximately six feet apart and parallel to each other.[4] About fifty partially embedded nails lined up on each strip. Esparza tugged on a thread from the bottom corner of the *serape* to begin to unravel it, then tied the thread to the top nail on the left strip, stretched it to the top nail on the right strip, then moved the strand back and forth until he had lines of thread about two feet high. The partially unraveled source blanket hung on the wall next to its reincarnation. Here the original, tightly woven and well constructed, spoke to tradition and strength. The new manifestation was loose and translucent and alluded to flexibility and possibility. Esparza explains, "The *serape* pieces are about transformation—about a history that is used in order to construct a new form."[5]

## Two Exhibits: The Juxtaposition
## of Tradition and Innovation

Border culture and the ideas of transformation and duality permeate Esparza's oeuvre. One of the Rubin's curatorial objectives is to contextualize the work of artists who live in our region with those who live elsewhere. Because of this and because of the impact and quality of his art, I decided that I wanted to showcase Esparza's artwork. In my mind, I began to incubate various themes for exhibits for which his work would be appropriate. A glimmer of possibility began to form in summer 2005 when I was living in Washington, D.C., for four weeks as a fellow at the Smithsonian Institute for the Interpretation and Representation of Latino Cultures. Each day I walked across the National Mall, the grassy boulevard bracketed by huge, stately buildings that house various Smithsonian museums. In early July, the Mall was occupied by the Smithsonian Folklife Festival, a sprawling, tented "international exposition of living cultural heritage."[6] This annual global survey highlights one nation and one U.S. state, region, or entity. The pairing is random and changes each year. For example, in 2004, it was Haiti and the mid-Atlantic maritime communities. In 2005, it was Oman and the U.S. Forest Service. The festival signage in 2005 advertised that the 2008 festival was to focus on Bhutan and Texas.

Adrian Esparza, *Here and There*, 2002. *Serape*, plywood, nails. Dimensions variable.

My thoughts raced. UTEP is probably the only place in the world that bridges these two locales: its campus is identified by its unique Bhutanese architecture and by its location at the western edge of Texas. This coincidental coupling on the part of the Smithsonian would be an opportunity to establish a connection between the Rubin's institutional mission—to bring innovative contemporary art to campus and to El Paso—and the Bhutanese aesthetic of the exterior of its building.

Bhutan is a nation about the physical size of Switzerland, located in the shadow of the Himalayan Mountains between India and China. It has a predominantly Buddhist population of about seven hundred thousand. In 2007, it transitioned from a monarchical form of government to a parliamentary democracy. The former king established a national economic policy based on Gross National Happiness rather than Gross National Product, and one of the pillars of that economic policy is the preservation of culture. The thirteen plastic arts that officially contribute to Bhutan's collective happiness include papermaking, goldsmithing, and woodcarving. Weaving was the process from this list that captured my attention since Bhutanese textile design and technique are similar to those of native cultures, including Mexican and Native American cultures, that predated the European influence in the American Southwest and still have a living presence in the contemporary visual culture of West Texas.

These multiple connections prompted me to focus on organizing an exhibition of Bhutanese textiles that would take place during summer 2008, at the same time as the Smithsonian Folklife Festival. It was my hope that some of the energy and attention that the Folklife Festival generated at the national level would make its way to El Paso, raising awareness about the Rubin's exhibitions and programs. I told UTEP President Diana Natalicio about my plan and she expressed interest in establishing a relationship between the university and the Smithsonian. Without delay, she contacted Richard Kurin of the Smithsonian's Center for Folklife and Cultural Heritage. The exhibition became a university-wide initiative before I even knew exactly what the exhibition would be.

There was another catch. The Rubin is not in the business of exhibiting traditional art forms. Instead, its primary focus is to commission and exhibit some of the most innovative art of our time and to draw upon a pool of artists recognized nationally and internationally for their avant-garde practice. We had developed a secondary concentration: idea-driven fine craft. Exhibitions such as *Hanging in Balance: 42 Contemporary Necklaces* (2005) and *Multiplicity: Contemporary Ceramic Sculpture* (2006) had been part of this vital programming. With jewelry and ceramics under our belt, textiles would be a logical medium to

explore and would also align with our institutional mission. So I began thinking about a second exhibition of progressive fine art that uses traditional art as one precedent. The exhibits would be simultaneous and in adjacent galleries. I knew of a few artists who were using cloth or thread as a means of addressing personal identity and the value of women's work, but I wanted to expand my understanding in order to settle upon a valid exhibition theme. Adrian Esparza's *serapes* held a place in my memory.

With the need for a show of contemporary textiles in mind, I attended *Radical Lace and Subversive Knitting* at the Museum of Arts and Design in New York City in winter 2007 to see if there might be some artists in that exhibit who interested me. With me was my colleague Stephanie Taylor, an avid knitter and an art historian with a keen intellect. It was while standing there together, in this large survey show, that we initiated a plan to co-curate a small, group exhibition that explored current knitting and textile practice in the creation of fine art. Later we decided that we wanted it to incorporate new media, such as photography and video, and draw from a talent pool that reached beyond the United States. We would present more than one piece by each artist so that the artists and the audience could investigate the subject in some depth. Most of the exhibition expense budget was invested in artist travel and lodging, plus the commissioning of one new work and of an exhibition publication.

During the next few months, Taylor and I each suggested several artists before we narrowed our list to the four eventually featured in the exhibition *Unknitting: Challenging Textile Traditions*: Adrian Esparza (El Paso), Rachel Gomme (London), Mark Newport (Detroit), and Sandra Valenzuela (Mexico City). (Coincidentally, none of them had been included in *Radical Lace and Subversive Knitting*, nor did any of them know of the others.) Gomme, Newport, and Valenzuela knit as performance and use photography or video to document that act or its resulting objects. They incorporate the craft of knitting into the production of fine art. Esparza, in contrast, unravels woven material rather than creating knitted fabric. Taylor took issue with including him in the show. "He doesn't even use needles," she argued. She suggested David Cole and Knitta Please as more suitable choices.

But I pushed back. Not only did Esparza fit well with the Rubin's periodic contextualization of artists from our region, he was also an alumnus and a source of pride for UTEP. Plus, his contributions to the show would expand the parameters of the exhibition in a manner that would strengthen it, especially because its ultimate raison d'être as a partner to the Bhutanese textile exhibit was to challenge our audience to develop its understanding of textile construction and use, both as functional item and as driver of ideas for art. Esparza's

interest in the cross-cultural mingling inherent to the border region related to the hybridization of two places as disparate as Bhutan and Texas. Taylor permitted herself to be persuaded. Esparza was in.

### "A Sense of Duality"

Over the years, Esparza's *serape* works have grown more complex. In *One and the Same* (2005)—a piece inspired by *View of El Paso Sunset*, a huge landscape painting from 1922 by Audley Dean Nichols that is part of the permanent collection of the El Paso Museum of Art—the threads run horizontally, vertically, and at angles, and they overlap one another at certain junctures. It is noticeably more intricate than the strict horizontals of the earlier work *Here and There*. Esparza retained the scale of Nichols's mountainscape and geometricized it.[7] The *serapes* permit Esparza to work in large scale without the expense and headache of shipping and storing oversized works: each condenses down to an instruction booklet, a few strips of wood embedded with nails, a partially unraveled blanket, and a spool of string from that blanket.

Curators Rita Gonzalez and Howard Fox included *One and the Same* in *Phantom Sightings: Art after the Chicano Movement*, an exhibition organized by the Los Angeles County Museum of Art that traveled in the United States and Mexico, 2008–2010.[8] Also in 2010, Esparza installed a new *serape*, *Before and After*, in *Volver: Mexican Folk Art into Play* at the San Francisco Museum of Craft and Folk Art (2010). Another *serape*, *Trade and Sell*, was featured in a solo show at the CUE Foundation in New York City in 2004, and yet another, *Then and Now*, in *Panamericana* at Kurimanzutto in Mexico City in 2010.

Adrian Esparza, *One and the Same*, 2005. *Serape*, plastic trip, nails. 60" × 144". El Paso Museum of Art, purchased with funds provided by Robert U. and Mabel O. Lipscomb Foundation Endowment.

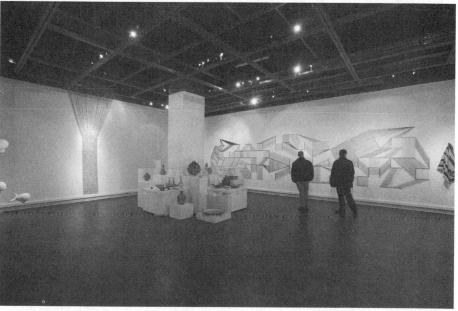

*Top:* Adrian Esparza, *Then and Now*, 2010. *Serape*, plywood, nails. Dimensions variable.
*Bottom:* Adrian Esparza, *Before and After*, 2010, as installed at the San Francisco Museum
of Craft and Folk Art. Photograph by Tomo Saito.

As of the time of this writing, Esparza has been present to set up each *serape* work. This has been at the request of the exhibiting venues. The artist believes that the *serapes* are conceptual and could easily be executed by someone else according to his instructions, much like Sol LeWitt's (1928–2007) wall drawings. But exhibitors thus far have been either unsure of their ability to realize the *serapes* properly, unwilling to allocate the staff time to their execution, or prefer Esparza to be on site to create the artwork so that it is as much about process as about concept. For *Unknitting*, Esparza improvised the creation of the piece in the gallery and developed it from scratch on site. No written instructions existed before the show opened.

The titles of the *serapes* are important. Each expresses, according to Esparza, "two physical states or two mental states [and] a sense of duality or companionship." Thus, the word "and" is instrumental: *Here and There, Trade and Sell, Then and Now* are examples. For *Unknitting*, he created the *serape* piece *Otro Lado / The Other Side* (2008), the title of which also captures the idea of two halves of the whole.

### OTRO LADO/THE OTHER SIDE: MOVING THE PERIPHERY TO THE CENTER

Esparza had originally proposed to stretch *The Other Side* between the pillars that divide the Rubin Gallery, but he eventually decided that the piece would lose some of its power if it were suspended in space. He and I agreed that this format would have emphasized absence rather than presence, visually and conceptually. At the time, residents of Juárez were fleeing the city due to the drug-related violence, leaving their homes shuttered and abandoned. The idea of absence and loss would have tied into this exodus, which was not what Esparza wanted to emphasize.

A couple of years later in 2010 when I asked Esparza about his personal bond with the borderlands, he replied, "My relationship to the border is a kind of performance piece . . . my inability to speak Spanish well means that . . . there is a kind of absence and maybe the work reflects that absence or that change." I related absence to the results of violence; Esparza, to a lack of effective interpersonal communication. Both interpretations related to the borderlands, a dual language area wracked by the repercussions of Mexico as a supplier and trafficker of illegal drugs to the lucrative U.S. market. The work's title, *The Other Side*, captured both of these approaches. It brought to mind two people on either side of a negotiating table, each telling one side of the story

that the opposite party misunderstands or disputes. It also referenced physical political boundaries. But these ideas were not on Esparza's mind during the execution process of *The Other Side*. Instead his decisions were based on "elements of design and what I felt was necessary in order to create a strong piece."

Once Esparza decided to anchor *The Other Side* to the wall, he completed the composition in about a day. When it was finished, he and I looked at it together for a while. I thought it was a dynamic and exciting composition and told him so. When I walked into the gallery the next day, which was the day before the exhibition opened, Esparza had disengaged the thread from the nails, rolled it up into a ball, and was starting over again. In this last-minute move, Esparza kept the wooden strips mounted where they were, most of them horizontal and parallel to one another. Within a few hours, he was finished with the second manifestation. The pattern created by the threads had completely changed. At the work's center was a two-foot-high band of vertical lines of string that looked like a wall or fence. The subject was El Paso / Juárez and the border divide, an interpretation affirmed by the work's title. All of the string above and below the barrier radiated from it. Esparza conveyed the border as epicenter and source energy. The horizontal axis of his composition was a symbol of a nation's edge. He made the periphery central.

For *The Other Side*, Esparza reflects, "I found myself with too much freedom. . . . I put up the image, felt the need to take it down and reconstruct it again." In 2008, after he completed *The Other Side*, the artist created a parameter for the *serape*s that uses *One and the Same* as precedent: he will use an artistic representation of the local landscape as a starting point for the *serape*. As he describes it, "I find myself returning back to the landscape . . . now I think that will be the criterion that informs the work . . . every time I make a *serape* piece. Living here in El Paso, whether I realize it or not, there has been this kind of ingraining of the horizon and clouds and the desert landscape." For the exhibitions in San Francisco and Mexico City, Esparza analyzed other artists' representations of those local landscapes and broke them down into geometric forms, Cubist style. For the 12th Istanbul Biennial, 2011, Esparza created *Far and Wide*, based on an aerial photograph from 1920 of Constantinople's cityscape. (Constantinople officially became Istanbul in the 1920s.)

Taylor states in her essay in the *Unknitting* exhibition catalogue that *The Other Side* can "be seen as a challenge to assumptions of race and class. In such works, Esparza changes the construction and meaning of 'traditional' Mexican textiles, which have already been drastically changed in order to fit the needs of the (mostly) white tourist trade. He transforms . . . [them] into

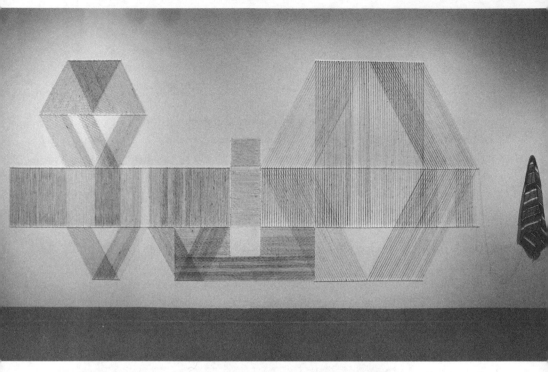

Adrian Esparza,
*Otro Lado / The
Other Side*, 2008.
*Serape*, nails.
98" × 252".
Photographs by
Marty Snortum.

high art reminiscent of the Bauhaus paintings of Josef Albers."[9] Paintings by Agnes Martin and Mark Rothko also come to mind. In an observation about Esparza's overall oeuvre, Alexander Freeman notes that his works are "intellectual aspirations of geometric abstraction with the more utilitarian traditions of craft. . . . They don't merely comment upon U.S./Mexico border issues, but embody them in the complex layering of meanings, forms, and reconfigured materials, rendering the precarious strategies of political negotiation as an aesthetic exercise."[10]

## MEDUSA 1.1 AND CONVERTING: BEYOND BORDERS

The other two works by Esparza in *Unknitting* were also created specifically for the exhibition though they reference Big Bang and rhizome theories rather than the landscape. *Medusa 1.1* (2008) consists of seven "posters," each created from two existing posters, promoting cinema or music stars, woven together. Some of the posters were from Mexico, some from other places. They came together to form a single expression of cultural hybridization that crosses political borders. *Converting* (2008) was a pieced fabric wall hanging made of crushed polyester velvet that the Rubin commissioned to fill the twenty-two-foot-high atrium wall. A tall rectangular compilation of tiny white, red, and black squares, each hand cut and machine stitched to the next, *Converting* predated by a couple of years the widespread use of Smartphone tag readers, but in its resemblance to them was a prescient reference to communication in today's world. *Converting* was neither patterned nor symmetrical, though at first glance, it looked as if it was both. It seemed to be expanding and growing and consequently referenced the rhizome, which Suzanne Weaver described in an essay about Esparza's work as "a structure always in process of formation and deformation, wandering away or sprouting from its original organ, existing as an independent part only to regroup or reform,"[11] a theoretical view of the border as a dynamic and changing entity. The work's graphic sensibility made it readable from outside the glass entry doors. The exhibition experience began even before visitors crossed the threshold of the building.

For *Converting*, Esparza created a preliminary drawing in ink on Mylar, working free-form from the center out. The squares seemed to explode from a focal point, conveying the artist's interest not only in the rhizome but also in the Big Bang theory of the origin of the universe. Both *Converting* and *Medusa 1.1* combined small bits of visual information to create an optical, nearly psychedelic, experience that furthered Esparza's investigation of amalgamation and cross-pollination.

*Top:* Adrian Esparza, *Medusa 1.1*, 2008. Found posters, cut into strips and woven. 98" × 102" overall dimensions. Photograph by Marty Snortum. *Bottom:* Adrian Esparza, *Preparatory Sketch for Converting*, 2008. Ink and masking tape on Mylar. 24" × 36". *Facing:* Adrian Esparza, *Converting*, 2008. Crushed polyester velvet. 288" × 128". Photograph by Marty Snortum.

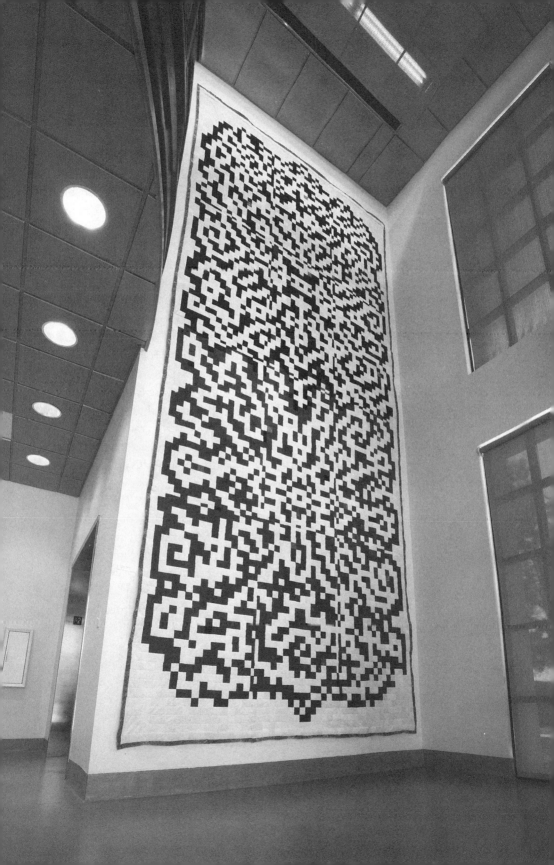

DREAM DROUGHT AND EXPANDING
THE AUDIENCE

In fall 2009, Esparza earned a residency at Artpace in San Antonio, Texas, and during his eight weeks there, he refined the ideas that he had incubated in *Converting* into *Dream Drought* (2009), an even larger pieced fabric work that he suspended like an arched curtain. Here about ten thousand pieces of tan, blue, and black fabric created a pattern reminiscent of a Navajo blanket. In a return to landscape as motivator, Esparza used colors to evoke the desert land and sky. The black sweep across the horizon referred to the border wall. Native American weavings geometricize nature just as Esparza did in *Dream Drought*, though the artist did not cite this as an inspiration. If a devotion to everyday materials links his bodies of work in what Esparza described as an "exaggerated flatland of equality," so does a commitment to the understanding and interpretation of the U.S./Mexico border and its culture.[12]

The scale and visual dynamism of *Dream Drought* prompted me to ask Esparza whether he had ever pursued public commissions. Often situated in areas trafficked by the general public who are not necessarily accustomed to, or even interested in, experiencing or interpreting art, public artworks have the potential to expand an artist's audience exponentially and to inspire the uninitiated with the communicative power of art. This led us to a discussion about audience, in general, and who, exactly, Esparza wants his art to speak to. He responded:

> Being in a studio trying to come up with an image or an idea or concept is a lonely process. When I ask myself "What is my role? What is my involvement with other people outside of myself and my family?" I come back to my inspiration and concern with analyzing community, especially here on the border. Watching the interaction, progress and development definitely informs the work. The idea of duality and two things coming together, or one that becomes two.[13]

My question about audience had prompted Esparza to reflect on the concept of community as subject matter—specifically, the borderland community. For him, to build an audience is to analyze it. In my experience as a curator and museum director, this is a valid first step. Understanding an audience is a requirement for growing it. If Esparza follows this trajectory, creating public art may be in his future.

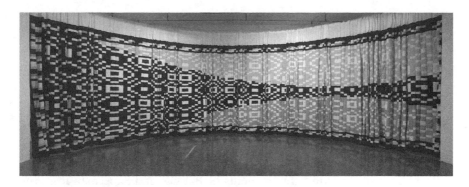

Adrian Esparza, *Dream Drought*, 2009. Bedsheets and thread.
144" × 1008". Photograph by Kimberly Aubuchon.

Esparza traces his deliberate artistic commitment to the border back to
an undergraduate painting class. Assigned to set up a still life and then paint
it, he selected mangos and limes from the local market rather than oysters
and lemons, which would have been truer to the Golden Age Dutch painters
that he was studying at the time. "I always love trips to the *mercado* in Juárez,
the smells of spices and colors of candy and ceramics figures. [Eventually] I
found them relevant to the point where I no longer needed . . . to buy a tube
of paint." This discovery led him to his current practice in which, instead of
constructing an image, he deconstructs and reconstructs yardage, blankets,
posters, clothing, and kitsch ceramics. He continued:

> There is a transformation of a culture or an object into something else. It
> retains that essence but at the same time something is lost. . . . The main
> thing is transformation and trying to capture that. . . . Each work becomes
> a sketch and a way to isolate an event of change . . . . What drives the work
> is the destruction of an object in order to understand the events occurring
> today in this region.

I grabbed onto this idea and to Esparza's recurring reference to loss. "The de-
struction you just referred to, you have been doing that for years, deconstruct-
ing and reinventing things . . . but do you see that relating to the violence in
Juárez? Do you think about that at all?" He thought for a minute. "Yes . . .
it exists everywhere, no matter what culture, this idea of disappointment or
hurt and of violence being a way to justify that pain. . . . It is self-preservation
[through] retaliation."

## *Unknitting*: Constructing, Deconstructing, Preserving

It was not until Esparza stated this, which was two years after *Unknitting* had been on exhibition at the Rubin, that I thought about the concept of self-preservation as a connecting force between the intentions of all four artists exhibited in *Unknitting*. Mark Newport knits costumes for superheroes of his own invention and generates prints, photographs, and videos of himself performing, sometimes wearing those one-piece outfits. These suits droop and sag, the antithesis of the skin-tight garments of Batman and Superman from the TV and movie series, making them more comical than intimidating. The only protection they offer is from the cold. In the print *Knitting a Forcefield*, Newport represents himself naked, sitting on the floor among a gathering of what appears to be uniformed men. Only the torsos and legs of these men are depicted and they connote law enforcement and threat. Newport knits furiously, as if that act will protect him from them, and from harm.

Newport performed in a hand-knitted version of one of his superhero costumes during the opening reception of *Unknitting*. At first, he stood guard in the gallery and later sat down to knit, in spite of the fact that his hands were

Mark Newport knitting, *Unknitting: Challenging Textile Traditions* in the Rubin, 2008.

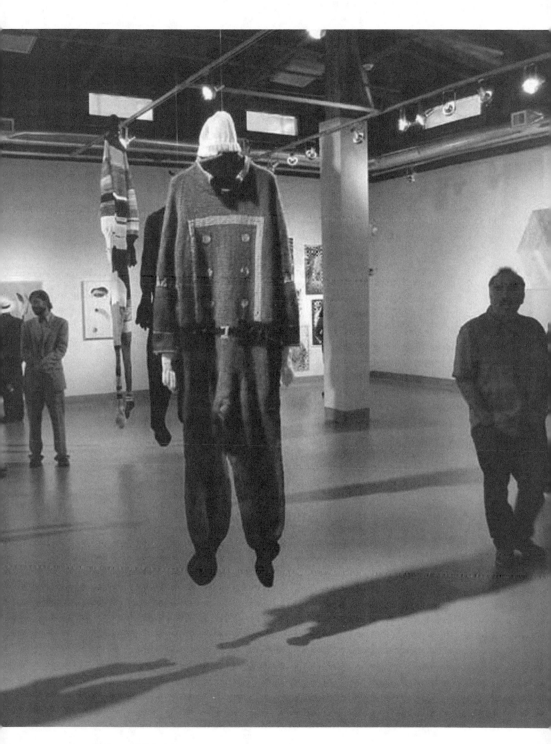

Installation of *Unknitting*, 2008.

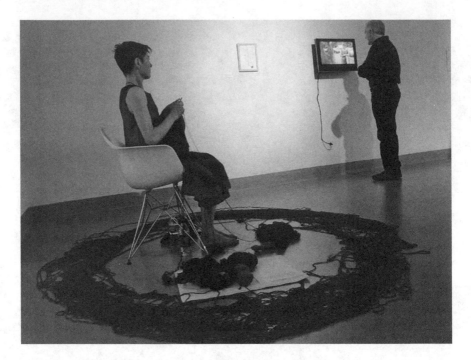

Rachel Gomme performing *Knitting a Rothko*, 2006. New and recycled yarn, natural and synthetic fibers, pencil on gallery wall. 85" W, expanding height. Photograph by Rubin staff.

encased in gloves. After about an hour of that, he strolled the area, randomly distributing notes that stated "I Owe You One Protective Gesture. Sweaterman." He did not speak. The suit, the silence, the knitting, and the promissory notes were acts of protection of self and others. On Newport's website is a video document of this performance that he annotated: "I patrolled the exhibition space dressed in the Sweaterman V costume standing guard over the guests and the artwork on view." This confirms his intentions to shield us.[14]

During the opening, Rachel Gomme also knitted in silence, her gaze downcast, and made some progress on her ongoing process piece, *Knitting a Rothko* (2006–). She annotated this work in pencil on the wall next to it with a description of each of her days in El Paso and the labor she expended. This fuzzy color-field wall hanging is on its way to becoming a knitted version of a modernist expression, and it complemented Esparza's equally modernist, hard-edged *The Other Side* hanging across the room. Her yarn surrounded her in a circle on the floor. Not a single gallery guest crossed over it into her zone of self-defense.

She assumed a similar stoic manner during her outdoor performance on campus the day before the opening. For this, she extended a line of green cotton string from a tree at the center of campus to the heavily trafficked student union, about a quarter mile away. She walked slowly for several windy hours, knitting the string into the scarf-like swath titled *Treeline* (2008). This injection of artistic process into public space was a platform for human connection and interaction, but most passersby were reticent to strike up conversation, possibly due to Gomme's intentness on her work. In the exhibition, the knitted portion of *Treeline* hung next to Gomme's description of its process that she penciled on the wall, similar to the penciled text she generated for *Knitting a Rothko*. The text was like a wish for something better, an abstract, contemporary version of an *ex voto*, or an illustrated prayer of devotion, which populated pilgrimage sites in the American Southwest. Gomme's handwork was her self-preservation.

Self-preservation also came into play in Sandra Valenzuela's series *Media Noche* (2007). The artist hired one of her mother's friends in Mexico to knit "hammocks" that cradle but only partially cover vegetables and fruits, which Valenzuela then suspended and photographed. The plants peep shyly from

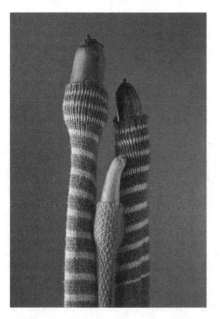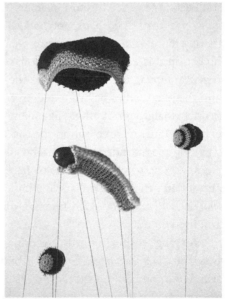

*Left:* Sandra Valenzuela, *Media Noche 1 / In the Dead of the Night 1*, 2007. Lambda metallic print. 36" × 27". *Right:* Sandra Valenzuela, *Media Noche 3 / In the Dead of the Night 3*, 2007. Lambda metallic print. 36" × 27".

their garments, becoming both surreal and erotic, tentatively revealing small portions of themselves from their protective blankets that partially shelter them from the viewer's gaze.

All three of these artists protect or preserve themselves or their subjects through knitting. In the context of a border torn apart by violence, this protective action filled a current need. Esparza was the only artist in the exhibit who calls El Paso/Juárez home, and *The Other Side* was the only work in the exhibition that first deconstructed an existing object and then built it up again. He rendered useless a former, traditional method of protection and Mexican identity and from it, he created a new one. By doing so, he symbolically envisioned a new approach to border relations, creating another link to the mission of the Rubin.

## Exhibitions Come Together

Like most handwoven textiles and like the artworks in *Unknitting*, the historical robes, dresses, and domestic weavings that composed *In the Weave: Bhutanese Textiles and National Identity* connoted protection. For this jewel of an exhibition, I borrowed five historical textiles and three pieces of jewelry from the Peabody Essex Museum in Salem, Massachusetts, and two contemporary weavings from El Pasoans who had visited Bhutan and purchased high-quality textiles there. Like most museums, Peabody Essex required a loan fee for each object (in this case, it was fifty dollars per item), the presence of their staff registrar during the installation of the textiles from the museum's collection, and that the textiles be presented on Medex, a formaldehyde-free MDF board product that does not off-gas like many plywoods. All of this was at the Rubin's expense. Plus, in preparation for the exhibit, I traveled to Bhutan for three weeks in 2007, funded by the Asian Cultural Council, to observe and interview weavers. The total direct costs of *In the Weave*, including research travel, was about thirty thousand dollars. Exhibition didactics included photographs from my visit and texts about my findings, documenting how the textiles were worn and used there.

Running in the Rubin Project Space simultaneous to these two exhibits was *Third Lie: Chromatic Deflections* by Chilean artist Monica Bengoa. It consisted of a poem about the five senses hand-scribed in graphite on one wall (an unexpected tie-in to Gomme's penciled annotations of *Treeline* and *Knitting a Rothko*) and small embroideries of still lives that morphed into drawings on the other walls. The exhibit reaffirmed our commitment to artists from south of the United States and also aligned with our summer-long focus on textiles.

The Rubin collaborated with UTEP's Asian Studies Program to host a Himalayan Culture Conference that launched the night of the opening of the exhibitions. Hundreds attended the opening reception, including a Buddhist nun wearing saffron robes; Mark Newport cloaked in one of his knitted costumes and distributing pieces of paper saying "I owe you" for protective gestures; and Bengoa and the half-dozen art students who assisted in the execution of her exhibition, as well as the usual mix of students, faculty, and supporters from the broader community. The energy was magnetic.

Later that summer of 2008, while the exhibits were still on view, President Natalicio invited Prince Jigyel Ugyen Wangchuck of Bhutan and several Bhutanese dancers to be her guests for three nights in El Paso after their stay in Washington, D.C., where they were visiting the Smithsonian Folklife Festival. The dancers performed in the university's basketball arena, which had been suitably transformed for the occasion to provide a worthy backdrop for the drama of Bhutanese dance. About five thousand people attended this spectacle. The night before the performance, the Rubin hosted a reception in honor of the Bhutanese guests. They arrived in garments just like those on view in *In the Weave*, bringing the exhibition to life. As they explored the exhibit, they exuded pride in their country. However, they were also intrigued with *Unknitting*—especially with Esparza's creation of new meaning and form from part of a cheap blanket. In an intentional curatorial move on Taylor's and my part, *Unknitting* reexamined and reinvented the sense of protection conveyed by the Bhutanese weavings. The concepts of selfhood and security that *In the Weave* built up, *Unknitting* questioned and reshaped. *In the Weave* was historical and hopeful; *Unknitting* was current and subversive. After one of the Bhutanese visitors studied Esparza's *The Other Side* for a number of minutes, she turned to me and said, "Tradition is not everything." There was no better way to summarize the synergy between that summer's exhibitions at the Rubin, a dynamic that supported our institutional mission of exhibiting progressive contemporary art.

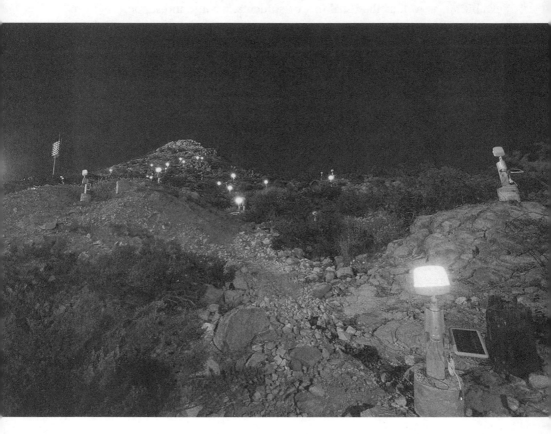

Leo Villareal, *Solar Matrix*, 2008. LED lights with cellular technology.
Dimensions variable. Photograph by Marty Snortum.

Nicola Lopez,
Noah MacDonald,
Julio César Morales,
Leo Villareal, and
Vargas Suarez
UNIVERSAL

*Claiming Space:*
*Mexican Americans*
*in U.S. Cities*
*2008*

## The Evolution of an Exhibition

My introduction to the art of Leo Villareal represented the beginning of one of the more complicated and conceptually fraught exhibitions I have ever organized. That exhibition would come to be titled *Claiming Space: Mexican Americans in U.S. Cities.* Susan Harrison introduced me to Villareal's work in 2002, when she was based in Washington, D.C., as an administrator at the Art in Architecture program for the General Services Administration, overseeing the commissioning of art for newly constructed federal buildings. The architectural design competition for the courthouse in El Paso was underway and ½ of 1 percent of the construction budget was set aside for art. Looking for people who might serve as art peers and contribute ideas for potential artists for the courthouse, Harrison ran across my name. She and I met for the first time at the initial meeting of the art selection committee.

The committee consisted of a federal judge, a representative of the architect for the new courthouse, a couple of community members representing the people of El Paso and the users of the building, several federal employees based in Ft. Worth and involved with the project, Harrison, and me. At the first meeting in 2001, Harrison presented the history of the Art in Architecture program and explained the committee's task, which was to have an artist on board soon so that he or she could develop a site-based artwork that would integrate well with the architecture of the building. Over the next few months,

each of us suggested artists to Harrison. It was an excellent opportunity for me to learn about and connect with national-level artistic talent. My relationship with artist Leo Villareal evolved because of this experience.

The second committee meeting convened several months later in early 2002 in a windowless room in the county building in downtown El Paso. Harrison presented images of art by the recommended artists, including Villareal, whom she suggested. Villareal creates sculptures from dozens of lightbulbs that blink at random moments. Each piece has its own unique software program, developed by the artist, that determines when each light turns on and off. In some of the artworks, the bulbs are exposed. In others, they are masked behind a scrim so that the lights blend together in expanses of throbbing, illuminated color that shifts from deep purple to bright orange and nearly every hue in between. Their brightness lit up the dreary chamber. After a full day of discussion, the committee advocated for Villareal to receive the approximately one hundred and fifty thousand-dollar commission.

Villareal was born in Albuquerque in 1967 of a Mexican father and an American mother, and he spent several years of his youth in El Paso. In 2002, and at least until the time of this writing, he was living in New York City, but his connection to El Paso, combined with the competency and power of his art, put him at an advantage in our deliberations. Harrison contacted him to inquire as to whether he was interested. The timing was perfect and he enthusiastically accepted. The contract was set in motion and the art and the architecture for the federal courthouse in El Paso began to develop simultaneously. Villareal's career escalated a couple of years later.

During summer 2004, I traveled to New York City for a few days in order to meet with Paul Henry Ramírez. I had invited him to produce the inaugural exhibition at the Rubin that fall. He and I needed to nail down the details of his exhibition and face-to-face interaction was the most expedient method. I took a few hours away from Ramírez to visit Villareal. His studio was in a warehouse building on a floor above ground level, its solid door nondescript and uninviting, only a few feet from the elevator shaft. But behind it was a wonderland of a workshop that looked like a nerve center. Long tables overflowed with wires and their connectors, lightbulbs, computers, and other tools. Shelves were piled high with memory boards and hard drives. Completed and in-process artworks lined the workshop's periphery. Villareal's well-groomed, clean-shaven appearance provided no clue to the pandemonium of his workspace.

Villareal developed an idea for the courthouse for a picture window-sized rectangular light box that would pulse with luminous color. In a well-crafted presentation to the committee, he discussed the meaning of the box and its

maintenance requirements. Because the building's façade was to be sheet glass, the artwork would be visible to people passing by, especially at night—a special perk for downtown residents, a demographic that the City of El Paso was motivated to expand. Villareal reminisced about his youth in El Paso at various points during his presentation. The wide-open spaces of West Texas had left an indelible impression on him. All of this was appealing to the committee, but the title of the piece is what sealed the deal. *Sky*. It evoked one of our natural assets and also the human motivation to reach ever upward toward our full potential as a species.

In summer 2005, I had an opportunity to witness a public presentation by Villareal, this time at Hirshhorn Museum and Sculpture Garden. One of his works was on view as part of *Visual Music*, an exhibition "that traced an alternative history of the abstract art of the past century, featuring artists connected by their explorations of ideas related to synaesthesia—primarily, a unity of the senses and, by extension, a synthesis of the arts."[1] The Hirshhorn's 270-seat auditorium was nearly at capacity and energy was high. Villareal eloquently discussed the unknowable character and quality of light.

## Honing a Theme

That same summer, a fellowship at the Smithsonian took me to Washington. My experience there represents the next chapter in the development of the *Claiming Space* exhibition. The program hosted about a dozen fellows; some were graduate students and others were museum professionals. The goal of this annual program is to nurture Latinos in the museum field by creating opportunities to network. I was the only non-Latino in that year's cadre. My application essay had focused on the fact that I am a transplant from Ohio via Oregon to the Mexican border in a position of curatorial responsibility where I program exhibitions for an audience that is more than 75 percent Mexican American. I have a master of arts in art history, but no formal training in the art of Mexico or the Southwestern United States or Latin America. I needed some guidance. The Smithsonian agreed and admitted me to the program.

Seminar discussions, led primarily by Smithsonian staffers, occupied the first two weeks of the fellowship and focused on how to address Latin American subject matter seriously and sensitively in museums and how to cultivate the tools to expand the Latino museum audience. Villareal at the Hirshhorn and Cuban American musician Celia Cruz at the Smithsonian Museum of American History were two Latino artists featured in the Smithsonian museums at the time, so Villareal was a topic of discussion, especially how his abstract art does not reveal his ethnic or national origin.

For the final two weeks, each fellow worked independently to develop a project that had some relationship to Latinos and to museums. Monica Ramírez-Montagut, the one other contemporary art curator in the mix of fellows, was at the time curator at the Price Tower Arts Center in Bartlesville, Oklahoma.[2] Born in Mexico City in 1971 and educated in Spain, Ramírez-Montagut self-identifies as "an architect and curator, with an experience of Latino culture that has little to do with folklore and much more to do with a perceptible attitude of survival, adaptation and achievement."[3] Ramírez-Montagut had joined Harrison and me for Villareal's presentation at the Hirshhorn and she was as impressed with him as I was. We paired up for our final project and agreed that we wanted Villareal to be part of it.

We went first to Melissa Carrillo, administrator of the Smithsonian Latino Virtual Gallery and one of the Smithsonian employees with whom our group of fellows had met during our first two weeks there.[4] Carrillo had encouraged all of us to present her with ideas for this exhibition resource, where the exhibition exists only online as an educational tool for Internet-savvy audiences. For Villareal, the software *is* the art because that is where much of the creative process and the value of the artwork reside. The relationship between his software and its physical results is akin to that between an architectural plan and a building. We proposed to Carrillo that Latino Virtual Gallery commission Villareal to develop software for an artwork meant to be experienced on a computer screen. Carrillo seemed intrigued with the idea. The sticking point was money. There was none.

So Ramírez-Montagut and I shifted gears. We proposed instead an exhibition that explored how artists of Latino descent of our generation and younger were adopting an abstract, urban aesthetic. Because his art is often installed on the facades of city buildings, Villareal fit in perfectly. So did Nicola Lopez and Vargas Suarez UNIVERSAL, two artists with whom Ramírez-Montagut and I became acquainted that summer in Washington.[5] Lopez represents urban roadways in woodblock prints on Mylar, a translucent polyester film. She then cuts, folds, and binds the prints into abstract bundles that convey the repercussions of urban growth and decay. The artist notes, "Often these roads don't get you anywhere. . . . The urban environment is alive, it grows, changes and evolves. So often there is urban growth without planning."[6] Vargas Suarez UNIVERSAL spent his youth in Houston in the shadow of NASA's Johnson Space Center. The images in his mural-sized line drawings look like fractured architecture and conceptually connect outer space exploration to a new world order.

We planned to ask Villareal, Lopez, and Vargas Suarez UNIVERSAL to provide us with images of select examples of their existing work and grant us

permission to exhibit them in the Latino Virtual Gallery with some explanatory text that Ramírez-Montagut and I would author as co-curators. All three artists fit into the aesthetic parameters of the exhibit because they capture the pulse of the city in abstraction. It is a counterpoint to the rural, figurative polemic of the prior generation that had ignited the Chicano movement of the 1970s and its associated politicized imagery of Atzlan, bleeding hearts, and the Virgin of Guadalupe. Latino Virtual Gallery championed this type of Chicano expression. We were asking the Smithsonian to step outside of its comfort zone and to expand the scope of Latino art that it presented to its audience.

This was a lot to ask. Plus, we had lost sight of our original intention of harnessing Villareal's skills and interests to create a piece for the Internet, using the computer as a tool for making and viewing. Instead, the exhibition would be a series of reproductions of sculpture and painting, a less compelling and less relevant concept. Carrillo was not convinced that the exhibition idea was worth pursuing. Ramírez-Montagut and I would need to transform the project in order to keep it alive. And so we entered chapter three of the exhibition's planning.

## And Then There Were Five

I remained committed to the validity of the curatorial concept of artists of Latino descent who are entering career maturity and employing abstraction to communicate their understanding of urban environments. In fall 2005, fresh from the Smithsonian fellowship, I applied for an Andy Warhol Foundation for the Visual Arts grant to support the Rubin in the production of several exhibitions between 2006 and 2008 that would include commissioned works. One of the exhibits cited in the proposal was tentatively titled *Latino Urbanism* and was based on this curatorial premise. We earned the grant in spring 2006.

Ramírez-Montagut and I got back to work on an actual exhibition for the Rubin rather than a virtual exhibit for the Smithsonian. We decided to focus on artists of Mexican descent living in the United States and to invite the three artists we had originally considered for Latino Virtual Gallery, all of whom were based in the New York City area. We would also include an artist from the West Coast and one from the Southwest to flesh out the geographic perspectives and to affirm the institutional commitment to contextualizing art from the Southwest region with that from other places. After discussing several options, we settled upon Noah MacDonald of Keep Adding and Julio César Morales. A Santa Fe–based artistic partnership between Noah MacDonald and Brian Bixby, Keep Adding took its art to the streets with guerrilla-style

paintings that improved neglected urban spaces.[7] (MacDonald executed all of the street paintings and Bixby took on most of the responsibility for the computer-generated imagery for artworks designed for indoor spaces.) Julio César Morales was living in San Francisco and exploring immigration and the informal economy created by Mexican street vendors in U.S. cities via photographs, video, and drawings. Finally, in chapter four of the planning process, the conceptual stage of the exhibition adopted its final shape.

## Realizing the Idea

These five artists varied in their generational connection to or remove from their Mexican identity. Morales and Vargas Suarez UNIVERSAL were Mexicans living in the United States and both read the urban environment as a structure that comes to life through the spontaneity of migratory activity. Villareal is a first-generation Mexican American who visits Mexico often and connects strongly with it. He engaged the urban setting as a testing field. The results were unpredictable. The ancestors of Lopez and MacDonald moved from Spain to New Mexico when it was still part of Mexico. MacDonald intervenes in the cityscape with the intent of improving it. With her turquoise rings and long braids, Lopez exudes the American Southwest. Much of her art emphasizes rupture, isolation, and distress.

The five artists would pleasingly fill the two larger galleries of the Rubin, which was at the time two and a half years old and in its short history had hosted several group exhibitions of art with a common idea. We had also supported solo shows of new, commissioned works that responded to the border.[8] We had more of both of these types planned for 2006–2007. This exhibition would combine the two trajectories: a group exhibition of commissioned work centered on an idea. We slated the exhibition to open in fall 2008 in hopes of coordinating with the unveiling of Villareal's *Sky* in the El Paso federal courthouse, but the construction of the courthouse building fell behind schedule. Consequently, it was the Rubin that introduced Villareal's art to the community that he at one time had thought of as home. (*Sky* came along about eighteen months later.) All of the artists agreed to participate with the understanding that each would create at least one new, commissioned work. We would fill out the show with preexisting artwork.

Between fall 2007 and spring 2008, Ramírez-Montagut and I conducted in-person interviews with the artists to better understand their artistic intentions and how their Mexican identity figured into their thinking processes, if at all. Although this identity was a factor for all of them, none of them

directly addressed it in their art, nor did they want their work to be understood as "Mexican." During this interview process, we became aware that not only were the artists focusing on either abstraction or the dynamic between abstraction and representation, they were also interested in technology and the future. They were creating architectural-scale paintings, sculptures, and projections that either responded to the urban environment or marked their place within it. Our selection of artists and our discussions with them refined the curatorial foci: through their art and technology, they were claiming urban space, which we adopted as the exhibition title.

## Claiming Space

Some of the most exciting moments of *Claiming Space* happened at its entrance. Villareal transformed the hillside to the north of the building with the commissioned *Solar Matrix*. This field of light represented the first time that the artist had employed solar energy to power his work: about forty lights, forty solar panels, and forty power boxes arrived a couple of weeks before the show was scheduled to open. Rubin Center staff created a stand from an 18-inch high, 2 × 4-inch piece of lumber, standing in a tree-stump-like form of cast concrete, for each composite of light fixture, panel, and power box.[9] We carried the stumps up the hillside, one at a time, and placed them to fan out from a cave about fifty feet from the hill's base, a casual configuration that the artist tweaked slightly when he arrived in El Paso. The lights blinked periodically and randomly, prompted by Villareal's software program, which was powered by a Mac Mini housed inside the gallery and transmitted via cellular technology to a chip embedded in the power box beneath each lamp. "They look like fireflies," Susan Harrison exclaimed. It was as if the stars had fallen to earth, their twinkling visible from Juárez and from UTEP's stadium during a season of football night games. *Solar Matrix*'s audience was huge.[10]

As soon as visitors to *Claiming Space* entered the building, they were confronted by Julio César Morales's *Informal Economy Vendor #2* (2008), a 22-foot-high black vinyl adhesive wall mural of a Mexican street vendor and his cart, exploded into dozens of pieces scattered across the wall. The fragments seem to pause, suspended in time, preparing to reconfigure into something new. In his formative book *Magical Urbanism*, Mike Davis points out that Mexican vendors are in theory applauded for their initiatives that contribute to the economy of the cities, but are in practice persecuted.[11] Morales renders this forced adaptation as destruction followed by reinvention. The graphic quality of the piece made it readable through the glass doors and windows of the entrance.

Installing Leo Villareal, *Solar Matrix*, 2008.

In the upstairs gallery, Morales presented four collaged photographs of street vendors at work. He cut around the image of the vendor, extracted it from the street scene, and replaced it with a compilation of details from other photographs so that the vendor was represented as a composite of other places and times. Each piece was a comment both on the hybridity, resilience, and adaptability of these entrepreneurs and on "the power of photography and the idea of evidence as a false truth."[12]

Morales's commissioned piece was a moving video projection that used images of empty urban lots for sale as backdrops for computer-generated drawings of vendors and their carts. Each cart suddenly combusted, a kaleidoscope of abstract parts exploding across the picture plane, and then reconfigured itself in a new place. The vendor changed neighborhood and product based on the market, a testament to the "glocal," an idea explored by Néstor García Canclini, the Argentine-born anthropologist now based in Mexico City, who is responsible for a body of scholarship about the complexity of the Latin American identity in a globalized world. "One lives within the local depending upon how one participates in globalization," he contends.[13] Morales himself is a case

in point of the hybridity that Canclini discusses. He is a savvy curator, educator, and artist who leverages each of these pursuits with the others. Born in Tijuana, he represented the United States in the Istanbul and Singapore Biennials, but Mexico in the San Juan Triennial.

Ramírez-Montagut and I visited Morales in spring 2008 in his home and studio, an early twentieth-century storefront in the Mission District of San Francisco. We walked through the crowded and chaotic workspace to the living space in the back, which was very tidy and tricked out with 1950s vintage furnishings in baby blue and soft brown. This controlled palette comes through in two of Morales's U.S./Mexico border–related series. The first is *Undocumented Interventions*, watercolor and graphite drawings that portray adults sequestered in automobile trunks, upholstery, and dashboards, and infants and children embedded in piñatas and toys in order to cross illegally into the United States.

The second series, which Morales began to develop in 2009, is *Narquitectos*. It refers to trained architects in Mexico who are commissioned by drug cartels to create tunnels to connect Mexico to the United States. One of these tunnels stretched more than 2,200 feet (around 7½ football fields), complete with train tracks and ventilation, and was used to move marijuana between a house in

Julio César Morales, *Informal Economy Vendor Mix #1*, 2008.
Type C photographic collage. 20" × 30".

Julio César Morales, *Informal Economy Vendor #2*, 2007. Analog and digital media rendered with vinyl. 258" × 192". Photograph by Marty Snortum.

Tijuana and a warehouse in Otay Mesa, California.[14] The eight billion-dollar U.S. border wall is rendered nearly useless against this type of ingenuity. Morales located photographic documentation from the U.S. customs website and, with the help of a retired architect, re-created in color pencil the tunnels and their locations. In these two recent series, Morales critically assessed drug and human trafficking across the border.

Nicola Lopez portrayed city life with her signature works of bridges and roads as both connectors and dividers: the construction of highways has destroyed many immigrant neighborhoods and displaced poor urban dwellers. Her implied spaces seem to offer no escape from their tentacles of growth and exploitation. *Drawn and Quartered* (2008) dynamically sliced through the gallery with actual and represented rope that connected several of her misshapen spheres of printed and cut Mylar. One seemed to grow from the ceiling, another from the wall, and yet another was hanging from "rope" from three sides, hovering just a few inches above the floor as if suspended in a state of indecision about its own fate. Vargas Suarez UNIVERSAL intervened in the cityscape of El Paso by digging mud from the Rio Grande River as a material for his landscape mural that depicted the view from the Mars Rover, the next frontier to be colonized and claimed. In order to do this, he projected images from the NASA website, then sketched directly on the gallery wall in river mud.

Nicola Lopez, *Drawn and Quartered*, detail, 2008. Woodblock on Mylar, ropes, aluminum armatures, dimensions variable. Photograph by Marty Snortum.

Julio César Morales, *Narquitectos 4*, 2009.
Ink and spray paint on vellum. 36" × 24".

*Top:* Installing Julio César Morales, *Informal Economy Vendor #2*, 2007, the Rubin. *Bottom:* Noah MacDonald creating *Stare Well*, 2008, the University of Texas at El Paso.

*Top:* Noah MacDonald/Keep Adding, *Stare Well*, Fox Fine Arts Center at the University of Texas at El Paso, 2008. House and spray paint. Dimensions variable. Photograph by Marty Snortum. *Bottom:* Noah MacDonald/Keep Adding, *Stare Well*, 2008. House and spray paint. Dimensions variable. Photograph by Marty Snortum.

Keep Adding offered two works to the exhibition, one inside the gallery and one outdoors. (MacDonald's other collective, Black Estate, was represented by two additional works.) The outdoor piece was a painted mural titled *Stare Well* that transformed an underused stairwell of the Fox Fine Arts Center, where the departments of theater, dance, music, and visual art are housed.

*Stare Well* most succinctly and obviously connected Keep Adding's oeuvre to the exhibition idea. It was also the most popular and long-lasting work in the exhibition, since it was on view for eighteen months and the rest of the exhibit lasted only three. At the beginning of the process, MacDonald and I walked through the campus in search of a site for the painting. We decided to focus on the Fox Fine Arts Center because, as one of the few non–Bhutanese-style buildings on campus, its walls are smooth concrete and vertical, rather than stuccoed and sloped. MacDonald identified the stairwell as one that would clearly benefit from some attention and color. His painting process was remarkably free-form and effectively responded to the angles and pockets of the architecture. He taped off the edges before executing the various sections of rectangular expanses of black and gray and thin triangular complements of red, but the decisions about where to place the tape, and how to manage the gradations of color within each section, occurred on-site as he painted. The abstract forms interacted to make the wall look as if it receded into space.

Students sketching Nicola Lopez's *Drawn and Quartered*, 2008. Woodblock on Mylar, ropes, aluminum armatures, dimensions variable.

Four of the five artists participated in educational outreach and in-person connections with the audience. Vargas Suarez UNIVERSAL provided critiques for UTEP art students, Nicola Lopez offered a public lecture, Noah MacDonald conducted a workshop for high school students about his strategies for maintaining a livelihood as an artist, and Villareal offered an on-site process discussion for sculpture students and a few other passersby. Lopez divided the ample space around her dimensional *Drawn and Quartered* in a compelling way, providing an ideal subject for sketching exercises for university drawing classes and for high school workshops. We maximized the opportunities for educational programming at a variety of levels.

## Lessons Learned

Where we did not achieve our fullest potential was in curatorial rigor, ambition, and reach. The idea of urban interventions by artists of Mexican descent could have more fully infiltrated the campus and the city via organizational collaborations and city support. Expanding the number of interventions in order to explore this concept of transnational social space more thoroughly may have brought into focus for Ramírez-Montagut and me the fact that the descriptive subtitle of the exhibition, *Mexican Americans in U.S. Cities*, was unnecessary and overly prescribed. The fervor of identity politics has subsided, and this is the very reason that Noah MacDonald chooses to work as a member of a collective, "I want the work to be viewed as artwork, with no names to associate me as a white person or as Hispanic. I want to avoid directing the reading of the image."[15]

A couple of years after the exhibit closed, I shared these reflections with Ramírez-Montagut. She countered:

> Most of the artists in the roster (Lopez, Morales, UNIVERSAL) work inside the gallery space so to ask them to do work outdoors would have been somewhat out of their scope. I think the strength of the show was to bring urban sensibilities and strategies into an abstract current language. It was challenging the established stereotype of the style of Latino art that was also important: no virgins, no bloody hearts . . . etc. This was high-tech and abstract with content coming from the city itself and its hybridization.[16]

An exhibition of urban interventions would be another exhibition entirely, with a different set of artists and a bigger research team to secure appropriate venues and organizational collaborators.

In addition, the exhibition was uneven as far as the quality of the individual works. For example, Vargas Suarez UNIVERSAL was in the process of shifting to a more representational mode after making a name for himself as an abstractionist with works such as *Space Station: Tenochtitlan* in 2005 at Museo de Arte Carrillo Gil in Mexico City and *Space Station: Jersey* in 2003 at the Jersey City Museum in Jersey City, New Jersey. We invited him to exhibit based on these abstract renditions, but instead he chose to represent the landscape of Mars in Rio Grande mud. Part of the risk of commissioned work is that artists usually, and appropriately, want to test new territory. I encourage this because it fulfills the Rubin's support of the research mission of the university and of the newest and most profound ideas about the border. Had I demanded from him an abstract painting, the curatorial premise of the exhibition would have been clearer to visitors. I privileged his artistic growth and change over our viewer experience. In this case, institutional research mission conflicted with our public service mission and with curatorial success.

Exhibiting *Sony Integration I* (2008), a depiction of an octopus fondling a geisha, by MacDonald and his other collective, Black Estate, was another misstep. Based on the Japanese erotic print *Girl with Octopus* by Hokusai (1760–1849), *Sony Integration I* conveys distress where *Girl with Octopus* conveys pleasure. In her exhibition catalogue essay, Ramírez-Montagut graciously connects it to Keep Adding's murals and describes its inclusion as conceptually sound:

> MacDonald emphasizes cultural contamination by revisiting the legendary Japanese artist Hokusai's prints. Here, like in graffiti, visual contamination integrates disparities, incorporates contradictions, and threatens, all key elements for participation in the global world. MacDonald's work aims to renovate. In spite of the decayed urban sites and the geisha/octopus struggle, the general tone is that of possibility, of starting all over again.[17]

Hokusai was working during a time just prior to the opening of Japan to the West (1852–1854), after centuries of isolation. MacDonald's drawing can be interpreted as portraying the fright and compromise of the potential of political colonization.

Nicola Lopez installing *Drawn and Quartered*, 2008, the Rubin.

Colonization was an underlying thread throughout the exhibition: Lopez addressed the encroachment of urban environments on surrounding areas and of roads on neighborhoods. Morales portrayed vendors' survivalist reactions to the economic colonialism of the United States in Mexico. Vargas-Suarez UNIVERSAL depicted the "takeover" of Mars by Earth. Conceptually, *Sony Integration I* worked, but the Asian connection seemed odd and did not integrate visually with the other art in the show.

I am committed to each of the exhibitions that I curate, but I had unduly high hopes for this one, and therefore these modest failures in curatorial judgment left an indelible mark on my consciousness. My hopes were based on the fact that the artists were top-notch, as were Ramírez-Montagut and the guest essayist for the exhibition catalogue, Victor Manuel Espinosa, a sociologist who had also been a summer 2005 Smithsonian fellow. Plus, the show synthesized so many aspects of what the Rubin had come to be about, such as the border, Mexico, and site-specificity. The direct cost of the exhibition was about forty-five thousand dollars. Each of the artists, Espinosa, and Ramírez-Montagut earned honoraria. Plus, as always, there were art transportation and publication costs. It was one of the more expensive shows that the Rubin had hosted up to that time, which added to my expectations for its success.

This is not to say that none of my hopes were fulfilled. To the contrary, the exhibition met many of them including embracing public space, investing in the creation of new work by artists of quality, and creating a platform for formative interactions between professional art and artists with university and high school students—all of which the Rubin strives to accomplish with each of its exhibitions.

There have been other exhibitions at other institutions that include commissioned art about how identity is shifting in a globalized world. *Phantom Sightings: Art after the Chicano Movement*, created and organized by the Los Angeles County Museum of Art and traveling internationally from there, was one of the best; it opened at about the same time as *Claiming Space* and Nicola Lopez and Julio César Morales were among its thirty-one featured artists. It was a difficult task to set ours above and apart from all the others.

Overall we may have been attempting to accomplish too much with a single project. Evaluating the strengths and weaknesses of each exhibition soon after it closes is a valuable tool for facilitating improvement and one that the Rubin staff engages in for every exhibition. But this is a behind-the-scenes exercise. I offer here a public self-critique, as the final chapter of the exhibition outlining how we could have done better, so that others can learn from my experience.

Even before I met Liz Cohen, I agreed to be her temporary housemate. My husband at the time David Taylor is a photographer and had offered to assist Cohen in the printing of a series of her photographs. The seven hundred and fifty prints would require their attention for about two weeks. Cohen stayed with us and she and Taylor ran the inkjet printer nearly every day from morning until night.

That was in July 2008. Before then, however, a number of factors led to Cohen and me coming together. In late fall 2006, my colleague Rachelle Thiewes—a UTEP art professor and metalsmith who served on the Rubin exhibition selection committee—gave me an article that she had clipped from the *Phoenix New Times*.[1] It told the story of a young female artist who was working in an auto body shop, making an old car new again. "Sculpture, women's studies, performance . . ." Thiewes said, "tap a new audience of car lovers." I gave it a cursory look, filed it, and moved onto other things. I was to learn later, upon closer reading, that the old car is a German Trabant that physically reconfigures itself, via hydraulics, into a Chevy El Camino in about fifteen seconds, *Trabantimino*.

About a year after my discussion with Thiewes, Taylor shared with me a highlight of his recent trip to Photoeye Bookstore in Santa Fe: "I got this great book, *Bodywork*. The artist is here in the Southwest, in Phoenix." (Proximity is relative; in the expansive spaces of the Southwest, Phoenix, more than four

Liz Cohen, *Welder*, 2005. Archival ink-jet print on paper. 36" × 46".

hundred miles from El Paso, seems almost next door.) I flipped through some photographs of a young, well-proportioned woman wearing high heels and a bikini while welding and using other power tools. Taylor continued, "Mash-up culture, fashion, a woman doing men's work . . ."

As it turned out, Cohen was the artist featured in both the Phoenix newspaper and in *Bodywork*. She not only inserted herself in the male-dominated world of auto mechanics, she also photographed herself working in that context and posing with the car. As she remarked, "I want to see if I can make the magazines and be the person that shows off the car."[2] Taylor telephoned Elwood Body Works, where Cohen and *Trabantimino* were spending their days, and left a message inquiring as to whether she would be willing to serve as a visiting artist at NMSU. Cohen returned the call promptly, interested in more details. After a few telephone conversations, she told Taylor about her new series

of photos titled *Proper Planning Prevents Poor Performance*, one hundred and fifty images, each of a single tool from Cohen's auto mechanic mentor's toolbox.[3] Black and white, 9.75 × 6 inches, with the tool isolated on neutral gray ground, the photos are reminiscent of Walker Evans's *Beauties of the Common Tool*, published in *Fortune* magazine in 1955. In early 2008, Taylor and I hatched a plan contingent upon faculty buy-in at both UTEP and NMSU: he would print the photos, I would exhibit them, and Cohen would serve as a visiting artist in both places.

## Cohen in Context

Before inviting Cohen, I researched a few precedents. Because it is a sculpture, *Trabantimino* distinguishes itself from image-based art about American car culture, such as Allan d'Arcangelo's representations of open roads rendered in bold colors, Ed Ruscha's gas stations, or Andy Warhol's disaster paintings. Artists who have used actual automobiles as subject, media, or both have exploited them for their material quality (John Chamberlain), manipulated and displayed

*Left:* Liz Cohen, *Proper Planning Prevents Poor Performance: Hammer*, 2007. Ink-jet print on paper. 9.75" × 6". *Right:* Liz Cohen, *Proper Planning Prevents Poor Performance: Groove Cleaner*, 2007. Ink-jet print on paper. 9.75" × 6".

certain parts to portray masculinity and status (Richard Prince), added volume to probe the connection between power and consumption (Erwin Wurm), or deconstructed and reconstructed them either as an attempt to reactivate an icon (Gabriel Orozco) or as a comment on the systemic economies of globalization (Margarita Cabrera, Damian Ortega). *Trabantimino* is more hopeful than any of these.

Ruben Ortiz Torres's sculptures of the late 1990s are possibly *Trabantimino*'s closest siblings. Ortiz created movable forms by customizing mundane machinery, such as old cars and lawnmowers. Often these "lowrider" works featured hydraulics, moving and dancing to the point that they are extreme and ridiculous. A Mexican adopting and adapting an important symbol of Chicano culture, Ortiz positions himself in today's technologically connected world where ethnic identity and its expression is only one component of a complex construction of self. Like Ortiz's apparatuses, *Trabantimino* is mechanical, and reinvention is part of its point. But Cohen invested her own time and sweat, whereas Ortiz sources other talent to achieve his vision. *Trabantimino*'s engine and upholstery shine, reminding us that its execution required sustained effort, education, and time, foregrounding labor, value, and a sort of preciousness.[4]

In addition to sourcing recent historical comparisons in art, I contacted Brenda Risch, the director of the Women's Studies Department at UTEP, and asked her opinion on the manner in which Cohen was presenting herself in these portraits. Was she exploiting her own body and, if so, what did that mean? Cohen willingly subjects herself to the male gaze, a term coined by cinema theorist Laura Mulvey that contends that the audience in mainstream cinema is assumed to adopt the perspective of a heterosexual man; the male gaze takes precedence over a female one.[5] It is a term often applied to representations in fine art, as well. Was Cohen also privileging the male gaze? And, if so, did the fact that she was presenting herself, rather than another woman, change the implications of this? Risch responded, "She should present herself however she wants to. Let's bring her here to talk about it."

I asked Cohen, "How do you place yourself in the realm of feminism: second wave, third wave, and post?" She responded, "I appreciate the really difficult political struggles that women have gone through, and I think they require different things from women at different times . . . the whole goal is for the woman to fully realize herself." Risch and Cohen were saying the same thing. I moved forward and garnered the support of the exhibition selection committee.

## No Room for Baggage

Cohen visited in July and then returned in October for meetings with art students, a presentation in a Women's Studies class, a public presentation, and the opening reception of *No Room for Baggage*, a solo exhibition that unveiled *Proper Planning Prevents Poor Performance*. In the presentation, she discussed the trajectory of her career, including her photographs of transgender sex workers in Panama (2000–2002) and her residencies in Germany and Sweden and how they all connected to *Trabantimino*. The exhibit in the Project Space consisted of *Proper Planning Prevents Poor Performance*, two large-scale color bikini photographs, and two videos. The first video, *Bikini Carwash*, documents her performance-as-fundraiser in San Francisco, where she attended graduate school and where she worked on the car for a year at Worldwide Customs in neighboring Oakland. Cohen stood curbside wearing high heels and a bikini and for ten dollars would wash a car. The goal was to raise money to help her complete *Trabantimino*. Her final client of the day was a group of firefighters and their truck; the last scene in the video is of Cohen posing for a snapshot with the group. The men lean with their backs against the front of the vehicle. Cohen faces them, a hand on one shoulder of each of the two men closest to

Installation of *Liz Cohen: No Room for Baggage*, 2008. Photograph by Rubin staff.

Liz Cohen, Polaroid documentation of *Bikini Carwash*, 2002. 3.25" × 4.25".

her, and coquettishly looks back at the camera. She washed forty cars that day and grossed six hundred dollars, which was about the same amount that she spent on window display, hot dogs and stand, T-shirts, and other miscellaneous expenses. The second video, *Bodywork*, is available on YouTube and documents Cohen wearing jeans and a T-shirt behind the wheel of the car, which jerks and groans as it extends. Over the years, Cohen has shaped and reshaped the car and, along with it, crafted her own artistic identity and life. Her story warrants telling as a preamble to a discussion of her exhibition at the Rubin, which drew a masculine crowd attracted to esoteric tools, cars, and seductive images of an attractive woman wearing almost nothing.

## The Evolution of a Lowrider

The idea of creating a lowrider took root not long after Cohen earned her Master of Fine Arts in photography from California College of the Arts (then California College of Art and Craft). Cohen launched the project in 2002 during a residency at Akademie Schloss Solitude in Stuttgart, Germany, the country where the Trabant ("fellow traveler" or "companion") was designed in the

1950s and manufactured until 1991. The Trabant represents a clear German identity (utility, practicality, economy) in the same way that the El Camino represents an American one (muscle, speed, flash). Cohen bought a 1987 Trabant 601 Deluxe in working condition for about four hundred dollars and, with virtually no experience in auto body or engine work, she began.

Its transformation took a leap the following year when Cohen moved back to her hometown of Phoenix. She convinced Don Barsellotti, owner of Elwood Body Works, to provide her, free of charge, a bay in which to work. There she apprenticed with mechanic Bill Cherry, who lent her his tools and took her under his wing. In 2005, Cohen engaged in a three-month-long performance-based exhibition at the gallery Fargfabriken in Stockholm, where she reconfigured the exhibition space as her gym and mechanic shop. There she worked with a personal trainer to recondition her own body to be weightlifter strong and supermodel elegant, and for part of that time, she also worked with Cherry, who traveled to Stockholm, to recondition the car. All this and the culminating photo shoot were open to the public.

In 2008, the artist and *Trabantimino* relocated to Bloomfield Hills, Michigan, a suburb of Detroit, so that Cohen could become the artist-in-residence in photography, a full-time teaching position, at the Cranbrook Academy of Art. It was in the Motor City that Cohen, together with several auto body, upholstery, and engine professionals, worked on the car—first at Kustom Creations and then at Al Sharp's garage—and finished it in September 2010. An El Camino's rear-wheel drive and V-8 engine replaced the Trabant's front-wheel drive and two-stroke engine, which is similar to that of a lawnmower. Six batteries powered the hydraulics. *Trabantimino* debuted in its final iteration in the newly renovated gallery of Salon 94 in New York City. Included in the exhibition was *Proper Planning Prevents Poor Performance*. That this series was part of an exhibition in the art world center two years after its presentation in El Paso marked a minor but notable victory for the prescience of the Rubin.

In *Trabantimino*, action and result are on equal footing as the car morphs from small to large and from European to American. Performance becomes crafted object and photographer becomes model and vice-versa. The American dream is as much about the open road as it is about entrepreneurship and social mobility. The past is left behind when rubber meets asphalt, and the driver-as-protagonist is absorbed by the expanse of the land, her former self distanced with each passing mile. In this sense, the transformed *Trabantimino* facilitates the transformation of its operator. It is a process work that results in a complex machine that literally and metaphorically transports its drivers, viewers, and maker.

116

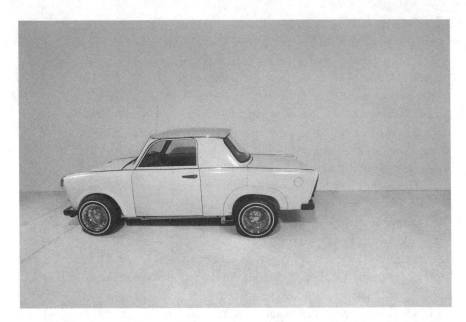

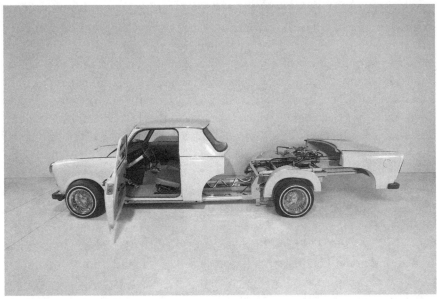

*Top:* Liz Cohen, *Trabantimino* (Trabant position), 2002–2010. Transformer car. 56"
× 112" × 66". Courtesy of Salon 94, New York. *Bottom:* Liz Cohen, *Trabantimino*
(El Camino position), 2002–2010. Transformer car. 64" × 112" × 66". Courtesy of
Salon 94, New York. *Facing:* Liz Cohen, *Trabantimino* and *Proper Planning Prevents
Poor Performance*, 2010. Courtesy of Salon 94, New York.

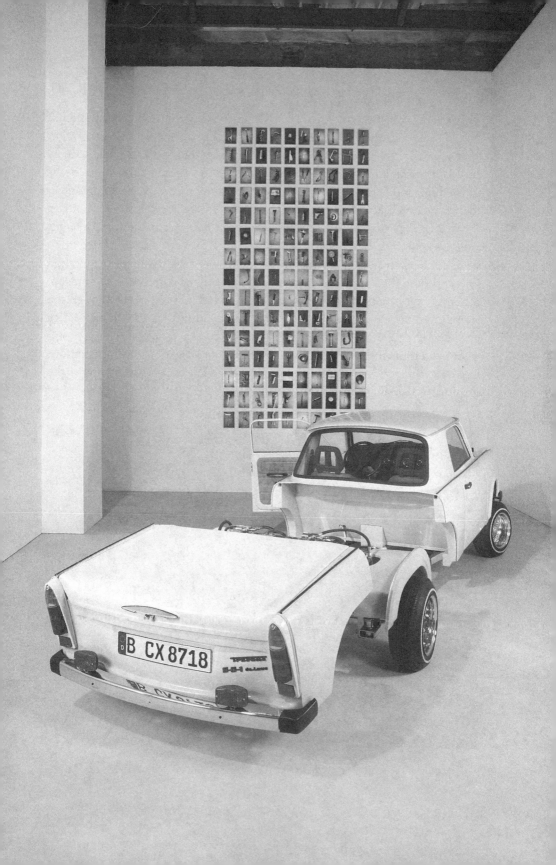

## Art About Place and Boundary

This idea of transformation connects Cohen's art to the Rubin's institutional mission and curatorial identity. Nearly every UTEP student is a first-generation college student; success at university will be the beginning of a life their parents could only imagine. *Trabantimino*'s relationship to Chicano culture also ties it to this time and place because our audience is primarily of that demographic; the lowrider is one of their pop culture symbols. During the run of Cohen's show, *Claiming Space: Mexican Americans in U.S. Cities* was on view in the larger galleries and around campus. (See Chapter 5.) The five artists exhibited there were of Mexican descent and marked or represented the cityscape as a method for expressing their relationship to place. The exhibits complemented one another. Cohen was born in Phoenix of Colombian immigrants. Although she is not Chicana, she is a native of the American Southwest and had immediate and natural access to Chicano images and ideas. She is both insider and outsider and adopts the lowrider as a symbol of what is possible. Both exhibitions expressed the power and potential of change while also supporting one of the Rubin's curatorial foci: art about place.

Liz Cohen, installation of *No Room for Baggage*, 2008. Photograph by Rubin staff.

The tool photographs appropriately dominated the exhibit. Cohen wanted them to emit immediacy and clarity without the intermediary of glass between photographs and viewer. She also insisted that they have the presence of individual objects and also be read as components of a larger unit. Our solution was to create a small ledge for each photo and display them in a grid so wide that it wrapped around nearly half the gallery. They conveyed one of the overarching emphases of Cohen's oeuvre: the complexity and richness of functioning both as an individual and as a member of a group. They also convey the sensibility of having one foot on either side of a defined boundary. This aligns with Cohen's experience as the maker of *Trabantimino*. The artist is academically trained and a professor, but she found a certain level of acceptance in the male-dominated arena of the mechanic shop, one that views academic training with a degree of skepticism. Has she ever felt accepted as part of the auto body shop culture? "I am coming with a different background so I am a different kind of member. I'm not on the payroll, but I stay at these places for a long time so I become a fixture . . . a freak member."

## In the Company of Madonna and Lady Gaga

Inclusion and connection as they relate to empathy interest Cohen. "What makes a person able to care about other people, what makes a group . . . what makes people identify with each other, or empathize with each other, or not?" As mentioned above, before Cohen purchased the Trabant, she photographed transgender sex workers in Panama. Eventually she dressed up and walked the streets along with her subjects, became part of the group while also documenting it, and also became simultaneously herself and other. Also clear are the ideas of charade and deceptiveness of appearance. In Cohen's photographs of herself at work on *Trabantimino* or on break from her labors, she wears a bikini and high-heeled shoes; her fingernails are long and painted. If there are other mechanics featured in the photograph, they are male and dressed as we expect a mechanic to be dressed: long pants, heavy shoes, T-shirt. They look the part, but Cohen is doing the work.

During our discussion about feminism and how she sees herself addressing feminist concerns, Cohen stated, "There is this woman named Dazza del Rio, who is the Madonna of lowrider bikini modeling. . . . This woman is probably in her late forties or early fifties. She is still doing the modeling. She sells her calendars. She is a huge enterprise. She was one of the early models and I would say even if she doesn't care about the same things that I care about, she is a pretty empowered person." This comment not only exemplifies Cohen's

expansive view of who is a feminist, it also opens the conversation about if and how her strategies run parallel to those of pop stars such as Madonna and Lady Gaga who dress or undress to highlight a certain aspect of who they are or to become someone else. I asked her about this comparison and she responded, "They have such a good control of theater and persona, but I don't really think that's where my artwork comes out of. . . . I'm inspired by people's courage."

When I asked Cohen whether she saw Madonna's and Lady Gaga's performances as more of a masquerade or a transformation, she responded:

> They are doing something even more interesting. Pop culture is an exercise in sampling and producing a certain group of values. . . . It's not what I am doing. . . . I'm not about this quick change. . . . The meaning from my work comes through how long it takes to do it because it's this whole journey . . . there is an endurance aspect. . . . The value for me is in the discovery. . . . I wouldn't do the projects if I knew the answers or what was going to happen. . . . I think Lady Gaga has a pretty good grasp on exactly what . . . buttons she's going to be pushing. It's not an exploration. That's not her goal.

The link between Cohen and Gaga is a shared commitment to an ongoing discovery of the potential of self and others. According to Gaga, *"Born This Way* is about being able to be reborn, over and over again throughout your life. . . . I do see myself to be in an endless transformative state."[6] The performer debuted prosthetic horns on her forehead, cheeks, and shoulders during Grammy week 2011. These are "my bones . . . [that] have always been inside of me, but I have been waiting for the right time to reveal to the universe who I truly am."[7] Both artists trust their audience to understand that whatever aspect of them a given artwork reveals, it is only one of many in a complex identity. And both exude a fearless self-confidence.

## Parade Dreams

Cohen's mention of endurance begs the question of what comes next. *Trabantimino* and its associated photographs and performances have defined her artistic practice since 2002. She may not leave it behind yet; she has expressed interest in driving *Trabantimino* as the lead in a lowrider parade. If this were to come to be, it would not be the first time that Cohen has engaged the lowrider community. In 2007, in conjunction with *Car Culture*, an exhibition at Scottsdale Museum of Contemporary Art where *Trabantimino* was being exhibited in its

yet-to-be-completed state, Cohen organized "Radical Mod," a one-day gathering of lowriders in and around the museum, featuring music, a fashion show of lowrider garb, and a demonstration of the car extending. A publication about each of the featured lowriders and their owners documents the event.[8]

In conjunction with *No Room for Baggage*, Cohen wanted to build upon this precedent by organizing a lowrider parade along Highway 28, the historic road that runs parallel to I-10 through the rural Mesilla Valley and connects El Paso to Las Cruces. Small towns all along the way punctuate the fields of chilies, onions, cotton, and pecan trees, with their luscious green canopy that shades much of the route. This would also support the Rubin's goal of connecting to and expanding its community.

During the two weeks that Taylor and Cohen were printing the tool photographs in July 2008, Taylor called a lunch meeting with the two of them; staff from El Paso Museum of Art, which is a municipal museum in downtown El Paso; staff from the City of El Paso's Museum and Cultural Affairs Department, who are in charge of public art and outdoor art festivals; and me. We asked the city representatives if they might like to be UTEP's partner in a parade. The plan: one autumn weekend during the run of the Rubin exhibition, we would host a parade starting in Las Cruces and concluding in the plaza outside the El Paso Museum of Art, complete with festival and party. Afterward, the car could be exhibited at the El Paso Museum of Art. Although the Rubin's facility cannot accommodate a sculpture the size of an automobile—its doorways and galleries simply are not large enough—*Trabantimino* could drive into the Museum of Art unfettered. The car downtown and *No Room for Baggage* on campus would be complementary exhibitions. We would share our financial and human resources, our marketing prowess, and our audiences. Not only would it be a citywide celebration, it would also be a formative project in Cohen's career.

It never happened. Lead time was too short and financial resources too limited. The Museum of Art opted instead to present Cohen's bikini photographs in a small exhibition, *The Builder and the Bikini Model*, in fall 2009, a year after *No Room for Baggage*. In conjunction with the September opening reception, the Museum invited lowriders to gather in the plaza and several did. Cohen was not present for that, but she came the following month for a public presentation. In it, she covered different territory from that which she had covered in her presentations at UTEP. She discussed how her work fit into the history of photography, and she showed examples of her newest photographs, completed the prior summer, which were set in the former Trabant factory in Stuttgart. In these self-portraits, she is costumed in one-piece swimsuits, which

are slightly more Eastern European in sensibility than a bikini. In one, she holds a sickle and hammer, symbols of the Soviet Bloc. In another, she poses in a standing back bend like that adopted by Romanian gymnast Nadia Comaneci in a photograph that circulated for a few years after she swept the gold at the 1976 Olympics. In *Proper Planning Prevents Poor Performance* Cohen references Evans's series published in *Fortune*. Here she once again draws upon historical precedent. Cohen and I chatted after her presentation at the Museum and she confided in me: "I'm done photographing myself. This is it."

Cohen and I spoke on the telephone in June 2011. Just hours before our conversation, she had gotten word that she had earned a twenty-five-thousand-dollar grant from the Kresge Foundation toward the realization of her next project, a film about moral dilemmas and the process of making a choice when there is no good choice. One of her goals is to broaden her audience. "Whatever unfolds," said Cohen, "it won't be as long of a project as the car."

*Trabantimino* was featured in the January 2011 issue of *Automobile* magazine. It was also featured on the Artforum blog in October 2010, testament to its acceptance by visitors to an automobile trade show as well as attendees of a contemporary art exhibit.

Have the twain met prior to this? Maybe not, but *Trabantimino* is the little engine that could. It transgresses boundaries with a rare combination of conceptual weight and public appeal. It challenges and encourages us to be greater than we ever dreamed of being and to believe in our own ability to change and develop. As this compact, beige, Communist car body expands to become a long and strong El Camino, it exudes a faith in people to reach the unreachable. In the words of Cohen, "I am interested in this idea that people can be multifaceted and . . . have integrity and have a unified self, but not be pigeonholed." The artist not only espouses this position, she also lives it. *Trabantimino* is proof.

# 7

## Margarita Cabrera

*To Flourish*
*2010*

When I first met Margarita Cabrera in 2001, she was experimenting with making impressions of teeth and presenting them as sculpture. Her work, titled *Piled Up Tension Along the Rio Grande*, implied dental records as a method for identifying a corpse when the rest of the body was unrecognizable, usually due to a brutal death. At the time, Cabrera was artist-in-residence at the Border Art Residency in La Union, New Mexico, which is about a twenty-minute drive northwest of El Paso. Born in Monterrey, Mexico, and raised in Mexico City, Cabrera moved to Salt Lake City at the age of ten with her family when her father's job transferred him to the United States. When Cabrera was in her teens, she relocated with her family to El Paso.

Cabrera earned an MFA at Hunter College at City University of New York in 2001. The Border Art Residency brought her back to the borderlands and entitled her to uninterrupted time to pursue her artwork in a one-thousand-square-foot studio in a loft constructed in a former cotton gin overlooking a fragrant peach orchard. There she launched the body of work that would move her toward maturity as an artist. A simplistic description of these early sculptures is "household appliances rendered soft." But they address the economic and social environment of immigration and of the border, subjects that Cabrera continues to pursue more than a decade later in a practice that includes Marxist-style community art production and that consequently raises questions about artistic ownership and authorship.

Cabrera earned a two-year-long display (2011–2013) of her sculpture at the El Paso Museum of Art, which is less than a mile from the university. I have never exhibited her art, but I have followed Cabrera's career closely over the years and attended many of her exhibitions. I appreciate how her sculptures unite political content with a strong physical presence. Cabrera has exhibited extensively and in high profile, especially in Texas, and tackles border issues via innovative methods. Consequently, her art fits comfortably with that of the other artists addressed in this book.

## The Larger Meanings of Small Appliances

In 2001, upon her return to the El Paso area, Cabrera began visiting and researching the many maquiladoras located in Juárez. These assembly plants blossomed with NAFTA, offering cheap labor to U.S.-based multinational corporations. Cabrera was most intrigued by the maquiladora that assembled small household appliances such as blenders, mixers, and vacuum cleaners. Gathering pre-made parts into final products, the workers actually manufactured only the plastic elements, which are the most noxious to make. In order to bring attention to this border industry and its environment of toxicity and exploitation, Cabrera began creating sculptures from these household appliances. She replaced the made-in-Mexico plastic parts with colorful, stitched vinyl fabric, keeping the original appliances' metal, glass, and electronic parts intact.

The maquiladoras enticed workers from all around Mexico to the border; many young women relocated to Juárez, primarily from rural communities. Because they were separated from their families and other systems of support and were unfamiliar with urban life, they were vulnerable to crime. Many were kidnapped, raped, and killed as they left work. These femicides continue at the time of this writing, though they no longer have the attention of the mass media, now dominated by the drug wars. Family members of the victims have posted pink crosses throughout the city as symbols of resistance. Directly referencing the femicides, Cabrera's *Blender* is pink, its on and off buttons look like toes, and its upright form is decidedly figurative.

Though these sculptures bring to mind Claes Oldenburg's Pop Art renditions of domestic machines, their conceptual intentions are completely different. Compare, for example, Cabrera's *Batter Mixer* (2003) with Oldenburg's *Soft Dormeyer Mixer* (1965). On the one hand, Oldenburg undermines the scale and form of the mixer by making it completely flaccid and oversized at thirty-two inches high. Cabrera, on the other hand, retains the structure and scale

of the original appliance and replaces only certain parts. In Oldenburg's sculpture, the mixer's beaters reference a woman's breasts. By anthropomorphizing and eroticizing the object, Oldenburg contradicts its cool, industrial character. Cabrera highlights the manufactured quality of the mixer because her handmade parts sag, drawing a sharp contrast with the original manufactured features. Oldenburg's muses were fast food and junk merchandise, but Cabrera celebrates handcraftsmanship. She stitches yellow vinyl with red thread, for example, and leaves it hanging, as if forgotten, an action that emphasizes labor and the handmade, which in today's postindustrial world is usually disregarded as a relic of the past. Cabrera describes *Batter Mixer* and her other small appliances as figural representations of the maquiladora employees, "exhausted, empty, coming undone."[1] Whereas Oldenburg toys with the surreal, Cabrera is firmly rooted in today's realities.

### Vocho

In summer 2004, Cabrera placed an ad in the *El Paso Times*, the city's daily newspaper, soliciting expert seamstresses. The artist could manage the fabrication of the appliances on her own, but now she wanted to "replicate" a Volkswagen Beetle (*vocho*), and this required more hands. She received an unexpectedly large number of responses from people formerly employed in the garment industry that prospered in El Paso prior to the passage of NAFTA. That same summer, I visited Cabrera in her temporary studio in a corner of a building the size of an airplane hangar. The building was being used as a storage facility and as the headquarters of a cross-border transportation company. There were a couple of women working with Cabrera as she prepared for a solo exhibition at Women and Their Work in Austin and for Art Basel Miami Beach, which has developed into the most prestigious art fair in the Americas. She spoke of labor, handiwork, and what the *vocho* represented to her.

For about thirty years, the original Volkswagen Beetle was manufactured in its entirety in Puebla, Mexico; the last one rolled off the assembly line in 2003. The Volkswagen plant not only created jobs for many Mexicans, it also provided them with personal and inexpensive transportation, truly a "people's car." Consequently, the *vocho* had attained the status of a national symbol of mobility and liberation. Cabrera's *Vocho* follows the precedent of the appliances in the sense that the artist fabricates the parts made in Mexico in brightly colored vinyl and combines them with some actual automobile parts. She uses a fabric typically reserved for a car's interior to fashion its exterior elements, bringing

Margarita Cabrera, *Vocho (yellow)/Yellow Bug*, 2004. Vinyl, thread, car parts. 60" × 72" × 156". William J. Hokin Collection. Photograph by Hermann Feldhaus.

the inside out, exposing it. The fabric hangs limply from its frame. The interior is empty as if rotten, a nod to the dystopia that dominates politics in present-day Mexico. Cabrera and the assistant seamstresses eventually created several sculptural renditions in fabric of large-scale and familiar "machines," including three *Vochos* (red, yellow, and blue) and a Hummer, which was originally a military vehicle. It hit the civilian streets initially as a symbol of status and later as one of extravagance and waste.

Cabrera's interaction with these women generated ideas for her art. Their stories prompted her to think about the implications of NAFTA and how it had changed the lives of the people with whom she now interacted on a daily basis. "The work became more focused on others telling their stories and not so much about my attempt to portray those challenges," states the artist.[2] This community of producers was to become the subject, audience, and underlying motivation for Cabrera's art. Thus, *Vocho* served as a transition between Cabrera's focus on global industries with production in Mexico to her focus on human mobility, immigration, and humane working conditions.

## Florezca

In late 2010, about six years after the first *Vocho*, Cabrera created a for-profit, multinational company under the moniker "Florezca" ("to flourish") and incorporated it in the State of Texas. The corporate mission is multifaceted. A promotional brochure created by Cabrera states that Florezca empowers Mexican nationals on both sides of the border, some of whom, along with groups of volunteers committed to the various museums and galleries where Cabrera exhibits, to come together in workshops to create art.

How does Florezca work? The answer to this question will be instrumental to the direction and meaning of Cabrera's art. The company is rooted in her desire to create opportunities for visual expression for Mexican Americans and Mexican nationals, as well as to support the craftspeople of Mexico. My understanding of Florezca—based on Cabrera's explanations via face-to-face communication, e-mails, and the promotional brochure—is as follows: Florezca coordinates community workshops and the people who participate in these workshops produce art objects. The workshops are differentiated from each other by subject matter and material, including: *Tree of Life* (*Arbol de la Vida*) (clay), *Craft of Resistance* (copper), *Space in Between* (embroidered textiles and soft appliances). The artist began each of these bodies of artwork on her own before she launched the community workshops and before Florezca was incorporated.

*Pulso y Martillo / Pulse and Hammer* (copper and performance) (2011) was the first workshop to take place after Florezca was born. Commissioned by Sweeney Art Gallery at the University of California, Riverside, Cabrera collaborated with workshop participants in the creation of art based on her knowledge of craft practices in Mexico. Later that year, *Cotton Circles* opened at the Center for Creativity and the Arts at California State University, Fresno. For this work, Florezca successfully secured a visa for artisan Luisa Monica Nambo Torres to visit Fresno and guide local participants in the traditional weaving technique of her hometown of Santa Maria de Huazolotitlan: makers sat in a circle around a tree to execute textile work. Cabrera will adapt the subject and materials of future Florezca workshops to the participants and the location. Cabrera plans for participants in the workshops to become shareholders in Florezca and to earn a portion of the profit on sales of all Florezca artwork.[3] Worker control makes Florezca, as Cabrera envisions it, a Marxist-style group endeavor in the sense that Lenin-style Marxism recommends a classless society controlled by direct producers.

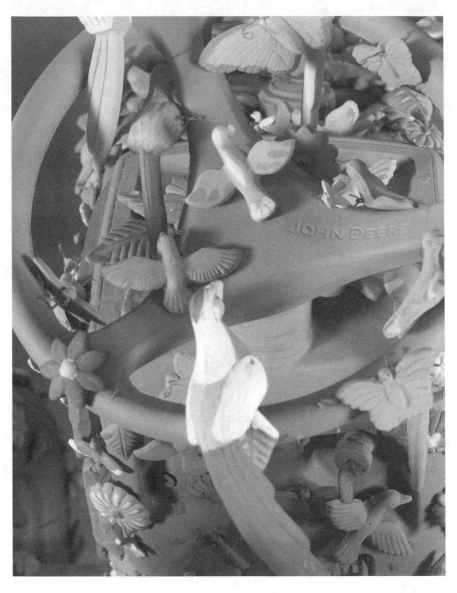

Margarita Cabrera, *Arbol de la Vida—John Deere Model #790*, detail, 2007. Clay, slip paint, latex acrylic, and metal hardware. 100" × 60" × 96". Photograph by Shaune Kolber.

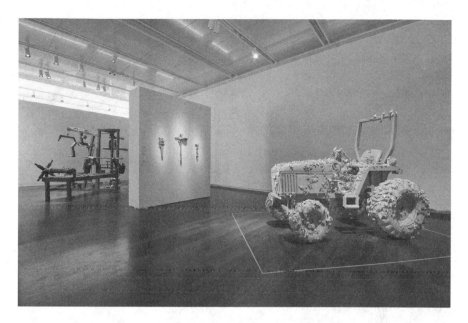

Margarita Cabrera, *Arbol de la Vida*, as installed in *New Image Sculpture* at McNay Art Museum, San Antonio, Texas, 2011. Photograph by Michael J. Smith. (Sculpture by OK Mountain in the background.)

One of the first workshops that laid the foundation for Florezca took place two years before the corporation was even a glimmer of an idea. In 2008, Cabrera was a resident artist at Artpace in San Antonio and there she conceptualized and realized *Craft of Resistance*. She set up several workstations in the gallery and invited members of the San Antonio community to re-create a production line typical of a maquiladora environment. Under her guidance, they created twenty-five hundred life-sized copper butterflies, inspired by the metalsmithing traditions of the people of Santa Clara del Cobre. Cabrera had visited this village in Mexico, and she taught the San Antonio participants how to craft the butterflies—in effect, sharing traditional craft techniques and extending their life and impact. The gallery exhibition was a process and performance piece with multiple participants. After it closed, Cabrera installed the butterflies in the home of an Artpace patron. The piece was viewable only on select visits arranged by Artpace. In this respect, *Craft of Resistance* represented a reversal of standard practice. Usually art is created by the artist in isolation and then exhibited in public. Here the creative process was on display in the public gallery space, and its results were presented in a private domestic space. Thus, *Craft of Resistance*, as it was realized in San Antonio, represented and

emphasized the gap between consumption and production in the post-NAFTA environment. Makers typically do not enjoy the fruits of their labor because the products they assemble are inaccessible to them due to price or because the items are shipped to faraway retail environments.

El Paso Museum of Art also exhibited the butterflies in a 2011–2013 solo exhibition for Cabrera. They perched on multiple surfaces. A swarm of them on the main, thirty-foot-high wall gradually dispersed into smaller groupings on pillars and the ceiling. Monarch butterflies migrate from Mexico north in the spring and back again in the fall. These copper renditions are the results of Cabrera's first workshop and symbolized the movement of myriad species defiant of political boundaries.

In early 2010, Cabrera conducted a *Space in Between* workshop at BOX 13 ArtSpace in Houston, Texas. It was during this workshop that the concept for *Florezca* took root. Cabrera provided workshop participants with new and

*Facing:* Margarita Cabrera, *The Craft of Resistance*, detail of installation, 2008. Twenty-five hundred copper butterflies at 2" × 3" each. Dimensions variable. Photograph by Todd Johnson. *Left:* Margarita Cabrera, *The Craft of Resistance*, Artpace, San Antonio, Texas, 2008. Dimensions variable. Photograph by Kimberly Aubuchon.

used U.S. Border Patrol uniforms. The task for the workshop was to construct soft sculptures of desert plants from the uniforms and then embroider them with personal, visual narratives in a style based on the tradition of craftspeople in Los Tenango de Dorio, Hidalgo, Mexico.[4] Cabrera then transported the sculptures to Marfa, Texas, where they were exhibited with *In Lieu of Unity*, a group exhibition at Ballroom Marfa in spring 2010. *Space in Between* works dominated the floor space in the group exhibition. Human sized, they confront the viewer. Their handmade quality, three dimensionality, and solid presence differentiated them from the photography, video, and documentation of performances by the other nine artists in the show. When I visited the exhibition, I was struck by the fact that it would not have held together visually without *Space in Between*; the sculptures were its heart and its unifying force.

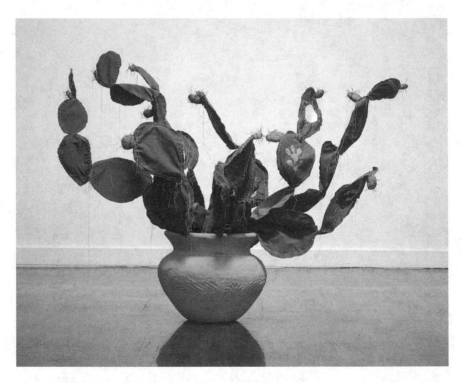

Margarita Cabrera, *Candelaria Cabrera: Nopal*, from series *Space in Between*, 2010. Embroidered border patrol uniform fabric, thread, vinyl, wire, foam, and terra cotta pot. 41" × 59" × 34". Photograph by Fredrik Nilsen.

## Pulse and Hammer

*Pulse and Hammer*, a solo exhibition at Sweeney Art Gallery in 2011, centered around *Craft of Resistance*, but the resulting work, also titled *Pulse and Hammer*, was performance-based. Even though Cabrera had previously collaborated in workshop format, this was the first Florezca workshop. On the night of the opening, in the soaring atrium of the University of California, Riverside Culver Center of the Arts, which is housed in a newly renovated late nineteenth-century former department store and includes the Sweeney Art Gallery, about thirty people stood around a rectangular table that supported two large flat sheets of heavy-gauge copper in its center. Each member of the group swung a sledgehammer and hit the copper, one after the other, in increasingly rapid succession, so the sound increased in volume and intensity as the performance progressed. Cabrera worked with Jason Heath, a PhD student in the music department, to develop the orchestration for the performers. The intense labor required to swing the heavy sledgehammers in orchestrated rhythm suggested a unified effort on the part of workers. About half of the participants were Mexican nationals residing in the United States, many of them enrolled as students at the University of California, Riverside.

In April 2011, I telephoned Tyler Stallings, director of the Sweeney Art Gallery and curator of the exhibition, to cull more details. Stallings's introduction to Cabrera's art came in 2007 at the Walter Maciel Gallery in Los Angeles. "It stuck with me," he stated, "and I knew I wanted to work with her in some capacity. U.S./Mexico relations are always on my mind. [And I appreciate] her interest in craft and her love of object making and how she brings that together with political and social ideals."[5]

Stallings got the ball rolling with a fifteen thousand-dollar grant for *Pulse and Hammer*.[6] As he noted, "There is a huge population of undocumented students in the University of California system." Cabrera discovered this during brainstorming meetings with graduate students, faculty, and some community-based organizations on the first of her two site visits to the campus in preparation for the exhibition. On her second visit, in November 2010, Stallings recalled that she "floated the idea of Florezca, Inc. She was still figuring it out. She wanted to work with undocumented people . . . [to create an opportunity] for them to have a voice in the U.S. I was interested in this idea."[7] The exhibition at the Sweeney consisted of select works going back to 2003, including stitched works from *Space in Between*, the copper butterflies from *Craft of Resistance*, workbench stalls simulating a maquiladora environment, ceramic work from the *Tree of Life* series, video documentation of the *Pulse and Hammer*

performance, copper artifacts that resulted from that performance, and *Mexico Abre La Boca/Mexico Opens Its Mouth*, a street vendor's cart that sold inexpensive handicrafts from Mexico and distributed brochures on the development and purpose of Florezca. The Sweeney commissioned both *Pulse and Hammer* and *Mexico Opens Its Mouth*, so these two works were shown there for the first time.

After the *Pulse and Hammer* performance, the Sweeney reconfigured the platforms that had supported the copper sheeting for the performance into a circular table, "twelve feet in diameter and in a Spanish Colonial style," wrote Stallings. "The table became the gathering point for a mock meeting of the Florezca board of directors, an event that served as a second performance piece titled *Florezca, Inc. Boardroom Table*, where the participants tried to speak over each other until they each gave up and stopped."[8] These participants played speaking roles, such as immigration, security, and corporate lawyers; immigrant; artisan; curator; and artist, among others. The vocal performance required both endurance and commitment.

*Florezca, Inc. Boardroom Table* was pure theater, but it also served as a metaphor for Florezca's goal of providing each person with a voice. A document about Florezca, which is downloadable from the Walter Maciel Gallery, states: "On March 5, 2011, Cabrera held a symbolic performance of a 'board meeting' [at this table] to launch the beginning of FLOREZCA . . . with an eye to creating new works, new working conditions, new markets, and new ways of approaching US-Mexico relations."[9] These goals are nearly as immense as those iterated by Karl Marx. "New working conditions" and "new markets" smack of his indictment of the isolation inherent to capitalism.

## Historical Precedents

Marx had little to say about art because he believed that human existence is determined by economic forces and by a struggle among classes of society for control of material resources and means of production. But Peter Bürger's classic text, *Theory of the Avant-Garde*, is a Marxist critique on bourgeois art that is produced and consumed by individuals. In Bürger's typology, sacral art is the most palatable because it is produced by a group in a manner that he describes as "collective craft." A group of people, or congregation, also receives it. But art of this type that is absorbed and accepted by society loses its capacity to critique.[10] The distance ascribed to individual experimentation, as championed by Modernism, is what permits social analysis, which is precisely what Cabrera is engaged in.

In addition, Cabrera, like any artist working today in community or social practice, struggles against the Modernist paradigm that privileges market forces and individual authorship. The museum world and the marketplace identify Cabrera's art with her as an individual artist, not with Florezca, though this situation continues to evolve. Plus, corporations such as Florezca are inherently capitalist entities, antithetical to worker control. There are many forces pulling against each other in what Cabrera is attempting to achieve. "I don't think Margarita has completely worked out issues of authorship," I said to Stallings during our conversation. "Is it Florezca or Cabrera?" He responded, "Well, that will be important for her to figure out."

We can look to Englishman John Ruskin, Marx's contemporary, for another ideological framework for Cabrera's art. Ruskin argued for a reconnection to nature and the manufacture of objects in a manner that allowed the individual worker to use his own powers of invention. His follower William Morris tried to apply these ideas to a commercial venture and established a design firm for interior furnishings that launched the Arts and Crafts movement. "Have nothing in your houses that you do not know to be useful or believe to be beautiful," he stated.[11] Handmade objects would come together to create aesthetically pleasing interiors that would ultimately foster a contented and responsible citizenry. Marx, Ruskin, and Morris all lived during the Industrial Revolution, when people were migrating from farms to factories. Cities grew. Industry forced economies and means of production into a state of flux. NAFTA and globalization have done this, too, and Cabrera's art recognizes this.

Collective ownership is part of Marx's message, and collective production is a component of the Arts and Crafts movement. When the movement migrated to the United States and Arts and Crafts potteries such as Rookwood and Fulper were established, for example, many people were involved in the creation of a single piece: the mold maker was different from the decorator. The identity of the individuals on the team usually did not determine the value of the object. A Rookwood Pottery vase was, and still is, identified with Rookwood, not with the specific people employed there. The same might be said, in part, for the Mexican craftspeople celebrated by Cabrera in her workshops: though all makers are acknowledged, it is the Mexican village where they live that carries name recognition. Cabrera seems to have this in mind for Florezca, and it is possible that the authorship will eventually shift from Cabrera to the corporation.

## Austin

A few days after my conversation with Stallings, I attended a panel discussion sponsored by *Art Lies: A Contemporary Art Journal* at the Blanton Museum of Art at the University of Texas in Austin in conjunction with the exhibition *Texas Biennial: An Independent Survey of Contemporary Texas Art*. The title of the panel was "Like a Whole Other Country? The State of Contemporary Art in Texas." The panelists were Cabrera, Alison de Lima Greene (Curator of Contemporary Art and Special Programs, Museum of Fine Arts, Houston); Trenton Doyle Hancock (artist); Dr. Richard Shiff (Effie Marie Cain Regents Chair in Art, University of Texas at Austin); and David Pagel (*Los Angeles Times* art critic). It was a distinguished crew. Shiff contended that the narrative tradition in Texas art related to the state's overall strength in literature and music. Pagel claimed—and de Lima Greene agreed—that Texas art was no different from any other art during this time of increased decentralization in the art world. Hancock referred to the natural landscape of Texas and his connection to it. Only Cabrera challenged her fellow panelists and the primarily Caucasian audience of about one hundred people. (Though it is impossible to discern a Mexican or Mexican American by appearance only, it is very possible that she was the only one in the room.) "It's all here," she said. "We just need to be more inclusive. Look at this audience for example. We should start in the schools and make it grow from there. If we did that, the demographic of the Biennial would be more reflective of that of Texas." She was referring to the fifty-plus artists participating in the Biennial exhibit. Pagel supported Cabrera's point and chimed in that by being more accurate to the demographic of the region, the show would be more global. Texas is about 40 percent Hispanic. Inclusion is Cabrera's message.

*Mexico Opens Its Mouth* was stationed in an empty parking lot in downtown Austin directly after the panel discussion. The Texas Biennial promotional literature marketed it as a piece by Margarita Cabrera. It was a silver street vendor cart, identical to the one exhibited at the Sweeney Art Gallery, selling crafts made in Mexico, ranging in price from around two dollars to about ninety dollars. Proceeds went back to the makers.

Similar projects and initiatives have been around for a while, where third-world craftspeople market their work in the first world via a benevolent go-between. For example, not long ago the *Martha Stewart Show* featured baskets woven by Rwandan widows and sold at Macy's. At the Sweeney, a banner emblazoned with "Florezca" hung from the cart when it was exhibited. In Austin,

there was no such banner: the cart was not accompanied by any signage due to an oversight on the part of the Biennial's organizers. If passersby were not familiar with the Texas Biennial, they were not aware that the cart was an artist's project until they either engaged in conversation with the performers, who acted as sales attendants, or read the brochures at the stand.

René Paul Barilleaux, chief curator at the McNay Art Museum in San Antonio, also attended the Biennial events and I asked him about *New Image Sculpture*, the exhibition he curated in spring 2011 at the McNay. He had included works by Cabrera from *Tree of Life*: several farm tools and a full-scale, limited edition, fired-clay replica of a tractor. Cabrera fabricated plaster molds of the various components of the tractor, slipped cast clay into the molds, fired the clay components, and then built the ceramic replica by combining the components over a steel armature. Attached to the surface are three-dimensional clay flowers, birds, and butterflies that, in Cabrera's words, "reference the Mexican 'tree of life' and the agricultural industry in the U.S. where many Mexicans are employed as laborers." Barilleaux explains that "Cabrera links her use of clay to the ceramic productions of Mexico's pre–Hispanic Olmec civilization, instantly connecting past and present."[12] Plus, representational art creates a point of entry for viewers because they recognize what they see. Cabrera's art supports her message of inclusion in part because it is image-based.

## Conversations about Authorship

Cabrera has in the past employed the skills of UTEP ceramics students in the execution of the sculptures from this series. Does the fact that the making process was exclusive and skilled dilute the work's message? Would it have better honored farmworkers if farmworkers had assisted in its creation, given the position of inclusion that Cabrera has postulated so strongly in her recent collaborative work?

I wanted clarification and so asked Cabrera to lunch. The theme of the *Tree of Life* is now listed as one of the workshops offered by Florezca. This potential workshop has not yet been realized in collaborative form. Cabrera explained that when the art is created in a Florezca workshop, it will bear the same theme as it has before, but it will also credit the names of all the participants involved in its creation. When the tractor and tools were exhibited at the McNay, however, they appeared with Cabrera's name on the wall label, press release, website, and exhibition catalogue. The authorship of past work in this series is different from the authorship of future work in the same series. I asked

her about this. "Florezca did not exist when I made the tractor that is now at the McNay," she explained. "But work in that series *could* be made in a workshop environment and I would like to do a *Tree of Life* workshop someday."

I asked how she began each workshop. "For *Space in Between*, for example, do you assign the task of creating a desert plant and then embroidering on it?"

"No," answered Cabrera, "they can do whatever they want. In Houston, one of the participants had crossed in East Texas and he wanted to create a plant more typical to that region, so he did."

"So why was *Space in Between* labeled 'Margarita Cabrera' rather than 'Florezca' when it was exhibited at Ballroom Marfa?"

"Because Florezca did not yet exist."

"How do the vendor's cart and the crafts made in Mexico fit in?"

"It is another way that Florezca empowers Mexican artisans by opening a market to sell their craft within the visual art world."

"How will you determine whether a sculpture is made by you or by Florezca?"

"If it is made in a Florezca workshop, it is Florezca. If it is made by me or by me with assistants, it is Cabrera."

"What is the difference between a workshop participant and an assistant?"

"Workshops are organized and a community-based organization is usually involved in finding the participants. They have input. On the other hand, I hire assistants if I need help executing my own ideas. For example, right now I am making some of the appliances for Smithsonian American Art Museum. I am making these myself. But, in my studio, I have also produced work with assistants, such as the tractor."[13] For the Florezca workshops, the makers share authorship.

## Creating a Market

Walter Maciel, Cabrera's L.A.-based dealer, offers further perspective. We met for a bowl of noodles before Cabrera's opening at the El Paso Museum of Art in summer 2011. "The nature and concerns of Margarita's work can easily be adapted to a workshop format. One of the big advantages of Florezca is that the corporation can apply for visas to bring craftspeople from Mexico to lead workshops in the U.S."[14] For past workshops, Cabrera traveled to Mexico to learn from the artisans and brought that information back to the United States. Now the artisans can come here on temporary visas. *Cotton Circles* was one example.

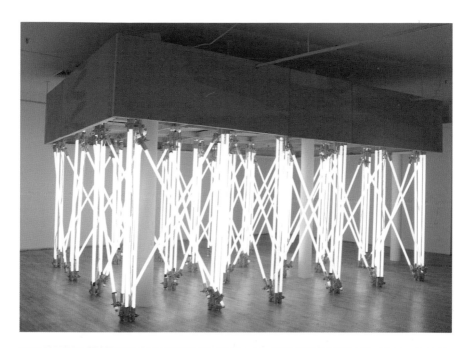

*Top:* Alejandro Almanza Pereda, *Andamio*, 2007. Fluorescent lightbulbs, forged steel clamps, ballasts, wood. Dimensions variable. *Bottom:* Alejandro Almanza Pereda, *Ahead and Beyond of Everyone's Time, Space and Rhythm*, detail, 2009. Table, silverware, chinaware, candles, cutlery, flowers, napkins, cups, vase, tabletop, chandeliers, disco ball, dimensions variable.

Marcos Ramírez ERRE, *Crossroads (Tijuana/San Diego)*, 2003.
Aluminum, automotive paint, wood, vinyl. 144" × 40" × 40".

*Top:* Marcos Ramírez ERRE, *La Multiplicación de los Panes/ The Multiplication of the Bread*, detail, 2003. Mixed media installation of light boxes, Persian rug, bread, stones, wood, and sand. Dimensions variable. Photograph by Marty Snortum. *Left:* Marcos Ramírez ERRE, *New Rulers*, 2005. Lambda print on paper. 59" × 70". Photograph by Marty Snortum.

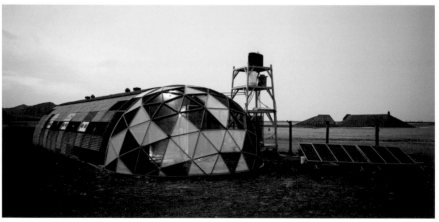

*Top:* SIMPARCH, *Hydromancy*, 2007. Detail of water distillers and pipeline to the Rubin. Photograph by Marty Snortum. *Bottom:* SIMPARCH, *Clean Livin'*, 2003–ongoing. Quonset hut plus surrounding structures, historic building, conventional and alternative building materials, found objects. 120" × 240" × 576".

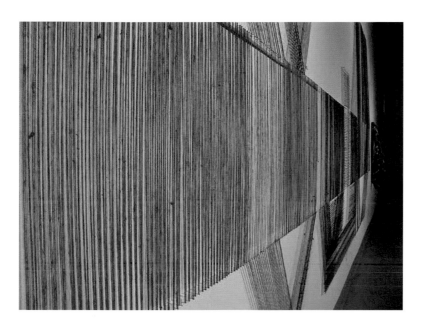

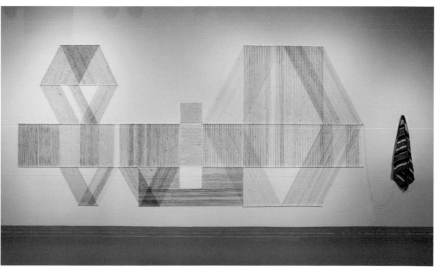

Adrian Esparza, *Otro Lado/The Other Side*, 2008. *Serape*, nails. 98" × 252".
Photographs by Marty Snortum.

*Left:* Adrian Esparza, *Preparatory Sketch for Converting*, 2008. Ink and masking tape on Mylar. 24" × 36". *Bottom:* Adrian Esparza, *Converting*, 2008. Crushed polyester velvet. 288" × 128". Photograph by Marty Snortum.

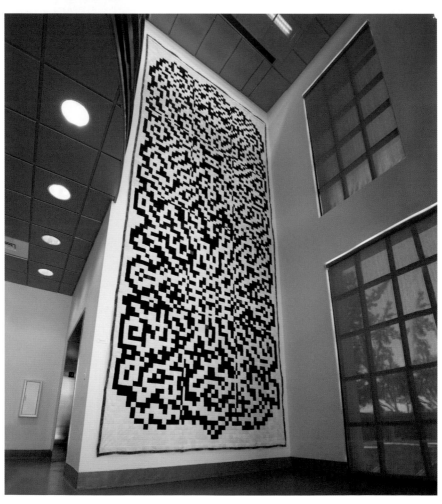

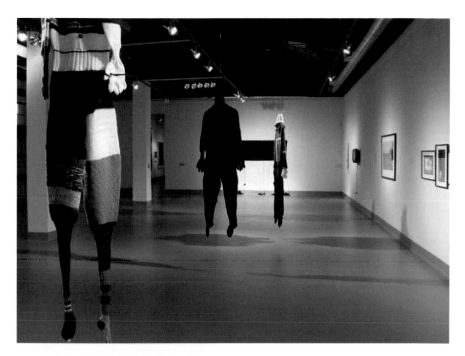

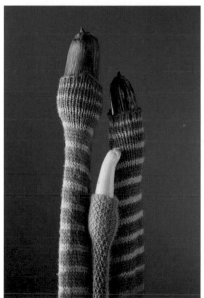
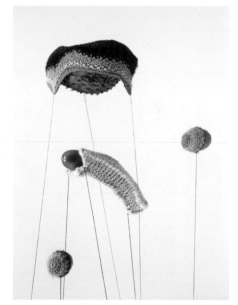

*Top:* Installation of *Unknitting*, 2008. Photograph by Rubin staff. *Bottom Left:* Sandra Valenzuela, *Media Noche 1/In the Dead of the Night 1*, 2007. Lambda metallic print. 36" × 27". *Bottom Right:* Sandra Valenzuela, *Media Noche 3/In the Dead of the Night 3*, 2007. Lambda metallic print. 36" × 27".

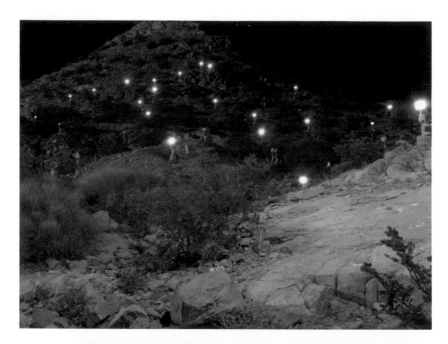

*Top:* Leo Villareal, *Solar Matrix*, 2008. LED lights with cellular technology. Dimensions variable. Photograph by Marty Snortum. *Bottom:* Noah MacDonald / Keep Adding, *Stare Well*, Fox Fine Arts Center at the University of Texas at El Paso, 2008. House and spray paint. Dimensions variable. Photograph by Marty Snortum.

Julio César Morales, *Narquitectos 4*, 2009. Ink and spray paint on vellum. 36" × 24".

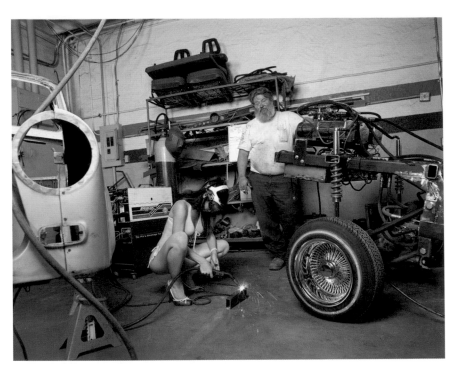

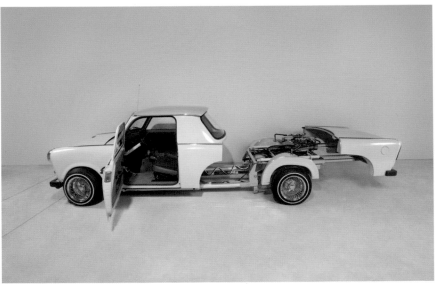

*Top:* Liz Cohen, *Welder,* 2005. Archival ink-jet print on paper. 36" × 46". *Bottom:* Liz Cohen, *Trabantimino* (El Camino position), 2002–2010. Transformer car. 64" × 112" × 66". Courtesy of Salon 94, New York.

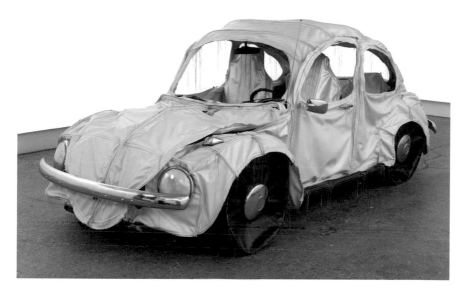

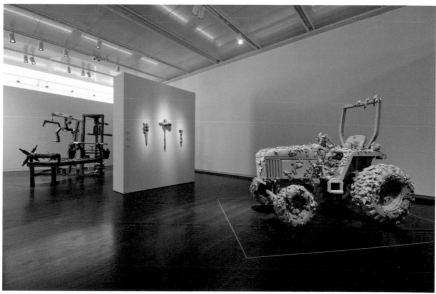

*Top:* Margarita Cabrera, *Vocho (yellow)/Yellow Bug*, 2004. Vinyl, thread, car parts. 60" × 72" × 156". William J. Hokin Collection. Photograph by Hermann Feldhaus. *Bottom:* Margarita Cabrera, *Arbol de la Vida*, as installed in *New Image Sculpture* at McNay Art Museum, San Antonio, Texas, 2011. Photograph by Michael J. Smith. (Sculpture by OK Mountain in the background.)

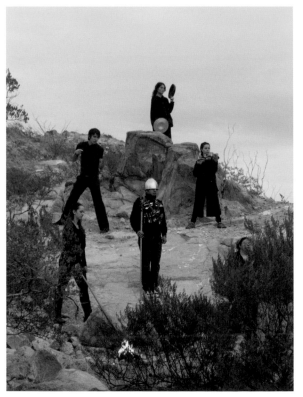

*Top:* Tania Candiani, *Protección Familiar: Cascos / Family Protection: Helmets*, 2009. Digital print. 22" × 16.5". *Left:* Tania Candiani, performance of *Battleground* at the Rubin, detail, 2009.

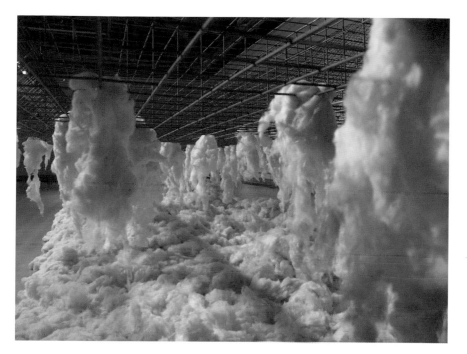

*Top:* Tom Leader Studio, *Snagged*, 2009. Steel, cotton. 394" × 132" × 72". *Bottom:* Tom Leader Studio, design for Calexico Port of Entry, Calexico, CA/Mexical, MX, 2010. Digital rendering, dimensions variable.

*Top*: Ivan Abreu, *Cross Coordinates*, 2010. *Bottom:* Installation of *Contra Flujo/Against the Flow*, 2010, at the Rubin. Photograph by Marty Snortum.

Enrique Ježik, *Lines of Division*, detail, 2011. Plywood, video, 15" monitors, chainsaw, sawdust, paint. Photograph by Christopher Mortenson.

*Top:* Atherton|Keener,
*90 Days Over 100°*, 2010,
Scottsdale Museum
of Contemporary
Art. Photograph by
Bill Timmerman. *Left:*
Atherton|Keener, *Light
Lines*, 2011. Steel and
plaster-impregnated
fabric. Photograph by
Bill Timmerman.

I asked Maciel, "How are you handling the sale of Cabrera's artwork? Do you sell it as hers or as Florezca's?"

He responded, "The work being made in her studio practice is hers and the work produced in Florezca workshops is Florezca. The revenue that Florezca generates maintains the corporation and all of its functions." Maciel predicted that Cabrera may be creating precedent for a model that will interest more and more artists and that dealers will need to accommodate. Previous models of artists who embraced capitalism and the commercial market include Andy Warhol and Takashi Murakami, two of the better-known examples. But their methods empower the artist and strengthen distribution channels for the art. Cabrera, on the other hand, intends to empower artisans and immigrants.

Cabrera's fall 2011 exhibition at Maciel's gallery included the boardroom table created in the performance at Sweeney Art Gallery; a video documentation of interviews with the participants of the mock board meeting and with Cabrera; *Mexico Opens Its Mouth*; and a few other works. For *Mexico Opens Its Mouth*, Maciel sold the crafts, which Cabrera had purchased from the artisan cooperatives. The museum or collector who eventually purchases *Mexico Opens Its Mouth* could choose to commit to periodically sell crafts and maintain contact with Florezca in order to keep the cart stocked. It will be a new, dynamic, and ongoing relationship between owner and object.

Whether the marketplace identifies Cabrera's art with her as an individual or with Florezca, it is clear that her underlying thrust is to catalyze fabrication workshops as a method of empowerment. These workshops create a vehicle for human interaction and an opportunity for individuals to be involved in the production of something larger than themselves. Cabrera intends for the participants to inform the art and for their participation to be one of its main reasons for being. The final product is equal in importance to the idea. This concept distinguishes it from conceptual art, where the idea is paramount, and from community-based art that emphasizes the making process. Here, artistic concept has an overlay of craftsmanship. In order to make sculpture that is socially relevant, Cabrera harnesses her personal identity and skills, and those of the artisans and immigrants, in the conceptualization of art and in grassroots mobilization. She has taken art as social practice one step further than most artists working in this vein by creating a corporation that will be owned in part by the art's participants and makers. How she manages the issues of authorship of works produced by this corporate entity in a capitalist art market driven by name recognition will be of interest to me as a curator, to the Rubin as an institution, and to the entire field of art as social practice.

# Tania Candiani

*Battleground*
*2009*

I made it a point to meet Tania Candiani during the weekend in 2003 when I visited artist Marcos Ramírez ERRE in Tijuana. She and I made a plan to meet in the traffic circle near the pedestrian border crossing; she came to a rolling stop in her faded red compact and I jumped in. The car rode close to the road, so it seemed as if Candiani was driving even faster than she was. The windows were open and the shrieks of city traffic forced us to shout the pleasantries of a first-time meeting. She drove us to her home studio, which was small and dark with bare adobe walls. It was at the top of a hillside crowded with homes similar to hers. She shared with me her series-in-progress, *Gordas*: soft, white, large-scale sculptures that explored the female body and contemporary society's obsession with body weight. There was a magnificence about the artwork that added to my sense that for Candiani, everything—possessions, personal time—was secondary to the art. The preliminary research for *Gordas* involved, according to Candiani, "some interviews and some models, but it was not conscious community-driven art."[1] This was about to change.

## Battleground as Complement

By the January 2009 opening of the Rubin exhibition, *Battleground: Tania Candiani and Regina José Galindo*, most of Candiani's work was decidedly community-oriented. Her role was that of director and organizer of others, and the

concept and scale of her artwork was invested in group participation and ideas. The title of Candiani's performance piece, *Battleground*, borrowed the exhibition's title and was its signature work. It synthesized many of the overarching themes that have shaped the artist's creative practice: women's labor, personal aspirations rooted in socially constructed desires, the domestic sphere as an arena of implied but false safety, the relationship between architecture and the human body, and mentorship as an artistic endeavor.

Kerry Doyle curated and developed *Battleground* as a complement to *Equilibrium: Body as Site*, co-curated by metalsmith Rachelle Thiewes and me. *Equilibrium*, a nineteen-artist exhibit of forty-eight wearable objects that affected sensorial experience, had been a couple of years in the making and would occupy the two large galleries. I asked Doyle to curate an exhibit for the smaller Project Space that focused on the body and that would consequently complement *Equilibrium*. She invited two artists who use the body as an instrument of political dissent: Candiani and Regina José Galindo, a performance artist who subjects herself to pain and discomfort as a protest against violence toward women and other innocents in Guatemala City. My role in the exhibition was one of guidance; I also suggested that we integrate student talent in order to highlight our role as an academic campus resource. Doyle shaped the aesthetics and ideas of the show and was the point of contact for the artists.

I hired Doyle as assistant director in August 2007 and her tasks were myriad—from supervising student workers to writing grant proposals. At the time, she had been a resident of the border for nearly twenty years and was invested in understanding its dynamic: she earned an MA in Inter-American and Border Studies in 2011. Doyle's flair for curating was evidenced in the first exhibition she organized for the Rubin, *The Third Lie: Chromatic Deflections,* by Chilean artist Monica Bengoa. Bengoa's combination of text, drawing, and detailed, handcrafted embroideries of still lifes demanded careful looking and sensorial receptiveness to the present moment. Doyle curated *The Third Lie* for the Project Space as a counterpart to the larger exhibitions that were already in the works: *Unknitting: Challenging Textile Traditions* and *In the Weave: Bhutanese Textiles and National Identity*. All three exhibits took place in summer 2008 and expanded our understanding of what textiles express and how.

In late spring 2008, Doyle began research for *Battleground* and, with the assistance of preparator Daniel Szwackowski, located both Galindo and Candiani through the Internet. Doyle had seen a few of Galindo's videos at the Museum of Latin American Art in Long Beach, but she had never experienced Candiani's work in person. Doyle was interested in how Candiani uses "everyday objects in absurd ways to reflect . . . the spontaneous ways in which

people have to defend themselves."[2] Spring 2008 marked a dramatic escalation of drug-related violence in Juárez and it was an ideal moment to address how residents there improvised methods of security.

## Battleground: Conceived and Reconceived

Candiani's focus on women's work and body issues was not what I had been looking for in 2003 when I was shaping the curatorial focus of the Rubin to respond to its border and desert location. But since that time, the artist had expanded her repertoire and had created several works about the physical divide between the United States and Mexico. Plus, what Doyle had in mind was sensitive to both Candiani's interests and to our programmatic and institutional missions.

Discussions unfolded during the summer 2008; Doyle asked Candiani if she would be willing to work with UTEP students in an object-making workshop. Candiani agreed, but she also wanted to add a performance component. I solicited faculty to recommend their finest students and came up with a list of ten. Doyle contacted several human rights and women's organizations in Juárez and made arrangements for Candiani and the students to visit and interview the staffs to increase their understanding of how Juárez residents were coping with the violence. The plan was for the workshop participants to spend nearly every day for a week in January in Juárez, interviewing victims of violence and creating art that synthesized the results of their findings. The students, Doyle, and Candiani had been residents of the border for many years and they would bring personal experience to the week of interviews and fact-finding. They were all deeply connected to the subject.

Candiani had pursued this type of interaction in 2004 in Tijuana and in response had created *Protección Familiar/Family Protection*, the series that encouraged Doyle to invite her to exhibit. *Family Protection* includes a series of neck-up photographic self-portraits of the artist wearing either an upside-down colander or an upside-down strainer on her head, secured with a chinstrap. Her eyes are covered; she is symbolically shielded by the kitchen-accessory-as-armor, but also made vulnerable due to compromised sight. *Family Protection* also includes *Protection Helmets*, the actual assembled headgear represented in the photographs, and *Lanzadas/Spears (2009)*, a sculpture consisting of about eighty brooms-cum-spears, cantilevered from the wall, their handles sharpened to a point and directed at the viewer.

Sometime in late 2008, UTEP President Diana Natalicio circulated a memo prohibiting university-related travel to Mexico. This was the first of many

Tania Candiani, *Protección Familiar: Casco 1/Family Protection: Helmet 1*, 2004. Digital print. 16" × 20".

*Top:* Tania Candiani, *Protección Familiar: Cascos/Family Protection: Helmets*, 2009. Digital prints, 22" × 16.5" each. *Bottom:* Tania Candiani, *Lanzadas/Spears*, 2009. Sharpened brooms and metal support. Dimensions variable. Photographs by Rubin staff.

unexpected developments that forced a reconceptualization of the exhibition project. Instead of transporting UTEP students to Juárez, Candiani and Doyle decided to work with two groups of students: one from Juárez and one from El Paso. Candiani and Doyle would cross the border daily, but the students would not. The Rubin had been collaborating with the Department of Art at the Autonomous University of the City of Juárez on planning programming related to our summer 2009 exhibition, *Los Desaparecidos/The Disappeared*. As a result, positive relationships with the faculty and students there were already established. Earning their support for and interest in *Battleground* was not difficult. Doyle states, "The fact that we couldn't bring students to Juárez made it even more urgent that the piece somehow reflect the separation. . . . The week [that Candiani was in residence in El Paso] was a lot of back and forth. As we came up against walls we had to get over them, and that affected the piece."

In the end, Candiani conducted almost identical workshops in Juárez and El Paso, where she mentored students in the transformation of the tools of domesticity into the tools of war. Choppers became axes; spoons and knives took the place of bullets in faux holster belts; bowls became helmets; a frying pan served as a shield.

On the evening of January 22, 2009, when *Battleground* opened, each respective group stood together in silence and stillness for one hour, holding their "weapons" as if prepared for battle. The UTEP performance was outside on the hillside, just north of the entrance to the Rubin. The audience was appreciative and the overall scene was lively. Hundreds of people attended. In Juárez, the students were alone in a classroom in a nearly empty university. As Doyle describes it:

> The students in El Paso had an emotional experience. The hour went quickly. Some of them cried at the end. The students in Juárez felt like the hour was very long, and they felt the tension of holding their positions. [At the end] they just put their weapons down and went home. In some ways, they woke up the next day and did the same thing . . . that is their experience . . . it was not just a performance for them.

Candiani adds, "Each student chose to be either a warrior or a defender. They were not protecting El Paso from Juárez, but protecting Juárez from Juárez. When Juárez students put down their weapons, the El Paso students did, too."

For the exhibition *Battleground*, Doyle chose to exhibit existing works from *Family Protection*. Candiani created a floor mat stenciled with the phrase "Exercise Your Vulnerability" that rested beneath and in front of *Spears*. The spears

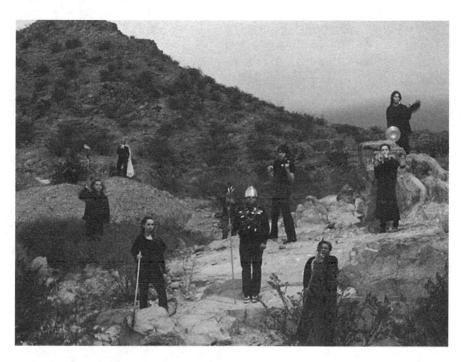

Tania Candiani, performance of *Battleground*, 2009. Photograph by Rubin staff.

and the altered floor mat together argued that defenselessness and kitchen tools are useless resources, but they are the only ones that some victims have.

Candiani created the floor piece after spending some time in the gallery space and considering the overall intention of the exhibition. For the opening reception at the Rubin, the performance of *Battleground* in Juárez streamed in real time, projected in video. Simultaneously, UTEP students performed, standing silent and still, armed and prepared. From the day following the reception to the close of the exhibition, side-by-side screens conveyed video recordings; the Juárez performance on one screen, the El Paso performance on the other. Doyle notes:

> It took us awhile to figure out how to involve the students in Juárez [in the actual exhibit]. The students from Juárez couldn't come here and the UTEP students couldn't go to Juárez so the virtual streaming of the performance was at first a pragmatic solution to this problem, but then it eventually developed into the central metaphor for the piece: the students in Juárez closed off in a room, sort of beamed in, which is the way that we get information about Juárez. And then our students here, on the front line in front

of everyone. The metaphor became richer as we worked through it, but at first it was pragmatic: how can we include these students [from Juárez] who don't have passports? But once we realized what we were going to do, it became part of the piece.

## One Border, Two Works

*Battleground* was a nexus for the convergence of several strands of Candiani's creative output. In 2008, she produced a series of three architectural-scale works in which she, for the first time, addressed the fence that divides the United States from Mexico. *Toque de Valla/Regimental Bugle Call at the Fence*, *Reinterpretación de Paisaje Cierre Libertad/Reinterpretation of Freedom in the Landscape*, and *Reinterpretación de Paisaje La Salada/Reinterpretation of Salt in the Landscape* were all created at the invitation of director Hugo Rodriguez for his film *Una Pared para Cecilia/A Wall for Cecilia*. Though Candiani lived in Tijuana for fifteen years and launched her art career there (she relocated to Mexico City in 2009), she had never examined the border as a physical entity until this opportunity arose.

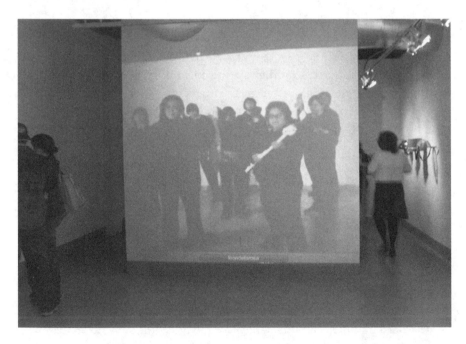

Tania Candiani, *Battleground*, 2009. Live stream of performance in Juárez as projected at the Rubin. Photograph by Rubin staff.

Tania Candiani, *Toque de Valla / Regimental Bugle Call at the Fence*, 2008. Wooden structures with steps and rope, action with regimental school bands and public.

*Regimental Bugle Call at the Fence* took place at the point where the fence bifurcates the beach and extends into the Pacific Ocean. Through Internet forums, Candiani located regimental bands, which typically compete against one another. She then convinced them to cooperate to issue commands via drums and trumpets, which the audience would hopefully recognize as manipulative and indicative of the current political situation. Candiani recruited, via megaphone, unsuspecting beachgoers to raise ladders on the fence, then band members coordinated the beachgoers' movements up the ladders in a formal and pseudo-militaristic exercise. This was at about the time that the United States was fortifying the fence—including increasing its height to sixteen feet—in select areas where illegal cross-border traffic was particularly active. "The next big business along the Texas-Mexico border is the 17-foot ladder business!" quipped some politicians and journalists.[3] Candiani orchestrated the talents of others with the goal of achieving a cohesive artistic vision, laying groundwork for skills that she would apply to her work in *Battleground*. She also addressed the landscape of the border, just as she did by positioning the UTEP students outside rather than in.

For *Reinterpretation of Freedom in the Landscape*, Candiani arranged junkyard castoffs at the base of a short section of the border fence, a pile of offerings that ascended in the center. It was a loosely systematized compilation and display of discarded stuff. Candiani had pursued a similar strategy for *Studio Dust*

(2002–2004): she filled nineteen plastic bags with the dust that she had accumulated and collected from her workspace over a two-year period. For *Studio Dust, London* (2006), the artist visited, swept, and gathered dust from one hundred and eighty artists' studios and documented that process in photographs. With these three pieces, Candiani aestheticized residue.

*Studio Dust* was a portrait of her own private space. *Studio Dust, London* documented the private spaces of specific others. And *Reinterpretation of Freedom in the Landscape* was a portrait of the general public installed in an open, highly accessible place. It was not only the most public of her pieces, it was also the largest in scale. The progression between *Studio Dust* and *Reinterpretation of Freedom in the Landscape* mirrors Candiani's interest in growing her work in scale and community impact. Recalling her work for Rodriguez's film, Candiani states, "The sad thing about all this movie collaboration is that at the end, nothing looks as I thought. But the nicest part is that I found the way to pay homage to the city [Tijuana] that makes me who I am as an artist."

## Precedents

The other components of Candiani's contribution to the exhibition *Battleground* reach further back in time and reflect cornerstones of her studio practice: women's work and the private spaces of our bodies and homes. Barbara Kruger's *Untitled (your body is a battleground)* (1989) was a silkscreen poster designed to advertise the 1989 March on Washington in support of legal abortion, birth control, and women's rights.[4] This seminal work created a visual language for the body under attack, a language that Candiani specifically referenced with the title of the performance piece at the Rubin.

Female artists using the kitchen as a site to emphasize the politics of women's labor also connect to Candiani's *Protection Helmets* and *Battleground*. In the black-and-white video *Semiotics of the Kitchen, A-Z* (1975), Martha Rosler, with deadpan expression, discusses several of the kitchen's accouterments—in alphabetical order, from apron to tenderizer—and demonstrates how to use them.[5] In speech and gestures that imply frustration, she eventually thrusts a fork at the viewer and dumps the contents of a ladle on the floor. She shapes *U*, *V*, and *W* with her arms and slashes the air with two kitchen knives to connote *X*, *Y*, and *Z*. Her movements are sharp, those of a fighter rather than a quintessential housewife.

Liza Lou, who is of Candiani's generation, is best known for *Kitchen* (1991–1995), a 168-square-foot kitchen where the artist covered every surface with glass beads that she applied by hand with tweezers: appliances, table, chairs,

sink filled with dishes, cereal boxes. She embellished the mundane to eternally sparkle with color and texture, engaging in women's work (beading) while questioning its validity by pushing it to an unparalleled level of finish. As one critic put it, "Oppression and pride coexist in Lou's *Kitchen*, the tone of the work oscillating from bitter to sweet. Such ambivalent feminism is common to women of Lou's generation, 'not wanting to be confined to the role of Cinderella on the one hand, but not wanting to forfeit the dream of Prince Charming on the other.'"[6] Candiani's *Protection Helmets* and *Battleground* have the ironic humor and the conceptual bite of all these precedents, a fusion of "intimidation with jest."[7] They also take them one step further to address the specifics of some of Candiani's concerns: daily violence, particularly in Mexico, inside and outside the home.

Contemporary literary and art theory of all types engages in what influential critic Terry Eggleton terms "body talk" and, true to this statement, there are even more examples of artists who have used their own bodies as sites of action and who relate to Candiani's overall oeuvre. For example, for *Other Narratives: Mattress Mantras* (2009), Candiani sat at her sewing machine and asked visitors to approach her and whisper into her ear a word or phrase used during moments of lovemaking pleasure. Candiani then stitched those words onto fabric.

Tania Candiani, *Other Narratives* performance, 2009.

In format, *Other Narratives: Mattress Mantras* was reminiscent of Yoko Ono's *Cut Piece*, performed in Kyoto and Tokyo in 1964, New York in 1965, London in 1966, and then again in Paris in 2003 in a call for peace in response to the events of September 11, 2001. In each performance, Ono wore some of her best clothes, sat passively on a stage, and invited audience members to approach her, one by one, and cut off a piece of her clothing. The first performance emphasized the sound of scissors against fabric. The New York performances were shaped by some of the audience members' desire to strip the artist, connoting violence and the infringement of personal space.

In *Other Narratives: Mattress Mantras*, the audience members approached Candiani one by one, as did Ono's audience in *Cut Piece*. But here the audience member exposed something of himself/herself and consequently placed the artist in a position of power, rather than the other way around. Candiani was active, translating terms of desire into women's work; Ono was passive, barely responding to being literally laid bare, "exposing the aggression that marks sexual difference and the laborious efforts women make not to be undone by it."[8] In both cases, the audience member entered the staged space and came close enough to the artist to touch her, acquiescing the role of voyeur and becoming a subject to be observed. The UTEP student performers in *Battleground* challenged audience members to do this as well, but their steely gazes, threatening poses, and weapons, along with the ruggedness of the terrain, discouraged the audience from entering the staged area.

In several of the other works in the *Mattress Mantras* series, Candiani extends the concept of private space beyond the body and into the home, examining the latter as a symbol of dreams and aspirations. *Lo Doméstico (The Domestic): Mattress Mantras* (2005–2007), for example, consists of several works including a few quilted "pillow" tops from full-sized mattresses that are pinned to the wall. Candiani pierces the quilted fabric repeated times in a grid pattern, dissecting it each time so that its inner contents are revealed and spread into the shape of a vagina. The exposing of inner sanctums and private spaces via sculpture created from craft processes is not new: works of the 1970s by Judy Chicago (several plates in *Dinner Party* look like orifices) and Magdalena Abakanowicz (the *Abakans* are soft, woven, and suspended architectural-scale cavities) immediately come to mind. But these artists constructed their forms from raw material, whereas Candiani deconstructs then reconstructs existing objects. The found quilt tops are the place where dreams are engendered; by cutting them apart and reconfiguring them, Candiani references dreams failed then remade. She describes *Found Mattresses* (2005–), her series of photographs of mattresses dumped curbside, as "an essay about abandoned, recycled and dumped dream surfaces."

Argentine artist Marta Minujín stepped into her *Mattress House* (1963), a simple, figure-sized structure draped in found stripped mattresses, and seemed swallowed; only her head peaked out. Then in 1973, she and artist Richard Squires installed *Soft Gallery* at the Harold Rivkin Gallery in Washington, D.C., covering the floor, walls, and ceiling with mattresses acquired from the local Hotel Cairo, which had recently closed down.[9] The padded space created a safe and inviting place for other artists to perform. Carolee Schneemann screened an experimental film; Charlotte Moorman played a melting ice cello.[10] But these associations of security are precisely what Candiani aims to dispel in her mattress works. She states, "Mattresses are loaded with sexual implications and different types of violence." She turns precedent on its head.

## From Self to Community

Candiani decided to explore the concept of home as a place of aborted dreams and false safety in further depth in *Habitantes y Fachadas/Inhabitants and Facades* (2007). This project also marked another step in her evolution as an artist engaged in social practice. She began by distributing a questionnaire to residents in a subsidized neighborhood of Tijuana as a method for "becoming closer to people and understanding their dreams." Some of the questions included "What is your ideal house?" and "What would your walls say?" As a final gesture, Candiani asked participants to "take a pencil to paper and draw your ideal home," a rendering based on the answers to the questions. Candiani conducted three hundred interviews and selected four (three women and one man) to visit once a week for three months. From these, Candiani established an understanding of a collective ideal home. For many Mexicans, this home is in the United States, a dream space that has very little relationship to reality. Tijuana is now residence for many people who came north and want to cross, or wanted to cross at one time, but, for one reason or another, cannot. This spirit of a populace with a shared desire to be somewhere else has meant that Tijuana has grown, in Candiani's words, "in a desperate way. There are many sad houses there." Soon after Candiani completed this project, she relocated to Mexico City.

*Inhabitants and Facades* set the stage for Candiani to work at an architectural scale. In 2008, she collaborated with graffiti artists to render visual messages on the exterior of an upscale hotel in Polanco, one of Mexico City's fanciest neighborhoods. Candiani secured permission from the hotel's owners (the only restriction they imposed was no foul language) and discussed with the team of scribes the idea of walking the city as an urban explorer. They were temporary inhabitants of the streets and of the hotel. The longest phrase is a

translated excerpt from Guy Debord's *The Society of the Spectacle*: "But certainly the present age prefers the sign to the thing signified, the copy to the original, representation to reality, the appearance to the essence."[11] Both Debord and Candiani encourage an individual and honest experience of the city by means of intentional and aware occupation.

About six months later in 2008, for Candiani's *Refranes/Sayings*, she rode a three-wheeled bicycle, outfitted with a mailbox to collect sayings and proverbs from nearby residents that reflect their hopes and dreams. (She gathered about fifteen hundred.) Later, she staged this piece in Cairo and San Francisco. Within the span of a few years, Candiani has increased her scale from studio object to urban space and the orientation of her practice from personally motivated to community driven. As a cross-border performance that embraced the landscape and involved multiple participants, *Battleground*, 2009, was yet another step in this transition.

During fall 2010, Candiani participated in the International Studio and Curatorial Program (ISCP), an artist-in-residency program in New York City that is allied with the Fondo Nacional para la Cultura y las Artes (FONCA/National

Tania Candiani, *Habitantes y Fachadas/Inhabitants and Facades*, 2007.
Four interventions over facades, Tijuana Mexico.

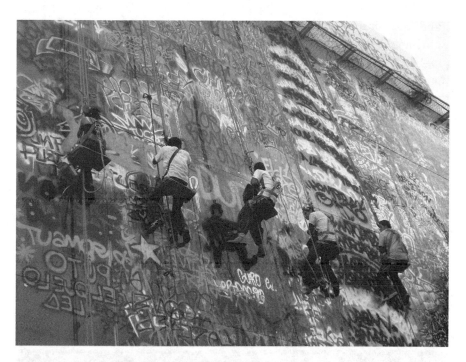

*Top:* Tania Candiani, *Habita Intervenido/Intervention in Habitation*, 2008. A group of taggers temporarily inhabited an exclusive hotel in Mexico City. During the process, they and Candiani discussed concepts about and definitions of identity, personal history, and city barriers. *Bottom: Intervenido/Intervention in Habitation*, 2008.

Fund for Culture and Arts) in Mexico City. There she researched the "Classic 6," middle- and upper-class apartment buildings that date to New York's pre–World War I (1880–1910) residential building boom. Until shortly after the Civil War, New York's wealthy lived in freestanding private houses; only the working classes and the poor lived in multiple unit buildings. The Classic 6 apartment has six rooms plus bathroom(s): a living room, formal dining room, two bedrooms, kitchen, and a maid's room. It tends to be deep and narrow. It also represented a shift in how domestic spaces in New York looked and functioned and how they conveyed status. Today Classic 6 apartments are some of the most prized real estate in the city.

Candiani researched these structures and studied photographs from real estate catalogues as well as architectural plans. For the exhibit at the ISCP, she stitched in black thread on canvas the floor plan of a Classic 6. She also cut green oak tag paper, which is traditionally used by tailors, into the shapes of the rooms as rendered in the architectural plans, layered these cut papers one on top of the other, and hung them from hangers like clothing. Her studio had the ambiance of a seamstress shop. She connected the spaces where we

Tania Candiani, *Classic 6*, 2010. Exhibition, installation view.
International Studio and Curatorial Program, New York.

live with the clothing that we wear, both expressions of personal identity and places of intimacy. Candiani states, "Public and private spaces are juxtaposed with an intensely private space such as the body . . . establishing the similarities between clothes and walls of houses—both as decorative elements and ways of enclosing oneself and trying to create an identity." And both convey social standing.

For her series about the Classic 6, Candiani drew upon the skills and interests that she developed in her previous works such as *Inhabitants and Facades* and *Battleground* by emphasizing her role as teacher and motivator with the goal of rethinking existing circumstances. She invited students of architecture to design structures from clothing patterns, encouraging them to consider the interior spaces of the body as comparable to the interior spaces of a building. Many fine artists have created clothing as an artistic expression. One is Joseph Beuys, whose iconic felt suit argues that protection and security are springboards to individual freedom. Another is Rosemarie Trockel, with her double-collared, knitted sweater that indicates connection and dependence. Candiani distinguishes herself from these precedents by emphasizing students as collaborators and by focusing on the likeness between clothing patterns and architectural plans.

Many scholars and artists have explored the connection between the body and architecture in a more expansive way. Scholar Robert J. Yudell begins his discussion of the caryatids of ancient Greek temples with the statement:

> The interplay between the world of our bodies and the world of our dwelling places is always in flux. We make places that are an expression of our haptic experiences even as these experiences are generated by the places we have already created. Whether we are conscious or innocent of this process, our bodies and our movements are in constant dialogue with our buildings.[12]

Vitruvius dedicated his treatise *De architectura* to his patron Augustus Caesar, the first Roman emperor who rose to power near the end of the first century BC. Vitruvius's aim was to represent his discipline of architecture as a means for making the emperor's body congruent with the imagined body of the world he would rule. The architect believed that the proportions and measurements of the human body, which was divinely created, were perfect and correct. He therefore proposed that a properly constructed temple should reflect and relate to the parts of the human body. He noted that a human body can be symmetrically inscribed within both a circle and a square; this idea influenced

his architectural practice. (Leonardo da Vinci's illustration of Vitruvius's treatise is perhaps better known than the treatise itself.) The architect's audience are all those who enter the building, his designs based on the collective "body" of that audience.

Some twentieth-century modernist practitioners of design, architecture, and art have also connected the body with buildings and in doing so have expressed their views on women's roles. For example, Frank Lloyd Wright designed clothing, furniture, and tableware to collaborate with his architecture, to affect methods of daily living, and in the words of scholar Carma Gorman, "to satisfy Wright's desire for total aesthetic unity."[13]

A couple of decades later, Margarete Schütte-Lihotzky created her iconic Frankfurt Kitchen in 1926–1927, under the direction of Ernst May, director of the Frankfurt Municipal Building Department, who had established the goal of standardizing housing so that it was affordable to the lowest-paid workers. In 1921, Schütte-Lihotzky read the first German edition of *The New Housekeeping: Efficiency Studies in Home Management* by Christine Frederick and became convinced that "women's struggle for economic independence and personal development meant that the rationalization of housework was an absolute necessity."[14] A women-focused interpretation of Wright's dresses and Schütte-Lihotzky's women-focused kitchen is particularly relevant to this discussion because Candiani's investigation of women's work, including sewing, led to her current interests in the connection between clothing patterns and architectural plans.

Contemporary artists who consider the body's relationship to space also connect to Candiani. In 2009, the San Francisco Museum of Modern Art organized *Sensate: Bodies and Design*, "a contemporary look at the way the human body figures in architecture and design," and included *A Sac of Rooms All Day Long* by Alex Schweder, an artist originally trained as an architect.[15] Schweder's research and creative output focuses on the relationship between human body parts and architectural space, which he terms "performance architecture," where "the relationships between occupied spaces and occupying subjects are permeable . . . until referring to the two as distinct becomes irrelevant."[16] His *Snowballing Doorway* (2010) is similar in structure and conceptual intent to *A Sac of Rooms All Day Long* and consists of two side-by-side inflatable arch forms, each about fifteen feet high, that inflate and deflate as air passes from one to the other. They are similar in form and function to lungs, though the forms expand rhythmically, one after the other, rather than simultaneously. Whereas Schweder creates spaces that reference the human form, Candiani connects

the plans for built structures with plans for "covers" for the human form. But the baseline for both is the body as it relates to architecture.

Candiani's multifarious practice connects with all these precedents, and *Battleground* was an energized point for that connection to come to life. *Battleground* addressed women's labor as political protest; the body as a source of inspiration for the design and structure of armor, clothing, and buildings; the border fence as a symbol of failed dreams and unnecessary division between people; and collaboration as a method for achieving greater impact and more complex expression. It was the first time that the Rubin had exhibited art on and about the U.S./Mexico border that directly employed the human body as an instrument for social action and a symbol of dissent. All of this meaning comes together in Candiani's oeuvre, ascending toward a gestalt that expresses the power of collective action to shape our constructed environments and our world. The artist and the Rubin each influenced the trajectory of the other.

Sarah Cowles, *The Steptoe Mess*, 2011. Ink on paper. 20" × 30".

# Tom Leader Studio

*Snagged*
2009

It was a dusty day in May 2008 when I first met Sarah Cowles. She was the resident artist at the Center for Land Use Interpretation in Wendover, Utah. I was passing through on a road trip with three friends. Then and there, on the border between Utah and Nevada, in the historic Wendover Airfield, not far from the shimmer of the Great Salt Lake Desert, the initial concept for *Snagged: Tom Leader Studio* took root.

Wendover Airfield was developed in 1940 when the U.S. Congress appropriated funds for the acquisition of the land for bombing and gunnery ranges. After the end of WWII, it played a key role in the postwar weapons development industry.[1] Today there is a museum, several restricted areas for testing and research, and the Center for Land Use Interpretation, a private nonprofit that identifies itself as a research and education organization "dedicated to the increase and diffusion of knowledge about how the nation's lands are apportioned, utilized, and perceived."[2] The Center hosts a resident artist, and one of the responsibilities of that artist is to provide visitor access to an ongoing project sponsored by the Center on one of the Airfield's restricted areas: SIM-PARCH's *Clean Livin'*, a sculpture-as-living-quarters complete with gray water shower and composting toilet. This quasi-military setting, marked by SIM-PARCH's intervention, may in part be responsible for the primary ideas iterated in *Snagged*: the vulnerability of our system of water production and control, the permeability of the U.S./Mexico border, and the juxtaposition and cohabitation of the agricultural with the urban.

I had exhibited SIMPARCH's *Hydromancy* at the Rubin in 2007 and wanted to visit *Clean Livin'*. (See Chapter 3.) So did my friends. One of them made arrangements with Cowles. She answered the door of her Airstream trailer with an ear-to-ear smile, ready with steaming cups of tea to quench our thirst after a long trip. We piled into our car and, as Cowles guided us around, we got to know her: she had earned a Bachelor of Fine Arts in sculpture from the California College of the Arts and a graduate degree in landscape architecture from Harvard University. At the time, she was working for Tom Leader Studio in Berkeley, California, and her Center for Land Use Interpretation residency was a temporary break from the job to do some sketching and writing. Under Leader's tutelage, Cowles was designing landscapes for clients in China and Europe. Her designs encouraged creative and conscientious land use and development. Leader had also successfully completed a few architectural-scale outdoor artworks in California and the landscape design for buildings created for the display of fine art, such as Pool Pavilion Forest. After our tour of the airfield, Cowles shared photos of these artworks and of Leader's *Compost*, an art installation at Ohio State University that consisted of three "walls" of quart-sized Ziploc bags stacked in rows, about four feet high and three feet deep, to form a three-sided enclosure. Each bag contained a discarded item. The piece overall looked like a fortress. *Compost* archived what we discard, pushing us to look at how our refuse is confining and controlling us.

These images of Leader's projects stuck with me, so soon after I returned to the office, I sent Cowles the floor plans of the three galleries at the Rubin. Within a few weeks, I had received a proposal for *Snagged: Tom Leader Studio*, an artwork that would divide the largest of the galleries with a floor-to-ceiling dimensional wall filled with detritus from border commerce and activity. The show would carry Leader's name; Cowles would be the point person and project manager. To Cowles, the title addressed how communication and physical movement get "snagged" at the border. To me, it referenced the "snagging" of materials and waste from previous lives and uses, and then repurposing them. Of Leader's previous artworks, *Compost* seemed the closest in spirit to what I envisioned *Snagged* would become.

But more importantly, *Snagged* would address the fence that divides the United States from Mexico, a structure only a few hundred feet from the UTEP campus. In 2005, the U.S. Department of Homeland Security established the Secure Border Initiative, which supported Customs and Border Protection, one of Homeland Security's most complex units.[3] For fiscal years 2006 through 2009, the Secure Border Initiative received about $3.6 billion in appropriated funds. Of this amount, about $2.4 billion had been allocated by late 2008 to

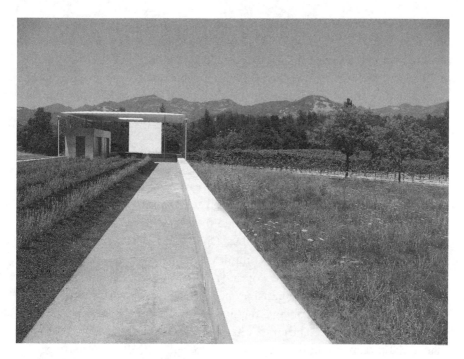

Tom Leader Studio, *Pool Pavilion Forest*, 2007. 16 acres. Napa Valley, California.

complete approximately 670 miles of fencing along the roughly 2,000 miles of border between the United States and Mexico.[4] The subject was topical and important, and my hunch was that Cowles would address it with sensitivity and style. Plus, it would build upon the Rubin's nascent track record of exhibitions about land-use issues established with SIMPARCH's *Hydromancy* in 2007. It would also drive home to UTEP students the fact that the creative professions are myriad and that landscape architecture is one of them.

In early fall 2008, I presented the proposal to the exhibition committee and scheduled the show for fall 2009; Cowles signed the exhibition contract on behalf of Tom Leader Studio. Stipulated in the contract was the Rubin's commitment of up to seven thousand dollars total, inclusive of a five-hundred-dollar honorarium and travel expenses for Leader to offer a presentation on the evening of the exhibition opening. It was up to Cowles to monitor the budget. She would need to figure out how to pay for any costs above and beyond that seven-thousand-dollar ceiling.

Pedestrian fencing marks the U.S./Mexico border in urban areas; Normandy barrier-type vehicular fencing delineates it in some non-urban areas. Large swaths of the border are not fenced at all. The materials and structure of the

pedestrian fence vary: in El Paso, it is now an intimidating grid of steel that stands as high as nineteen feet. This new, fortified fence had not yet been constructed when Cowles proposed the installation project, but it was scheduled to be completed by the time the exhibition opened. At the same time that the Secure Border Initiative was working on the fence, we would be working on *Snagged*, planning for the transformation of the gallery as we watched the borderline being physically reasserted.

In August 2008, just before we signed the exhibition contract, Cowles was appointed assistant professor of landscape architecture at the Knowlton School of Architecture at Ohio State University. She earned this job in part because of the professional contacts that she cultivated at Ohio State while working with Leader on *Compost*. She would continue to be associated with Tom Leader Studio but would be living in Columbus, Ohio, and teaching full time. Cowles convinced me that she was still committed to *Snagged* and would achieve it with success. This long-distance working method between her and Leader was the first of many shifts in the initial proposal. In fact, around this time, Cowles sent me a document describing a revision of the team's plans for the physical form of the exhibition: "The entire interior of the gallery space—walls, ceiling plane, and columns will be wrapped or 'papered' with flexible netting. The netting will be filled with detritus organized into masses, bunches, and thickets of varying sizes."[5]

## The Border From Another Perspective

In December 2008, Cowles phoned. She wanted to design a summer seminar about the U.S./Mexico border for Ohio State undergraduate and graduate students from several disciplines. Their research about the area would in turn feed the conceptualization and physical realization of the exhibition. Would UTEP be willing to host them at no cost to the university, except for staff and student time expended in interacting with the visitors from Ohio?

One of the Rubin's many roles is that of a laboratory for student-assisted artist's research, so Cowles's idea would extend our mission to directly touch students from an institution similar to ours, a public university focused on educating the citizens of its region. Our students would converse with Ohio State students; insights from residents of the border would intersect with fresh ones generated by visitors. The process of executing this exhibition was organically aligning with our mission of serving the university audience. "Absolutely," I said. Cowles began planning the course in earnest.

Part of the planning included Cowles realizing that the talents of her colleague, architect Alan Smart, would empower the seminar and *Snagged*. Smart was, like Cowles, a thirty-something, first-year teacher at Ohio State. The two of them came to El Paso for a couple of days a few weeks prior to the seminar to get a feel for the area and to solidify plans for the class. Smart had worked as an architect's assistant and as a gallery preparator, hanging paintings and setting up sculptures. He consequently brought design, carpentry, and installation skills to the table, all of which would be instrumental to the raising of a dimensional wall. Smart would also prove to be important to the discussion and generation of ideas for the exhibit.

In mid-July they arrived with nine students enrolled in LARCH 760: *The Osmotic Potentials of the U.S./Mexico Border*. One cornerstone of the methodology of the class was to load up a minivan with seminar participants and drive along the border to simply observe the pedestrian and vehicular activity and the quality of the landscape. Eating Tex-Mex cuisine, shopping for Tony Lama cowboy boots, and witnessing border checkpoints all became part of the pedagogical experience. Another cornerstone was group discussions of a selection of literature about the border, including seminal essays by authors such as Teddy Cruz, Néstor García Canclini, Douglas S. Massey, Lawrence Herzog, and Michael Dear/Gustavo Leclerc. Cruz, in particular, interested me because he resides on the border, a Tijuana-based urban planner and academic who focuses much of his practice on sorting through the conflict that occurs over political jurisdiction and conditions of ownership.

Firsthand experience of the border enhanced the students' understanding and interpretation of the secondary sources. For example, we spent one morning at the Rio Bosque, a managed wildlife area in east El Paso that was literally sliced in half by the newly fortified border fence. Its director, John Sproul, hiked around with us and told us about the nesting kites and the burrowing owls that lived there and about how the fence had diverted animal migration patterns. He emphasized that federal building projects require environmental impact studies, but border walls are above the law.[6] We made the short pilgrimage to Border Marker #1, the first of the six-foot-high obelisks that were installed in the late nineteenth century to mark the land boundary between the United States and Mexico from El Paso/Juárez to Tijuana. The marker sits on the west bank of the Rio Grande: a visitor can face the obelisk and have one foot in the United States and the other in Mexico, an unusual opportunity in an urban environment where the border is heavily fortified and patrolled. East of here, the Rio Grande River marks the national border and is patrolled by

the U.S. Border Patrol; just west of here, the river bends north through New Mexico and into southwestern Colorado, its banks a place of recreation and repose. It is at Border Marker #1 that the river is, in the words of Smart, "re-signified from a national to a natural feature."[7]

## A Second Iteration: The Inspiration of a Ditch

During this weeklong visit, the physical form of *Snagged* once again began to shift.

When Cowles was in Berkeley, she worked with Leader on the design of Shelby Farms Park Conservancy, which is situated on acreage in Memphis, Tennessee, and bifurcated by an interstate. It focuses on the conscientious growing and marketing of organic plants and livestock and "gives rise to a celebrated 21st century park that defines and shapes a great city."[8] For high school, Cowles had attended Putney School in Putney, Vermont, a boarding school situated on an organic farm; gardening and poultry care were part of its curriculum. She explained, "Farming has been part of my world view in terms of how things are organized . . . in relation to natural systems, one of its overlays."[9] Leader, too, thought of farming as "a very efficient engine of cultivation that requires a sensitive understanding of the site and clear intentions. . . . If we're going to intervene in the landscape, it should be for a clear reason."[10]

Cowles's interest in agriculture resurfaced as the seminar participants investigated the Rio Grande Valley. Though we spent many hours in the shadow of the border fence, it was the irrigation ditches that left the greatest impression on her and the others. We drove along them, and crossed and re-crossed them, to reach our various destinations. The land to the north and east of El Paso is agricultural. (To the south and west lies the sprawl of Juárez.) Fields of chili peppers, cotton, lettuce, and other crops are only a few miles from the downtown core. Horses, cows, chickens, and other livestock also live here. Just eleven inches of rain fall each year; the air and the land are dry and dusty.

What makes farming viable are the irrigation ditches that channel water from the Rio Grande to the fields. U-shaped, about eight feet wide and equally deep, they resemble arteries in both importance and function, ubiquitous and vital to the movement of the lifeblood of the region. As Teddy Cruz states, "The most dramatic conflict on the border is between the natural and the political."[11] By the time Cowles, Smart, and their students were preparing to return to Ohio, Cowles shared with me a sketch of an open form. It was only three lines: two sloped 45 degrees up and out from either side of a flat bottom. It was the shape of an irrigation ditch.

The physical form that would manipulate the interior space gallery had changed for the second time, but the task of gathering clean refuse, such as computer parts and used plastic bags, had not. The Leader team still planned to somehow stuff the ditch form, but with what and in what way were still to be determined. Sun Bowl Stadium is the Rubin's neighbor to the north and only about one hundred yards separate our front doors. New AstroTurf was being laid in the stadium at the time, and Tyvek bags full of clean scraps of the material were heading for the dumpsters. Cowles thought the vibrant green might add some visual interest, so we accumulated a dozen or so human-sized bags of the faux grass. Castoffs of computer hardware were also available from the Office of Institutional Technology on campus, so we hoarded as much of that as we could as well.

In September 2009, Smart sent me photographs of the ditch-in-progress. Units of gabion, which is thick, galvanized wire, would be connected with zip ties. They planned to suspend these from the gallery's interlocking system of steel struts that hang just above the track lights, parallel to and about thirteen feet above the floor. Gabion's industrial use is erosion control; this material connected *Snagged* to its roots in landscape architecture. Historically, gabion baskets were used as blockades during medieval times. (Gabion can be made from a variety of materials, including metal, wicker, and canvas.) They have also been used by the military as detention cages, an application that intersected with the border context of *Snagged* and the use of detention cells for illegal migrants.

Cowles shipped the gabion from Columbus, and it arrived in late September, a week or so before Cowles and Smart. They brought with them two other collaborators, John Also Bennett and Jason Braun. Bennett is a sound artist who owned and operated Skylab, a performance space in Columbus. During his week in El Paso, he gathered field recordings of the area and then edited and compiled them to become the sound track for *Snagged*. Braun is a sculptor who is adept at building things. Within a day or so, Smart and Braun assembled the ditch form. Its bottom and its sides each consisted of two planes of gabion material, for a total of six planes. Cowles intended to fill the eighteen-inch voids between the gabion planes with detritus, so the sides of the container would be bulky and bursting, but the open-mouthed form itself would be empty. Prior to filling the walls of the "artery," the Leader team, together with members of a class of UTEP sculpture students, hoisted the vacant minimal form so that it hovered about four feet above the floor, in what Cowles described as "an incredible moment . . . of seeing what the thing had become . . . and understanding it had rules of its own."

## A Third and Fourth Iteration: The Unfilled Void and the Juxtaposition of Soft and Hard

The sculpture was a ghost-like imprint of a section of El Paso's irrigation system. It signaled death waiting for new life, rather than movement and activity. The vacant form powerfully reversed the original concept of a ditch bursting with stuff. We had gathered a good amount of clean trash, but it was not enough to fill the void areas between the gabion planes. Cowles and Smart decided that total emptiness was better than partial emptiness because it seemed more intentional. A void was more visually resolved than a half-filled structure would be. We were also concerned that the literal weight of the filled structure might compromise the limits of the gallery ceiling supports. So at that point we abandoned the idea of filling the "ditch" with trash and decided to leave it empty. The vacant armature de-emphasized the representational quality of *Snagged* and instead highlighted the structural and material quality of gabion. Its grid of steel recalled a screen; it became metaphor for the border as filter. Negative space predominated, emphasizing the unseen processes of the border and the undetected people and substances crossing it constantly and illegally. It communicated the border as, in the words of Smart, "crackling with invisible potential." Its severity and emptiness made it open-ended.

The team had also produced a rectangular gabion tube that ran the length of the ditch form and rested on the floor. It referenced a core sample, which is a cylinder of rock that geologists harvest from deep down below the earth's surface, and also served as a bench for visitors. On the afternoon of the day before the exhibition was to open (which was the day after we had hoisted and suspended the sculpture), we debated the possibility of filling this bench component with the detritus that we had gathered.

But then Tom Leader arrived. By midafternoon the next day, *Snagged* had changed again. Leader spent the morning in a horizontal position beneath the sculpture, scooting around on a rolling cart like an auto mechanic under a car. From the outside plane of the bottom of the ditch, he hung long wads of unprocessed cotton that Cowles had purchased from a local farm. (She had originally intended for it to be part of the filling, along with AstroTurf and e-waste.)

The material contrast was visually arresting: soft against hard, organic against manufactured, secreted against structured. Many contemporary sculptors have combined hard and soft materials: Louise Bourgeois, Panamarenko, and Jessica Stockholder are only a few. But the trait that distinguished *Snagged* from the work of others is that what each material represented was the very point of the piece: steel ditch as process and organic cotton as product. Here,

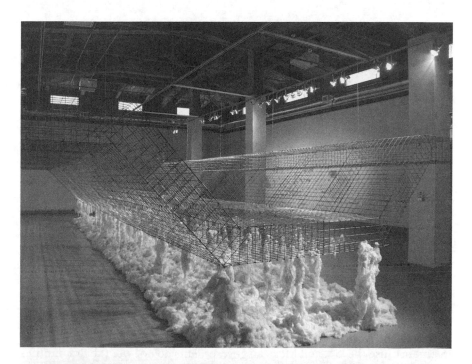

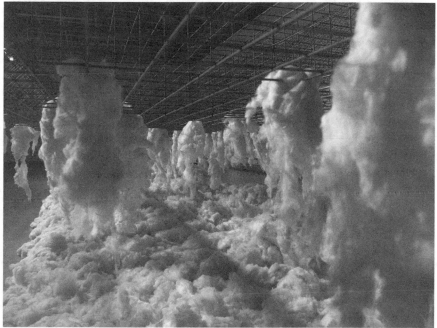

Tom Leader Studio, *Snagged*, 2009. Steel, cotton. 394" × 132" × 72".
Photographs by Rubin staff.

the hard existed because of a need for the soft. The point where they physically joined was almost sensual. *Snagged* shaped and defined space, a characteristic allied with architectural-scale minimalist sculpture that is sometimes created from a single material, such as the fluorescent lightbulbs of Dan Flavin and the steel of Tony Smith. The ditch alone would have closely referenced these precedents; the addition of cotton took it to another place.

## Flow and Process

Conceptually, *Snagged* portrayed El Paso's irrigation channels as functioning organisms. Some of the water that flows through them seeps through their earthen sides and bottoms, like escaping afterthoughts of a flawed system. *Snagged* represented cotton as both success (crop) and failure (seepage). It also addressed, in the words of Smart, the "permeability and impermeability of the border as a membrane . . . and how water flows and becomes a metaphor for economic or population flows, and the devices and mechanisms the regime has put into place to regulate and control them." The Rio Grande is victim to a concrete infrastructure in politically sensitive locations such as El Paso. This is in part because the U.S. and Mexican governments do not want their countries to change in shape and size. The naturalness of the river has been imposed upon and nearly obliterated in order to control water flow and the stability of national boundaries. On the opposite end of the spectrum, the U.S. government has protected the land along certain areas of the border, such as Organ Pipe Cactus National Monument in Arizona. Increased human movement due to crossings has damaged these lands, which are literally trampled because of ineffectual and inefficient immigration laws. An article in the September 9, 2002, *Arizona Daily Star* contends: "Ecologically, the entire border region is getting hammered by wave after wave of illegal border crossers." This includes trash and human odors and excrement. (*Snagged* portrayed seepage as a thing of beauty.) The ultraconservative flip side of this argument is that the threat is not on the land but on the concept of Americanness in the United States, on the connection between territory and nation, and between primitive and civilized.[12]

Though commissioned art always evolves as the artist explores the place and the options, the process of the production of *Snagged* was the most organic and group-oriented I have experienced as a curator. Working with SIMPARCH was a warm-up exercise, but that collective was less transparent about its decision-making process than the Leader group. So this time around, I was privy to more warts in the methodology. Plus, Cowles involved even more people than SIMPARCH did. As she described the process:

I have a background in sculpture and many years of working in design of-
fices. These are two distinct approaches. . . . I enjoyed the process of mud-
dling those two. . . . I understand how important it is to collaborate and
have productive discussions and allow ideas to develop . . . and add more
layers. . . . In art school, the question was "what is your idea? What is your
instinct?" . . . If you had an idea it was already done and you just had to
make it. . . . In design school, you are trained to roll with limitations and
changes and a constantly evolving process.

The conceptualization and fabrication of *Snagged* was closer to that of a de-
sign team than of an individual artist. The results were a singular but complex
expression that included a room-sized sculpture, didactic texts, and a sound
component.

The didactic panels hung on the wall next to the flying ditch; they were
produced and designed by the Ohio State seminar students, under the guid-
ance of Cowles and Smart. The panels explicated in detailed text and diagrams
the history of research, commerce, and immigration in the region. The visual
density originally intended for the sculpture was contained instead in these
panels. Most of the visitor's time was spent reading this information, rather
than looking at and contemplating the sculpture. It was the most text-heavy
exhibition in the Rubin's history. In spring 2010, the panels were exhibited on
their own at the Center for Land Use Interpretation exhibition gallery in Los
Angeles, California.

The coolness of the overall impact of both the panels and the sculpture
mirrored Cowles's and Smart's approach to interpreting landscape by, in the
words of Cowles, "using the language of design and the conventions of ar-
chitecture to sort of dry everything out and create dimensional drawings. . . .
You could build the border from our drawings." Bennett's sound track of aural
experiences excerpted from the El Paso/Juárez area connected the sculpture
to the didactics. As viewers observed or read, they heard the compiled essence
of gravel moving, drums beating, and rubber meeting the road. The sculp-
ture, including the gabion bench (which, in the end, also remained empty),
and the panels were successful independent entities, but together they created
an art-as-science exhibition that also functioned as an environmental and so-
cial investigation, a cross-disciplinary enterprise that brought together various
departments of the university, including biology, anthropology, environmental
studies, and art.

## Snagged Moves Forward

The subsequent work of Leader, Cowles, and Smart connected to the experiences and research that resulted from the El Paso project. Though Tom Leader Studio is always engaged in several endeavors, two projects directly linked to *Snagged*. First, in the Studio's contribution to the Minneapolis Riverfront Design Competition, a stone-filled gabion retaining wall ran parallel to a brick-filled gabion bench, an oversized sister to the bench in *Snagged*. Second, the Studio is collaborating with architecture firm Perkins + Will to generate a site plan for a border-crossing checkpoint at Calexico, where there is a heavy flow of migrant workers from Mexico to California's Imperial Valley. In the plan gabion terraces filled with native stone insulated the interior spaces of the building against the heat. They also etch the parched land into a bas-relief, creating detail and scale where water for planting does not exist.[13] Gabion is a ubiquitous material in landscape design, but Tom Leader Studio's proposed design for the Calexico project and his design for *Railroad Park* in Minnesota draw particularly heavily upon it. In *Snagged*, Tom Leader Studio employed it to create a tactile and compelling aesthetic expression.

Smart, Cowles, and I had many discussions about visiting artists responding to the border in an informed but nonpolitical manner. Smart, in particular, was interested in applying the analytical methods of architecture and urban

Tom Leader Studio, *Railroad Park*, 2010. 19 acres.
City of Birmingham/Railroad Park Foundation.

Sarah Cowles, *The Salt Mountain Disturbance: Saline Dam and Furrows*, 2011. Ink on paper. 20" × 30".

design to express the condition of the border with a cool dryness. In early 2011, he was using his skills as an academic to study the radical urban movements in industrialized Europe because, in his words, squatters "reorganize urban space by intervening in the choreography of the city."[14] He was, in effect, contextualizing urban squatters as urban architects in the same way that he contextualized border politics, be they sanctioned or not, as the "architect" of the urbanscape of El Paso. Irrigation ditches, like all architecture, are human-designed and -constructed impositions on the land. Smart's ideas took visual form in *Snagged*.

*Snagged* helped Cowles shape her approach to her creative work and her pedagogy. For *Critical Disturbance*, one of her ensuing artistic investigations, she created drawings, such as *The Salt Mountain Disturbance: Saline Dam and Furrows*, and models that envision the future of the site of an abandoned railyard in Columbus, Ohio, half of which is a twenty-meter-high stockpile of road salt and the other half the remains of concrete foundations that have been colonized by trees and shrubs that thrive in harsh habitats such as this. This research on "a site-specific approach that engages the aesthetics of disturbance" has informed her development of an Ohio State course about site-specific art and what it means to "go somewhere that you are not familiar with and try

to interpret it . . . an artist as an ethnographer type of model."[15] In her more traditional landscape architecture classes, she applied field studies that survey the politics and history of a place to help students learn why landscapes look the way they do. In Cowles's mind, public art is one of the "edges to landscape architecture" that she is interested in adding to her hybrid practice.

Exhibitions of research by architects and landscape architects typically consist of drawings, designs, and models. *Snagged* distinguished itself from these others because its primary physical component was sculpture. Through intensive research by a committed team, *Snagged* morphed from the original concept of an abstraction of the border wall to an abstraction of an empty irrigation ditch dripping with raw cotton. The ditch form floated as if in a state of temporary transcendence and captured and conveyed some of the most important concerns of our time. Some of these concerns connect to other exhibitions at the Rubin: how to provide the requisite water to our nation, how to reconsider the effectiveness and consequences of our border policy, how to reflect on our history as it influences our present, and how to acknowledge that the margins influence the center.

Ivan
Abreu
and
Marcela
Armas

*Against the Flow:*
*Independence and*
*Revolution*
*2010*

In fall 2007, the Rubin was presented with an opportunity that posed a moral dilemma. The year 2010 marked the bicentennial of Mexico's independence from Spain and the centennial of the Mexican Revolution. The Mexican government encouraged cultural venues worldwide to acknowledge this milestone and was prepared to help with the funding; organizations were encouraged to apply for support through their local Mexican consulates. El Paso was important to this anniversary because the sister cities of El Paso and Juárez played a significant role in the Mexican Revolution: in 1911, the Battle of Juárez and its resulting treaty marked a turning point toward victory for democracy and the end of the initial stage of the revolution. Consequently, the Museum and Cultural Affairs Department of the City of El Paso, under the advisement of the Consulate General of Mexico in El Paso, organized a planning committee to discuss 2010 as "The Year of the Homeland." In December 2007, I attended the committee's first meeting with the objective established by the Mexican government of cultivating "solidarity, reconciliation and national pride for Mexico."[1]

It was awkward timing. President Felipe Calderón assumed office in December 2006 and established an agenda of battling Mexico's drug trafficking organizations. He increased spending on security and sent thousands of troops and federal police to combat the cartels in Mexican states along the U.S./Mexico border and throughout the country. In October 2007, the United States and Mexico collaborated on the Mérida Initiative to fight drug trafficking, gangs,

and organized crime in Mexico and Central America.[2] In response to the government's crackdown, the cartels fractured, restructured, and escalated the violence. Eventually, only a few cartels controlled the lucrative drug trafficking corridors through which drugs flowed north from Mexico into the United States, and high-powered firearms and cash flowed south, further fueling the narcotics trade.

Deaths continued to escalate. In August 2010, CBS News headlined Juárez as the "murder capital of the world" and reported more than twenty-eight thousand dead since Calderón's assumption of the presidency. Often the killing was random; innocent people in the wrong place at the wrong time. Juárenses adopted a home-to-work routine and rarely went out in public. The streets that were once full of people and cars were now desolate. Law enforcement and drug traffickers were often one and the same.[3] No one knew whom to trust. UTEP students who lived in Juárez arrived to campus tired and tense from living in a state of fear.

The Mexican government was asking us to acknowledge the anniversary of a revolution that conferred power to its people at a moment when those people felt powerless. The irony was inescapable. But if any cultural institution in El Paso was in a position to challenge and question this contradiction, it was the Rubin. We took the opportunity seriously and by fall 2008 we had decided to organize an exhibition of Mexican artists who employ technology to address social and political upheaval. Kerry Doyle took on the challenge of curating the exhibition for the two largest galleries. Doyle had curated two exhibitions for the Project Space; this one would be far bigger and more complex and would require significant outside funding.

While researching artists, Doyle discovered that many of those she was most interested in had participated in exhibitions organized by Karla Jasso, curator at Laboratorio de Arte Alameda (Alameda Art Laboratory), a visual art exhibition venue in Mexico City that focuses on new media art. In early 2009, the Rubin sent Doyle on a curatorial research trip to Mexico City, where Jasso introduced her to many artists. During that visit and the months that ensued, Doyle and Jasso had a number of formative conversations about the ideas and intentions behind the exhibition. Jasso proved to be instrumental in the shaping of the concepts and in identifying a capable and compelling group of artists. Doyle appropriately invited her to co-curate.

By fall 2009, Doyle and Jasso had settled upon a list of artists, all based in Mexico City. Ivan Abreu, Marcela Armas, Arcangel Constantini (assisted by Jaime Villareal), Gilberto Esparza, Ivan Puig, Rogelio Sosa, and Laura Valencia Lozada (assisted by Lola Sosa) employ technology in some way in their work.

To value collective over individual experience was an important link between the Mexican Constitution of 1917, which resulted from the revolution, and the intentions of two of the artists, Ivan Abreu and Marcela Armas. The constitution contains several articles promoting cooperative organization of agriculture, business, and the economy. Part of its message was that individualism was to blame for social ills that led to the revolution.[4] Abreu relinquished some control over the making process by including the input of others in the realization of *Cross Coordinates* for the Rubin exhibition. Armas addresses the idea of collective ownership in *I-Machinarius*, the piece that visitors saw first when they entered the galleries. Both of them have created public works that harness the energy of collective viewership. In the following paragraphs, I touch upon the work of all the artists exhibited, but I focus on these two because of this shared interest that connects them to the impetus of the exhibition.

## The Title Challenge

Establishing a title for this exhibition proved to be a challenge. In early fall 2009, it was *Tremor: Independence and Revolution*. The Spanish word *"tremor"* translates as earthquake and, like an earthquake, the artists would be moving from the source and center (Mexico City) to the periphery (Juárez). The artists as a group expressed disaffection for this title because its secondary definition translates as "corporeal spasms." It was important to all of us for the title to convey the appropriate idea in both languages. By the time UTEP President Diana Natalicio and I visited the Mexican consulate in November 2009 for a face-to-face funding request, the exhibition title had morphed to *Grito: (in)dependence and (re)volution*. *Grito* translates to "shout" or "scream" and is typically used as a celebratory remembrance of Mexican Independence Day. The irony was conveyed in the parenthetical phrase: Mexico is economically dependent on its northern neighbor and cycles of dependence and violence often revolve, rather than evolve, to repeat themselves. Consulate staff was uncomfortable with this working title because *grito* spoke only to independence from Spain in 1810 and not to the revolution of 1910. (The title may have been a worthy, if coincidental, distraction during this meeting because it shifted the focus away from the subtitle as a critique.) Despite this concern, Dr. Natalicio and I walked away with a commitment from the consulate to cover the transportation costs of both the artwork (or components of the artwork) and the artists from Mexico City to El Paso and back—about forty thousand dollars—plus the consulate staff's skills and time required to negotiate customs requirements for the temporary importation of art. Given that the exhibit critically assessed

the role of the Mexican government in the current crisis, I had expected some resistance from the consulate. But there was none. Whether consulate staff recognized the show's inherent satire is still not clear. Being accompanied by the university president no doubt helped my cause.

By early 2010, the university was ready to launch *Mexico 2010: 100 Years After the Revolution,* a yearlong series of programs that included lectures, films, and exhibitions. One cornerstone was the Department of History exhibit *El Paso: The Other Side of the Mexican Revolution,* hosted by the El Paso Museum of History. Another was the Rubin exhibit for which we had yet to settle on a title. One option was *2010: (in)dependence and (re)volution.* It seemed too generic and too likely to become lost in the mix of exhibits honoring the bicentennials of the independence of many Latin American countries from their European colonizers, not to mention the exhibits acknowledging the Mexican centennial anniversaries.

We finally settled on a Spanish title and English subtitle in honor of the combination of Spanish-speaking artists and curators with the North American exhibition venue: *Contra Flujo: (in)dependence and (re)volution.* "*Contra flujo*" translates as "against the flow" and was also the title of one of the eight works in the exhibition, a cross-border piece that the Rubin commissioned from Arcangel Constantini. The title captured the fact that the artists were challenging the discourse of progress and the idealized and romantic image of the country that Mexico was attempting to propagate. They were pushing back, resisting the flow. But given that we were asking readers to accommodate a dual language title, we simplified the subtitle by dropping the parentheses so that it described rather than analyzed. We finalized the title *Contra Flujo: Independence and Revolution* in early spring 2010, just before the press releases were distributed.

Many of the artists knew one another or of one another as members of Mexico City's community of artists. Valencia Lozada knew Sosa, Constantini knew Villareal, and Abreu, Armas, Constantini, Esparza, Sosa, and Puig all knew one another. Doyle's goal was to build upon this atmosphere of connection, so she offered her home to all the artists as a place to stay during their time in El Paso. The Rubin hired a housecleaner and a cook for about two weeks; in the end, the financial outlay of about four thousand dollars was significantly less than the costs of hotel rooms and restaurant meals. Doyle's generosity and strategy were effective. The artists were invested in each other's success and in the impact of the exhibition as a whole. I observed them stepping in to help each other create and install their artworks and to solve technological problems, often late into the night. The exhibition was stronger because of it. Doyle was present for every moment of the installation process.

## Ivan Abreu: Social Practice as Connection

Abreu was the first to arrive about three weeks before the show opened. His research required community involvement, and he crossed the border almost daily during these weeks to galvanize support and trust from participants in both cities. Leon de la Rosa, art instructor at Autonomous University of the City of Juárez (UACJ), proved instrumental in coordinating a team of students to support Abreu's interactions with Juárenses, the documentation of those interactions, and the editing of that documentation. Abreu created a four-foot-long carpenter's level and invited pairs of people to attempt to bring it into balance. With one person on each end of the level, the balancing process was more challenging than it appeared to be and required delicacy and sensitivity, characteristics of the rich binational relationship between El Paso and Juárez during the best of times. Abreu titled it *Cross Coordinates*.

Abreu executed the first iteration of the piece, *Nivel Burbuja/Carpenter's Level*, in Mexico City in 2008. He went to public places and invited people of different social classes to work together to strike a balance. In El Paso, the focus was on cross-border equilibrium. One morning, students from UTEP and from UACJ, along with Doyle and Abreu, met at Sunland Park, New Mexico, and they

Ivan Abreu, *Cross Coordinates* (inventions in downtown Juarez and on the border fence), 2010. Photograph by Christopher Mortenson.

slipped the level through the chain-link border fence. On other days, the artist went to public plazas and other gathering places in both cities and invited random participants. Abreu also invited high-profile El Pasoans to balance with their counterparts from Juárez. For example, President Natalicio collaborated with Rector Jorge Quintana of UACJ to balance. They met in Natalicio's office for two reasons. First, Abreu wanted to document her environment as a reflection of her and her position. Second, the University of Texas System had prohibited employee travel to Mexico due to the violence there. It was not an option for her to meet the rector in his office in Juárez, a twist that supported the main point behind *Against the Flow*: Mexico is not the idealized place that the centenary celebration was promoting. John Cook, mayor of El Paso, and José Reyes Ferriz, mayor of Juárez, accepted Abreu's offer to balance at the annual Border Security Conference on the UTEP campus, but only Mayor Cook honored the commitment. An employee from the Mexican consulate pinch-hit for Reyes Ferriz and partnered with Cook in an unplanned but poignant comment on the strength and stability of El Paso relative to Juárez. Paul Foster, CEO of Western Refining and El Paso's only billionaire, balanced with Miguel Fernández, former owner of all of the Coca-Cola bottling plants in Juárez. The cooperation of the executives impressed me because their participation was completely outside of their job responsibilities, and they had very little to gain from it. They gave valuable time in support of Abreu's expression of cooperation.

*Above and facing*: Ivan Abreu, *Cross Coordinates*, 2010.

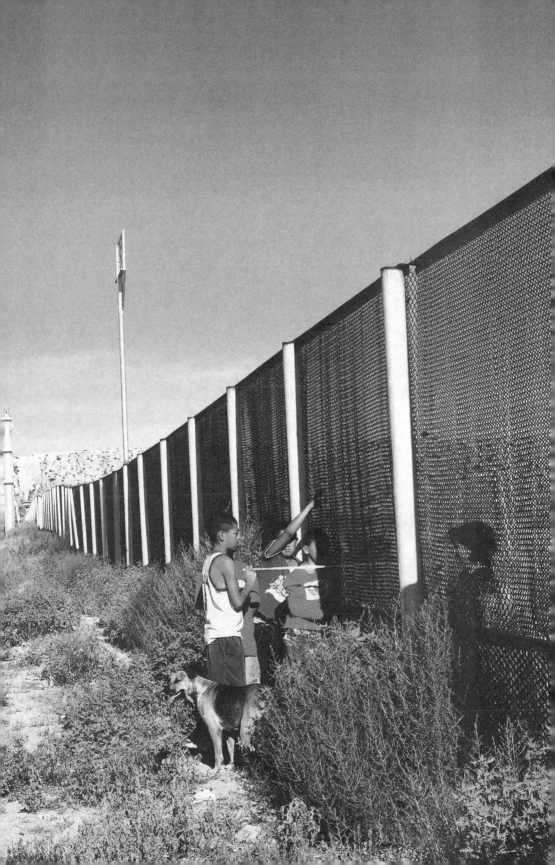

*Top*: Ivan Abreu, *Cross Coordinates*, 2010. *Bottom*: Ivan Abreu, *Cross Coordinates*, Paul Foster and Miguel Fernandez in El Paso near the border with Juárez, 2010.

In the exhibition, the level in *Cross Coordinates* rested on a simple metal stand and visitors were encouraged to pick it up and bring it into balance. Behind it was a ten-foot-high projection of white numbers on a black background. Each time visitors handled the level, the numbers ascended, triggered by a counting device attached to the center of the level that recorded its activity. Abreu established the goal of reaching 3,169,000—the length in meters of the U.S./ Mexico border—by the close of the exhibition. We did not quite achieve this number. However, Abreu created a web-based version of *Cross Coordinates* that mimics this dynamic by measuring the presence of two players online at the same time. In the Internet version, Abreu had recorded 15,324,168 "meters of cooperation" as of December 2012.[5] Also on display were photographs and videos documenting El Pasoans and Juárenses engaged in the balancing process over the course of Abreu's time here. Curator Caitlin Jones, who has written extensively about Internet-based art, observed that "the systems used by new media fundamentally challenge art institutions in some of the same ways that socially engaged practice does." This is important to remember in the context of *Cross Coordinates*. Both new media art and socially engaged art are based on systems and on interdependence: political scientists might use the terms "collectives" and "cooperatives," socially engaged artists might use "dialogic systems" and "collaboration," and new media practitioners might use "interaction" or "open systems."[6] All convey the same meaning. According to these definitions, Abreu is both new media artist and social practice artist.

Abreu claims appreciation for the Situationist International, an avant-garde artists' collective that was active from 1957 to 1972. Marcela Armas and Laura Valencia Lozada do, too, as do many contemporary artists who work in the realm of public art. At least one of the ideas that the Situationists championed connects to the underlying message of the Mexican Constitution—namely, the value of collective ownership and experience. Of the international artists' groups that developed during the 1960s, the Situationists have possibly had the most long-lasting influence, in part due to the fact that the group published a journal. The predecessor of the Situationists, Lettrist International, was less oriented toward radical politics, but the collective shared the Situationists' goal of achieving cultural revolution.[7] It is the Lettrist's initiative of unitary urbanism that connects to Abreu's practice.

One of the first unitary urbanist events in 1956 promoted the framing tactic of psychogeography, which revealed the normative status of geography and reframed the city and its civic functions. The goal of the unitary urbanists was a restoration of a totally human experience, which they felt had been compromised by capitalism. They encouraged artists to abandon useless art forms and

to instead focus on creating an environment for developing new forms of collective ownership. Abreu achieves this because he and other participants, both random and invited, together created *Cross Coordinates* and *Carpenter's Level*. These are group endeavors of collective authorship. Each encounter brought new meaning based on the participants involved.

In another work, *APNEA* (2010), Abreu employed the Situationists' strategy of collective viewership, though he is the sole author. For this work, Abreu attached dozens of propellers, each about the size of a spool of thread, to grates in Mexico City sidewalks that ventilate the subway system. Each time a train passed, the propellers danced; surprise and joy defined the audience's reaction. It restored humanity to the impersonal nature of the city and brought newness to the familiar.

*Cross Coordinates* and *Carpenter's Level* are the only works in Abreu's oeuvre thus far that can be identified as participatory social practice, where the artist orchestrates conversations, creates context rather than content, and serves as catalyst rather than author. This is distinct from most public art, such as *APNEA*, which has a single artist recognized as main author. Art historian Grant Kester describes the art that results from participatory creation as "dialogical." Conversation becomes an integral part of the art, which is an "active, generative process that can help us speak and imagine beyond fixed identities, official discourse and the perceived inevitability of partisan political conflict."[8] The artist surrenders self-expression in the attempt to create a model for effective communication. Rather than criticizing what has gone wrong, the artist creates a platform to make things better. It is a new approach to the avant-garde.

*Cross Coordinates* was the piece in *Against the Flow* that best exemplified a dialogical aesthetic. We have exhibited others at the Rubin, namely the work of Tania Candiani (Chapter 8). With Abreu and Candiani, Doyle connected the artists with community groups in Juárez to make their socially engaged artworks possible.[9] As co-curator of *Against the Flow*, she not only fulfilled the traditional curatorial tasks of selecting *Cross Coordinates* for exhibition and interpreting it for the exhibition's audience, she also facilitated relationships and participated in its making, tasks more recent to the skill set required of contemporary art curators. Abreu, who was trained as an engineer, and Doyle each brought a broad perspective to their respective roles in the world of contemporary art practice to create art as social interaction rather than object production. This approach expands the potential impact of both artist and curator. At the same time, they never lost sight of the importance of the aesthetic of the art and of the exhibition as a whole and produced a visually engaging experience.

## Arcangel Constantini

Though Arcangel Constantini's *contra* <~> *flujo* also depends upon two participants for activation, it is less likely than Abreu's *Cross Coordinates* to spark conversation between them. One half of this commissioned diptych was situated in the Department of Art at UACJ and the other was at the Rubin. Each half was a straight-backed chair that faced a screen and two joysticks. A visitor would sit down, grab the sticks, and see, hear, and feel the person seated in the same position on the other side of the border. VoIP (Voice over Internet Protocol) facilitated this sensorial experience via the Internet2 network that includes static and dynamic circuits and optical networking.[10]

*contra* <~> *flujo* connected to the theme of the Mexican Revolution. During that time in the early twentieth century, El Pasoans would pay a quarter for rooftop access to the downtown hotel in order to watch the combat ensuing in Mexico. The "other side" was spectacle, removed from daily experience. On the border today, this spectacle is often mediated by a computer or a television screen. As fewer and fewer El Pasoans venture into Juárez, their connection to their neighboring city comes largely from electronic media. Constantini counteracted this traditional relationship and the experience of Juárez to El Paso, and vice versa, by sensually connecting people.

A second tie to the past comes through the tradition of Mexican street vendors who stop in cantinas carrying a case enclosing a battery connected to several hand-held devices. They sell small "shocks" to groups of revelers so that they can bond with one another, reassert alertness, and continue to drink. *contra* <~> *flujo* was serious fun. It reminded us that actions on one side of the border reverberate on the other and that positive relationships between individuals have influence.

## Esparza, Valencia Lozada, Sosa, and Puig

Gilberto Esparza's *Remanente/Reminder* consisted of six white depositories that hung from the ceiling and were filled with .22 caliber gun shell casings. They were easy to overlook because they were ten feet above the floor and near the entrance to the room where Marcela Armas's *Resistencia/Resistance* was displayed. Visitors tended to focus on the intrigue of Armas's darkened space. *Reminder*'s near invisibility empowered it because it increased the work's subtlety. The depositories were connected to a device that Esparza programmed to dispense twenty-eight casings each day, the median number of daily deaths across Mexico during the three months prior to the opening of the exhibition.

Audience interaction with Arcangel Constantini, *Contra Flujo / Against
the Flow*, 2010. Wood, electronics, dimensions variable.

Exactly when the casings dropped varied from day to day, emphasizing the
randomness and unpredictability of death, especially in Northern Mexico. In
August, only a few casings were on the floor; by December, there was a circle
about five feet in diameter.

Laura Valencia Lozada's *Carbón Negro, Hueso Blanco / Black Coal, White Bone*,
animated by Lola Sosa, was a site-specific mural-sized drawing that represent-
ed the border and referenced the historical events and people who have had an
impact on it. Rogelio Sosa's *Un-balance* hung in the atrium, a sonic mobile that
quivered as it emitted the din of violence in Juárez that the artist had sampled
from the Internet. Ivan Puig's *Líder de Opinión / Opinion Leader* portrayed the
Mexican mass media as a source of misinformation. With the exception of
*Opinion Leader*, these works were developed as commissions for *Against the
Flow*.[11]

## Marcela Armas

Doyle and Jasso identified another pre-existing work, Marcela Armas's *I-Machi-
narius*, as the signature work of the exhibition. This was in part due to the fact
that photographs were available for media and marketing purposes and in part
due to the connection between the ideas behind the piece and those motivat-
ing the exhibition as a whole.

*I-Machinarius* was an 11-foot × 8-foot wall sculpture; thirty rotating cogs kept an oiled chain in constant motion. The chain formed an outline of the country of Mexico turned upside down. A bubbling geyser of crude oil slowly and constantly flowed from the points where wall and cogs met. Over time, an abstract shape formed where the oil stained the sheetrock of the temporary wall as it dripped from the cogs into a stainless steel basin below. It was then recycled back through the motorized mechanisms housed behind the wall.[12] The human and natural resources of Mexico are being drained by and to the United States. The cycle is relentless; more and more wealth heads north.

Article 27 of the Mexican Constitution of 1917, which was approved as the Mexican Revolution drew to a close, states that all natural resources in national territory are property of the nation. Armas created *I-Machinarius* in 2008 in reaction to President Calderón's threat to privatize Mexico's oil industry. Thousands of protesters took to the streets of Mexico City, many dressed as *adelitas*, the female soldiers of the Mexican Revolution. Armas's interest in collective ownership and participation is expressed by this work, which was exhibited that year at Alameda Art Laboratory.

In El Paso, *I-Machinarius* had additional resonance. Many Juárenses have relocated to El Paso, driven from their homes by the violence. El Paso has been

Marcela Armas, *Resistencia/Resistance*, 2009. Heating resistance, insulators, steel cord, sensors, electricity. Dimensions variable. Photograph by Marty Snortum.

heralded as one of the safest large cities in the country, second only to Hono-lulu. The City of Juárez's planning department reported that more than one hundred thousand houses were abandoned between 2005 and the beginning of 2009. Based on average family size, about four hundred and twenty thou-sand people, or 30 percent of the city's residents, have moved out of Juárez, either to other parts of Mexico or to the United States. About thirty thousand moved to El Paso, many bringing their entrepreneurial spirit and skills. Restau-rants, hair salons, bakeries, and other locally owned shops increased in number and quality.[13] The safe environment of El Paso is in part due to the large per-centage of immigrants among its population. Many studies have revealed that immigrants are less likely than natives to commit crimes.[14] Juárez's loss was El Paso's gain. All of this was articulated in *I-Machinarius* as the gears turned and the oil drained.

Those familiar with avant-garde Latin American art recognize *I-Machinari-us* as an homage to Uruguayan modernist Joaquín Torres-García's *Upside-down Map* of 1935. This line drawing of an inverted map of South America became the guiding symbol of the School of the South, a group of Latin American artists who, beginning in 1935, claimed a place in an art world dominated by Europe and the United States. "The North is now below," claimed the artist.[15] *Upside-down Map* inspired the title for the formative 2004 exhibition *Inverted Utopias: Avant-Garde Art in Latin America*, curated by Mari Carmen Ramírez, curator of Latin American art at the Museum of Fine Arts, Houston (where the exhibition took place) and Héctor Olea, an independent scholar and cura-tor. The title refers to the utopia proposed by European modernism, where a universalist aesthetic creates a condition of sociopolitical harmony.

But Latin America was most familiar with a Europe that was a colonizer rather than a harmonizer, one reason why so much Latin American art is so-ciopolitically driven. The Situationist International was most active during the Cold War when two superpowers resisted the use of arms and instead did battle through "psychological warfare." Such warfare was often carried out through the medium of culture that, according to the Situationists, colonized every aspect of daily experience by privileging the political economy. *I-Machinarius* updated this message by attributing the present-day flight of resources to U.S. economic colonialism and to Mexico's inability to create jobs for its people. The movement and fragrance of the oil strength-ened this specific message. But the physical form of *I-Machinarius* and its overarching concern with

*Facing:* Marcela Armas, *I-Machinarius*, 2008. Industrial chain and gears, ½-HP motor AC, lubricating system, crude oil, steel tank. Dimensions variable. Photograph by Marty Snortum.

the abuse of power were rooted in Latin American modernism, specifically Torres-García's *Upside-down Map*.

Many postmodern artists have employed the map as a critique of conquest and colonization and consequently connect both to Armas's strategies and to the Rubin's curatorial focus on the place where it exists, a region historically marked by power struggles and cultural assimilation. Artist Jaune Quick-to-See Smith, a member of the Confederated Salish and Kootenai Nation and an Indian rights advocate, renders the United States as a map of a time when its lands were roamed and named by Indians. Painter Julie Mehretu portrays mapped space as one where abstract forms coalesce. Countries morph together to defy political borders, earth connects to the cosmos, and territory is shared. Helen Mayer Harrison and Newton Harrison have produced projects for the past three decades that respond to conditions of ecologically fragile terrain; maps, photographs, and written text are all components of their research. Joyce Kozloff, Lordy Rodriguez, Guillermo Kuitca, Mark Bradford, and many other artists have appropriated or created map-like images to examine past injustices or to propose a new world order. All of them would be excellent choices for an exhibition at the Rubin, and all of them create a context based on a map-like format within which Armas and *I-Machinarius* reside.[16]

A few months after Doyle and Jasso invited Armas to participate in *Against the Flow*, the artist conceptualized *Resistance*. A hot coil of the type used for burners on electric stoves stretched to about ten feet in width to create a three-dimensional line drawing of the U.S./Mexico border. At first glance, the drawing seemed to float, suspended in a darkened and isolated room. Upon closer inspection, it became clear that it was held in place by thin, steel wires pulled taut, some connecting to the floor below and others extending above, crisscrossing to create a network of tension that radiated both north and south to each nation's urban capital where political and financial decisions are made. The border felt the heat from directives established elsewhere. The wires also referenced the transportation system and the flow of goods, both legal and illegal. Armas shared, "For me, the border line is an abstraction that involves and triggers concrete phenomena. . . . *Resistance* is a kind of web or tissue that partitions the physical space; it is filled with tension and incandescence."[17]

Because *Resistance* directly addressed the border, Doyle and Jasso decided to include it in *Against the Flow*. Armas was the only artist to have two works in the exhibit. All of the others were represented by one piece and, with the exception of Ivan Puig, each of them examined and responded to the border as a locus of criticality in what Armas describes as the current "moral, economic, and political crisis" of Mexico.[18]

In *Ocupación/Occupation* (2009), which was not included in *Against the Flow*, Armas addressed this crisis by walking through the traffic-filled streets of Mexico City, wearing a backpack outfitted with seven different automobile horns connected to an activator that she wore on her arm. She moved with ease with the traffic, beeping the horn when necessary to assert her presence. Her body alone was quicker and more efficient than the three-thousand-plus-pound machines that surrounded her. An observer watching her walk might have envisioned tree-lined walkways rather than clogged motorways. Through this action, Armas asserted the potential for a reentry of humanity to a place where machines have taken over. We will once again occupy places that today are lost to traffic jams. As a re-imagination of the civility of the city, Armas's *Occupation* follows a Situationist model. She did not perform *Occupation* for *Against the Flow* because her work already dominated the show and because traffic is not nearly as problematic in El Paso as it is in Mexico City. Had this not been the case, *Occupation*, as an action to envision a better world, would have been appropriate to the exhibition.

Other important artworks have been executed in and about the streets of Mexico City and served as precedent for *Occupation*. *El hombre atropellado/A Man Has Been Run Over* (1973), by the artists' group Proceso Pentagono,

Marcela Armas, *Ocupación/Occupation* performance, 2009.
Electric and air car horns, power switches. Mexico City.

Marcela Armas, *Ocupación/Occupation* performance, 2009.
Electric and air car horns, power switches. Mexico City.

pointed to the inhumanity of the highways and overpasses built in the 1960s
and 1970s. This infrastructure redefined or replaced pedestrian-oriented neigh-
borhoods. The group laid out sheets of plastic on the sidewalk in front of Pa-
lacio de Bellas Artes, or Palace of Fine Arts, and drew the contours of human
figures in red paint, then left them in the middle of the road to be run over by
passing cars. The resulting red marks on the pavement were, in the words of
literature scholar Ruben Gallo, "an unorthodox form of 'action painting' that
read like the bloody aftermath of a terrible traffic accident."[19] More recently,
artist Francis Alÿs has walked the streets of Mexico City as artistic expression.
For *The Collector* (1991), he took small toy dogs, magnetized and on wheels,
for daily walks, literally collecting metal detritus and metaphorically collecting
the poverty and neglect that that detritus represented. In *Sometimes Making
Something Leads to Nothing* (1997), the artist pushed a piece of ice about the size
of a large suitcase along the city sidewalks until it melted into nothing. Like
Sisyphus pushing the rock, the action had no result. There was an endurance
aspect to this piece, especially at the beginning when the ice block was large
and heavy, and the artist was straining. In contrast, Armas in *Occupation* was
by necessity quick and nimble. But all of these works were empowered by a
collective, public, and open viewership in a place where art was not expected.

They followed the Situationist concept of a "constructed situation" that is "intended to replace artistic representation with the experimental realization of artistic energy in everyday environments."[20]

Their identification with the collective cry of the Situationists inspired the participation of Armas and the other *Against the Flow* artists in an exhibition that addressed the Mexican Revolution and the societal progress that it attempted to instigate. El Paso, perhaps more than any other city in the United States, influenced the course of events of the Mexican Revolution. Mexican citizens who opposed the dictatorial-style government of the time prior to the Revolution took asylum in El Paso, just as they do today from the violence that accompanies the struggle for power between the drug cartels. The artists in *Against the Flow* challenged the image that Mexico was propagating of itself as it honored the hundredth anniversary of the revolution and of Mexican democracy. They questioned the definition and value of progress. Because of this, they created an ideal exhibition for the Rubin that acknowledged the anniversaries and was also true to our mission of challenging the status quo and encouraging adventuresome thinking and dialog.

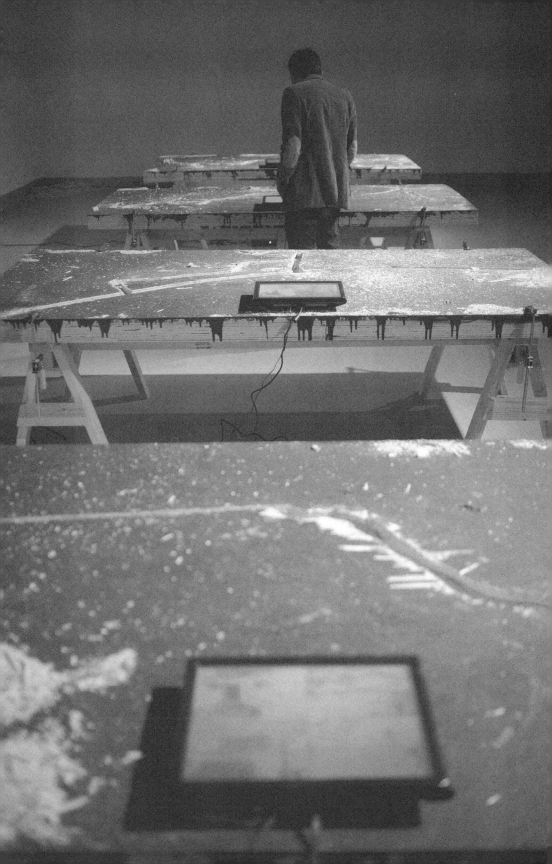

# Enrique Ježik

## Lines of Division
### 2011

When I first met curator Mariana David, she was backdropped by a grid of baguettes suspended over a Persian-style carpet that was covered in sand. Marcos Ramírez ERRE's 2005 exhibition had propelled her to visit the Rubin and I happened to be in the gallery at the time. We struck up a conversation and realized we had similar tastes and interests in contemporary art. It was David who introduced me to the art of Enrique Ježik. David had studied art history and held various curatorial posts in museums in Mexico City; she also interned at a few of the international art fairs and biennials where she met dozens of artists and other art-world players. From this platform of experience and connections, she set out on her own as an independent curator.

In 2006, David was preparing to launch her own nonprofit, *El Palacio Negro* (The Black Palace), that would focus on new art commissions co-generated by her and mid-career artists. I learned about this endeavor during our correspondence over the few months following that initial meeting. *Juárez: An International Art Project* was the Black Palace's first curatorial venture and Ježik was part of it. Groundwork for it required that David travel to Juárez frequently from her home base in Mexico City. It was during one of those trips that she crossed the border for an afternoon in order to experience ERRE's exhibition.

Enrique Ježik, *Lines of Division*, detail, 2011. Plywood, video, 15" monitors, chainsaw, sawdust, paint. Photograph by Christopher Mortenson.

About six months after David and I first met, I received a letter signed by Fausto Gómez Tuena, chief of the Department of Art at the Institute of Architecture, Design and Art at the Autonomous University of the City of Juárez, and Gracia Emilia Chávez Ortiz, coordinator of the Program of Visual Arts at the same institution, inviting the Rubin to participate as an official partner for *Juárez: An International Art Project*. The letter described the project as focusing "on analyzing—through artistic and intellectual perspectives—the social, economic and political factors behind the border situation and the recent escalation of violence in Ciudad Juárez."

Thirteen artists were to participate in *Juárez: An International Art Project*: Miguel Calderón, Paco Cao, Jota Castro, Antonio de la Rosa, Enrique Ježik, Juan López R., Gianni Motti, El Perro, Yoshua Okon, Santiago Sierra, Tercerunquinto, Javier Tellez, and Artur Zmijewski. I respected those whose work I knew, but was unfamiliar with many of them, including Enrique Ježik. In the end, he was the one I thought to be the most appropriate of all the *Juárez: An International Art Project* artists to connect to the Rubin and to the university.

Ježik was born in Cordoba, Argentina, in 1961, but he has built his career in Mexico City, where he has lived since 1990. He uses violence as a tool to address violence as a subject, ultimately expressing that brutality is both damaging and ineffectual. I found this to be appropriate food for thought, given the times we were living through in the borderlands.

One of the unique opportunities provided by the Rubin's border location is the potential for cross-border programming. And one of the advantages of being part of a large university with a commitment to research about the U.S./Mexico border is the opportunity for cross-departmental investigations of the topic. Involvement with *Juárez: An International Art Project* offered the possibility for both. I expressed my interest in becoming involved to David, Gómez, and Chávez and called a meeting with David and various UTEP faculty members who were also unit heads. I wanted to explore how far we could take the collaboration on campus. In attendance were chairpersons of the departments of art, Chicano studies, humanities, and history, and the director of the Center for Inter-American and Border Studies.

The meeting was premature. Faculty were interested in the prospect of participation but needed to know more about how they might effectively get involved. David's written stated objective of *Juárez: An International Art Project* was "to produce a critical body of work within the context of Ciudad Juárez and the border, trying to go beyond the apparent social commentary and extending the analysis and comprehension of the various cultural elements that generate a violent social reality."[1] This platform was too vague for programming to take root. I would need to create and provide the details.

Over the next couple of years, David visited on occasion and e-mailed frequently. She and her cohort, David Enriquez, another young curator based in Mexico City, presented a few ideas as options for how the Rubin might get involved in *Juárez: An International Art Project*. The cornerstone of an exhibition might be a video projection by Artur Zmijewski or an El Paso counterpart to Santiago Sierra's *Words of Fire* (2007), an "intervention" in Juárez for which the artist hired laborers to dig into the land the word *"Sumisión"* ("Submission"). Paco Cao came to El Paso to meet with me and share his idea of a visual encyclopedia that challenged the authority of the museum.

## The Search for the Right Project

But the most interesting proposals that David presented involved Enrique Ježik. One proposal was to exhibit *Rastreo/Tracking* (2006), a life sized drawing of a military helicopter and accompanying footage of various wars where such helicopters had served as a mode of both transport and destruction. The downside of this idea was that *Tracking* was an existing work and Ježik, David, and I were more interested in a new commission. The other proposal was an ambitious comment on the culture of the maquiladora. These factories had multiplied rapidly in Juárez during the years that followed NAFTA (1994), bringing many Mexicans from rural environments to the city for work. Juárez's infrastructure of services was not prepared for this dramatic influx, and the transplanted workers were not prepared for city life away from the support of their families.

Ježik proposed to demolish one of the maquiladoras that had fallen into disuse and then transport the rubble to El Paso. He would then "exhibit" these remains in an open, stainless steel container. In form, it would nod to Donald Judd and his 100 aluminum boxes at the Chinati Foundation, only a few hours' drive from El Paso. In concept, it would invert the more typical trade pattern of Mexico shipping finished goods north. This time Mexico would send to the United States the useless remains of this industrial symbol of promised prosperity that had never been realized.

The logistics proved to be daunting to the point that the project stalled. First, there were U.S. import regulations and, second, there was the problem of securing a site for the piece. The UTEP campus was far too systematized and pristine to be appropriate for this particular sculpture. Plus, we did not have the appropriate site. I communicated to David that I did not want to get involved in finding an off-campus location for the piece if the project did not in some way fulfill my responsibilities to the Rubin. Her solution was an exhibition of working drawings for the piece. I resisted. A small show of ephemera

would not be enough for the Rubin's purposes, relative to the time commitment that would be involved in sourcing the funding, site, and support for the sculpture. I was already stretched thin.

At this point, it was mid-2008 and we still had not landed upon the right project. The exhibition schedule was planned through late 2009. I offered the option of exhibiting one of Ježik's pre-existing videos on the entry wall in conjunction with another exhibition, but that was not an ideal solution for any of us. *Juárez: An International Art Project* continued on; the artists were working on the realization of various ideas that addressed the circumstances of the city. But we still had not found a method for the Rubin to become part of the project in a meaningful way. By this time, David had relocated to Italy. Our correspondence went from sporadic to none at all.

In March 2010, Ježik's name resurfaced when the Rubin staff was discussing the 2010–2011 exhibitions and programs. The largest of the three galleries was yet to be scheduled for January–March 2011. Ježik would be an ideal conclusion to the 2010 year-long international acknowledgment of the two hundredth anniversary of Mexican independence and the hundredth anniversary of the Mexican Revolution. The university had hosted *Mexico 2010*, a university-wide series of lectures, programs, and exhibitions, including *Contra Flujo: Independence and Revolution* (see Chapter 10). *Mexico 2010* was similar to what I had been aiming for when I organized the meeting with UTEP administrators and faculty to introduce them to David and her vision for *Juárez: An International Art Project*. Ježik had exhibited widely in Latin America, but he had never been the subject of a solo exhibit in the United States. I was motivated to be the first to do this. I contacted Ježik; he enthusiastically accepted my invitation for a one-person show.

### From Wall to Table

During summer 2010, Ježik and I began discussions in earnest about exactly what the exhibition would consist of. I was intrigued by his piece *Estreno de la OTAN/Premiere of NATO* (2008). In this work, he represented six of the many Serbian airports bombed by NATO in 1999 by carving their architectural plans into six pieces of sheetrock. He displayed the sheets horizontally on sawhorses, one airport per 4-foot × 8-foot sheet, and called them "mapping tables." Resting on each was a small monitor that conveyed video footage culled and edited from declassified intelligence information about the bombing of the airport denoted on the table. *Premiere of NATO* refers to the Kosovo War of 1999 when NATO, for the first time in its history, engaged in military operations against targets in Serbia. Combat is short-lived. Its results are not.

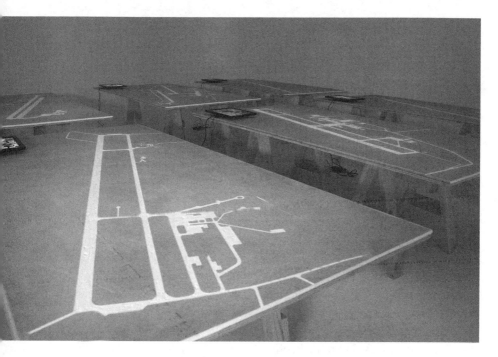

Enrique Ježik, *Estreno de la OTAN/Premier of NATO*, detail, 2008. Plywood, video, video monitors, sheetrock. Photograph by Tania Candiani.

I communicated to Ježik that I enjoyed the matter-of-fact and non-emotive quality of *Premiere of NATO* because it presents the artist as researcher and translator. By early October, Ježik had crafted a proposal that included computer-generated drawings for a new work consisting of five 8-foot-high plywood panels sprayed in concrete to outline contested national borders: U.S./ Mexico, Colombia/Venezuela, Israel/Palestine, North Korea/South Korea, and Afghanistan/Pakistan. These abstracted three-dimensional topographic maps would lean against the wall. This piece would continue along the lines of *Premiere of NATO* because of the mapping motif and the use of construction materials. Ježik sent a computer-generated working drawing of the piece and wrote, "I am exploring new materials. I like the reference to street art, the roughness of material and texture, the process itself. But it should be done by a technician."[2] Ježik knew of a company in Houston that could execute the panels, but he was counting on the Rubin to source the talent in El Paso. The weather in January can be chilly in El Paso, so the conditions outside might not be amenable to the process, and it would be too messy to execute inside the gallery. As I was exploring who might actually do the spraying and where, Ježik e-mailed that he would be in Juárez for a conference later that month and that

he wanted to make time to cross to El Paso to see the Rubin. We set a time to meet in the gallery. As soon as he saw the space, his approach to the concept changed. It was now late October.

We talked for a few hours and by the time I dropped Ježik off at the pedestrian bridge to Juárez, he and I had decided that the format of the piece would follow that for *Premiere of* NATO, with horizontal tabletop maps displayed on sawhorses, rather than panels tilted against the wall. This was a better use of the volumetric space of the Rubin Gallery. Ježik would stick to the proposed subject of contested borders, but he would carve them with a chainsaw into plywood. He suggested filling the wall space with two of his existing videos. He generated a materials list on the spot: twenty-five sheets of 4-foot × 8-foot plywood (five sheets per sculpture), C-clamps to secure the plywood into stacks, five pairs of sawhorses, five fifteen-inch monitors, and an electric chainsaw. We would also need a video projector and a screen for the video displayed on the wall. The Rubin would purchase all these items, pay Ježik an honorarium of two thousand dollars, and cover his travel and lodging expenses for his seven-day visit to El Paso. We would also publish an exhibition catalogue. While Ježik was in El Paso, he would create the artwork, oversee the installation of the exhibition, and offer critiques for art students.[3]

## Action as Art and Message

I relayed to Ježik that I thought our audience would appreciate the performance aspect of his art. This is one of the characteristics of Ježik's practice that interests me the most: his art is a twenty-first-century manifestation of Process Art because his action, its documentation, and/or its remains carry the message. Two previous artworks in Ježik's repertoire exemplify this. The first artwork, *Untitled (damage and repair)* (2005) at Enrique Guerrero Gallery in Mexico City, involved two different interventions. The first was a rough hole created in an exterior wall with a sledgehammer. For the second intervention, craftsmen extracted material from another wall to repair the gap. The wound that resulted from brutal force was bandaged with great skill, time, and care and according to a highly rationalized and structured procedure. The message that rapid destruction begets slow reconstruction was similar to that of *Lines of Division* and *Premiere of* NATO. States Ježik, "Wrecking a place and then wrecking another just to fix the first one is a direct reference to unplanned governmental policies that end up needing correction or compensation, which in turn, does not really solve the problem, but creates more trouble elsewhere."[4]

The second artwork, where the action was the art, was *What comes from outside is reinforced from within* (2008), an intervention at MeetFactory in Prague.

MeetFactory occupies an old industrial building and has galleries on the ground floor. Its largest room has seven windows. The lower half of each window was covered on the interior to create wall space for exhibiting art. Ježik persuaded the directors that an aggressive intervention was compatible with the industrial character of the site. He began by using a piece of construction equipment to align a concrete block on the floor in front of each of the seven windows for a total of seven blocks. From the outside an excavator broke the windows to enter the interior, its arm scratching the blocks with its shovel, like random drawings. The machine that had aligned the blocks with the windows then moved the scratched blocks to one corner of the room to create a landscape of ruin that referenced the Soviet invasion of Prague in 1968. It also related to a current event at the time: George W. Bush's initiative to install early warning radar in the Czech Republic in order to monitor and forestall the threat of "dangerous nations." (This was primarily due to increasing ballistic power in Russia and to Iran's increasing military sophistication and aggressiveness.) Aiming the excavator to enter the window rather than destroying the façade of the building required calculation and precision, much like the military intelligence before the destruction. For this artwork, only the residue of violence remained. Both *Untitled (damage and repair)* and *What comes from outside is reinforced from within* used violence as process, and both are entirely action oriented and do not result in an object-based sculpture. My hope was that the Rubin commission could follow along these lines but also have a material end result. But I did not want to require a performance, and I did not want an "action" to seem forced. Ježik promised to consider how he might work those considerations into the overall intention and execution of the piece.

American artists such as Robert Smithson, Michael Heizer, James Turrell, and numerous others have employed earthmoving equipment in the creation of landscape-based art. Chris Burden adopted machinery as his subject in *Flying Steamroller* (1996). He suspended a twelve-ton steamroller from a pivoting arm, which housed a hydraulic piston. At the other end was a counterbalance. The steamroller was driven at maximum speed until the piston lifted it off the ground; it continued to roll for several minutes, seemingly defying gravity. The earthworks artists moved and shaped art in acts of reconfiguration and construction, and Burden's point was to defy expectations and to challenge what is possible. Ježik stands apart from these precedents because his action and message is destruction. *Untitled (damage and repair)* and *What comes from outside is reinforced from within* are only two of his many works that convey this message.

In early November, I initiated the discussion about the exhibition title. Up to that point, we had been calling the exhibition *Lost in Surveillance*, a title Ježik had established early on. Ježik wrote:

It's always difficult for me to decide a title, but perhaps it could be "Borders were just lines"—I am trying to suggest the idea of both the arbitrariness of borders (considering history and how borders have been traced/drawn, beyond geographical accidents) and the fact that borders have grown as separations but still are places of all sort of trades, many times in a violent form (violent background or violent present).⁵

After a couple of weeks of back and forth, we settled on *Lines of Division* as the title for both the exhibition and the commissioned piece that would be the focal point. This title would better capture the idea of discord.

Ježik arrived in El Paso on January 20, 2011, for a week of creating and installing the art and meeting select UTEP art students nominated by the faculty for critiques. The first matter of business was to paint five pieces of plywood black. Ježik wanted these to seem as if they were executed quickly, complete with paint drips down the sides; a gritty, urban aesthetic underlies his art as a whole. These would be the top sheets on the stacks and would make the chainsaw cut more visible—blond scar into black ground. We leaned these against the wall and projected onto each one of Ježik's computer-generated line drawings of one of the borders. He then traced the projection in white chalk. Two

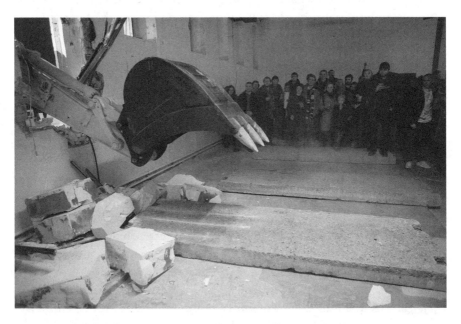

Enrique Ježik, performance of *What comes from outside is reinforced from within*, 2008, MeetFactory, Prague. Photograph by Viktor Vejvoda.

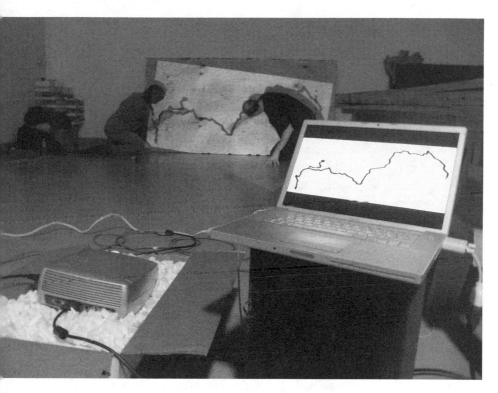

Enrique Ježik, installation process of *Lines of Division*, 2011. Photograph by Rubin staff.

days before the exhibition was to open, Ježik decided that he would carve this top layer on the night of the opening reception. This would be his process action. He would carve the bottom four panels beforehand, a procedure that would require too much time for an opening night performance.

The decision about which videos would be displayed on the wall was also resolved the week before the opening. Ježik proposed *Tripas y Sangre/Blood and Guts* (2010) and *Costillar/Ribcage* (2001) and I agreed with these selections because both videos indirectly conveyed violence and its pervasiveness in our daily lives. The most recent one, *Blood and Guts*, is filmed in high definition, but the imagery is slightly pixilated because it is a small detail of a much larger picture of a dump truck filled with animal parts. Blood drips, but its source is not evident; neither is the context. Tension dominates throughout most of the footage until, toward the end, a hatch releases and the guts spill, literally. Even then whether the body parts are human or animal is unclear. It is apparent, however, that the remains are a result of a violent action. Ježik relates this to recent and widening violence in Mexico, especially in the northern states.

*Six cubic meters of organic material*, an action that consisted of unloading animal remains from a dump truck into a quarry near Juárez, was Ježik's contribution to *Juárez: An International Art Project*. Ježik sees this piece as similar to another outdoor action artwork, Robert Smithson's *Asphalt Rundown* (1969, Rome, Italy), in which a large dump truck released a load of asphalt down a gutted and weathered cliff in an abandoned section of a gravel quarry. It was one of Smithson's many comments on entropy and change.[6] Ježik's *Six cubic meters of organic material* has similar intention and impact, but it is specific to the borderland violence of our times. He documented the actions in video and photographs. Museo de Arte Carrillo Gil in Mexico City included four of Ježik's photographs of *Six cubic meters of organic material* in a fall 2010 exhibition that consisted of art produced with the invitation and support of *Juárez: An International Art Project*. This exhibit wrapped up Mariana David's endeavor. Ježik excerpted details from his video footage of *Six cubic meters of organic material* to create *Blood and Guts*. So the two works are separate but related and connect the Rubin exhibit to the source of my introduction to the artist.

The blood from domesticated animals that predominates in *Blood and Guts* connects it to the earliest work in the exhibit, *Ribcage*, which the artist created during late summer 2001, when the worldwide mass media presented Mad Cow Disease as the twenty-first century plague. An animal carcass resting on a table fills the screen, front and center. An anonymous man stands behind it and beats it with a hammer, using the tool of construction as a weapon of destruction, though he only severely damages, and never completely destroys, the cadaver. He employs seven different hammers in his attempt to "combat" this inert enemy; the pitch and resonance of the sound changed with the type of hammer, and it is always uncomfortably loud. Ježik completed this work only a few days before the destruction of September 11, 2001, and it is he who is featured in the video, though the viewer is not made aware of this.

These two pieces are powerful and appropriate, but I thought that we needed an additional video to fill out the space. Ježik and I agreed upon *Eliminar Islas/Eliminate Islands* (2006) because it focuses on the destruction of nature, one detrimental result of imperialism and military aggression, which linked it to the commissioned work. The screen is divided in two with the images in each half functioning independently of one other. At the top are clips of warfare. The bottom conveys primarily found footage of U.S. military testing of nuclear devices in the Pacific Ocean. The bottom half also includes some footage excerpted from an earlier work in which the artist strapped video cameras to his wrists, dug a tomb-like hole in the ground with his hands, and then refilled that hole in a gesture that disturbed nature. The explosions

have a macabre beauty; they eventually eliminate the islands entirely as ocean waters swallow the land. The detonations "succeed" where the hammer in *Ribcage* "fails" because they obliterate the perceived threat. *Ribcage* would be projected, and therefore dominant, and the other two would play on twenty-three-inch monitors.

The final concern was the artist-performer's clothing. On the day of the opening, Ježik and I went to the military clothing supply store in downtown El Paso. There he purchased boots appropriate to the performance: black, mid-shin-high lace-ups with lug soles. He would wear these with a black T-shirt and a pair of black trousers that had ample pockets for carrying stuff, the type typically worn by people who need to be prepared for anything, such as soldiers, construction workers, and mountain climbers. A few hours later, the show began.

## Performer/Destroyer

The gallery was cloaked in darkness except for the three moving images that glowed from three different walls and the spot-lit mapping tables, lined up perfectly in the center of the room like worktables at a construction site. In shadow, the stack of painted plywood panels leaned against the fourth wall. Many people milled about, but conversation was difficult because the sound of the beating hammer in *Ribcage* dominated. The air was filled with anticipation; something seemed about to happen.

Two people dressed in black moved toward the leaning sheets of wood and, with effort and coordination, hoisted one, placing it on top of the first stack. Ježik, his trousers tucked into his boots, stepped onto the first tabletop. He carried a chainsaw and with it "drew" a line at his feet near the center of the plywood sheet, wounding it beyond repair, in a quick but precise action. The black surface gave way to an exposed interior of raw wood. Every few minutes, Ježik gracefully turned the saw upside down so that the air exhaust emitted from its top moved the wood-chip remains of the scarring process. With this cleansing, the artist could clearly see where the line had come from and where it was going. Taking approximately ten minutes per table, the destruction was rapid and emphasized the fact that to tear apart is quicker than to build and repair.[7] The audience saw and felt this. The sound of the saw was relentless and unnerving; the hammering in the video added to the tension. By the fifth table and the fifth line, Ježik was exhausted.

In this action, Ježik was both graceful performer and unforgiving destroyer. By behaving as if he were omniscient, insensitive to the lives that these borders

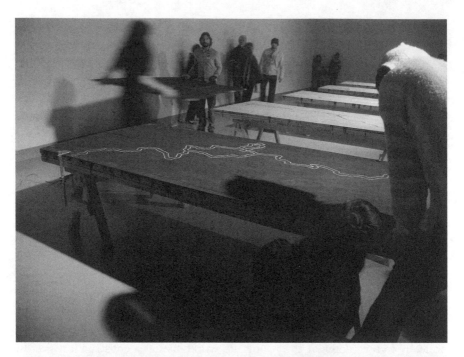

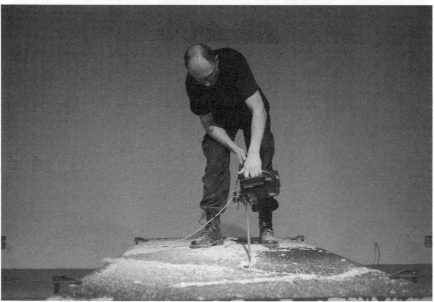

*Top:* Enrique Ježik, installation view of *Lines of Division*, 2011, the Rubin. Photograph by Christopher Mortenson. *Bottom:* Enrique Ježik, *Lines of Division* performance, 2011, the Rubin. Photograph by Christopher Mortenson.

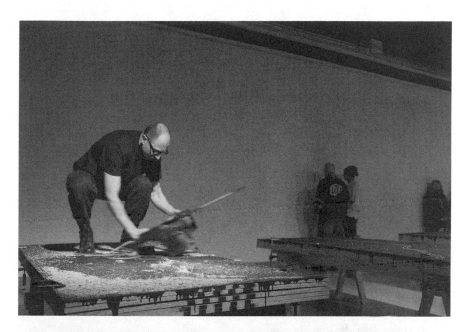

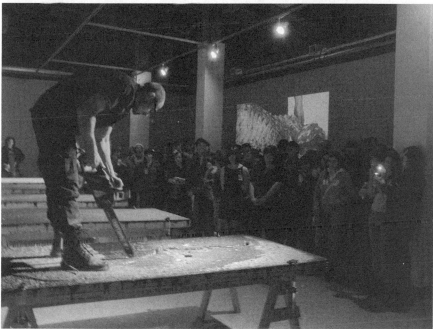

*Top:* Enrique Ježik, performance of *Lines of Division*, 2011, the Rubin. Photograph by Christopher Mortenson. *Botom:* Enrique Ježik, *Lines of Division* performance, 2011, the Rubin. Photograph by Christopher Mortenson.

affected, and the families they divided, he referenced the actions of govern-ments that established these national boundaries. After Ježik marked each tabletop, one of the black-clad assistants who had hoisted the plywood placed a small video screen on it; they were both participants in and audience for the art. The room smelled of cut wood; there was sawdust everywhere. The same people who placed the plywood and the screens swept up the sawdust so that neither Ježik nor the viewers would slip on it.

Each of the five screens conveyed imagery that relayed the history of the border represented in the tabletop on which it sat. Ježik appropriated and edit-ed the footage from the Internet, primarily from YouTube. Some was general-ized intelligence imagery: the Afghanistan/Pakistan footage, for example, was entirely constructed from this type of visual information. Video surveillance predominated on the U.S./Mexico screen, interspersed with information from mass media news. This was the same for Colombia/Venezuela and Israel/Pal-estine. For the Koreas, the footage was excerpts of propaganda: North Korean documentation of a Soviet-style military parade, South Korean contemporary images of political persuasion, and a U.S. documentary about the Korean War. In all of them the predominant representations were of large tanks, explo-sions, and people in military uniforms, gripping weapons and running in a state of panic. YouTube is highly democratic in the sense that anyone of any political persuasion or ideology can post a visual message. Plus, it is widely

Enrique Ježik, film stills from *Lines of Division*, 2011.

dispersed. Ježik's intention was to add broader meaning by changing the context or narrative for this type of information. Each loop was only about two minutes long, intentionally short so that the viewer could digest and process it. (As the artist says, "There is so much information today, but you can end up knowing nothing."[8])

## Critique of Destruction

Conflict and tension defined the videos and the carved tabletops, which together created the single artwork, *Lines of Division*, another chapter in Ježik's exploration of violence as it relates to political mapping. In this exhibition, Ježik strategically determined the height of the tabletops, which are twenty-eight inches from the ground, because the distance between the viewer and the screen is greater than it would be between a personal computer and its user. Plus, the hierarchical relationship between the two is atypical: the observer is above, rather than across from, the screen, which implies dominance. He aimed for the juxtaposition of the ephemerality of the images on the screen with the heavy and thick stacks of plywood. He paired new media with traditional media and fleeting image with permanent mapping table. This is also true of the subject depicted: the land is eternal, unmoving, in contrast to the relatively recent political divides. Thus, there was interplay between the relationship of dependence and connection inherent to shared space with one of rupture and suspicion often characteristic of relationships between governments.

Today a multitude of globally recognized artists, like Ježik, comment on social and political circumstances by destroying things and then exhibiting the documentation or residue. Two such artists, Cai Guo-Qiang and Ai Wei Wei, are Chinese. Cai's signature material is gunpowder, a material that "reflects an indigenous affinity . . . and relates to both celebratory social events as well as the ominous military confrontations taking place between Mainland China and Taiwan."[9] The artist creates gunpowder drawings and dramatic, monumental explosion projects, which in the 1990s referenced the Big Bang but more recently commemorate victims of terrorism and war.[10] Ježik's intentions are to parallel those of Cai.

Ai Wei Wei is more direct in his messages about labor and consumerism as they relate to attachment to material objects. The artist brings attention to the damage wrought by Chairman Mao Zedong, who stated, "Unless [feudal culture] is swept away, no new culture of any kind can be built up. There is no construction without destruction, no flowing without damming and no

motion without rest; the two are locked in a life-and-death struggle."[11] In Mao's mind, new beginnings depended upon the eradication of history. In the exhibition *Dropping the Urn* (2010), Ai responds to this with irreverence by using neolithic and Han dynasty vessels as "ready mades" that he subjects to a variety of procedures, including smashing them on the ground in photo-documented performances.

This act of destroying objects in order to highlight an ignorance of and disconnection from history links to Ježik's actions. Pilar Villela argues that Ježik's "works emphasize the fact of any creation also means the destruction of a previous state."[12] But I believe that Ježik is critiquing destruction rather than highlighting its positive point of renewal. Both he and Ai use demolition to point out its ridiculousness and to challenge its value.

Ježik is Argentine and spent his teens and early twenties in Buenos Aires during the Dirty War (1976–1983) of state-sponsored violence, when citizens who disagreed with the military regime, particularly left-wing activists, were disappeared, tortured, and killed. Today he returns to Buenos Aires regularly to visit family members. His early experiences in Argentina may subliminally feed his need to criticize governments' unjust treatment of their own people. Other Argentine artists of Ježik's generation who address the Dirty War include Marcelo Brodsky and Guillermo Kuitca. Brodsky tends to take a more personal approach than does Ježik, and his art investigates how the Dirty War affected his immediate family. Kuitca shares Ježik's interest in mapping and how it entails the recording and abstraction of spatial relationships, but his work does not obviously address physical violence.

In *Práctica/Practice* (2007), Ježik shot a series of twenty plywood silhouettes until they were riddled with bullet holes. This work references *El Siluetazo/The Silhouette*, a public intervention that took place in Buenos Aires in 1983, during the last days of the military dictatorship, and consisted of human-sized silhouettes, representing disappeared people, traced on paper and pasted on exterior walls throughout the city.[13] Ježik rarely discusses the Argentine political situation, nor does he address it often in his art, instead focusing on how the United States has abused its role as superpower. Ježik has lived in Mexico for more than two decades and has built his career there. However, his connection to Argentina and the political environment there may warrant further discussion, by him and others.

*Lines of Division*, as it was displayed alongside the three earlier works, opened up our understanding of Ježik's overall oeuvre and how he revealed the consequences of violence and destruction and the abuse of political power. This intention seamlessly connected to his portrayal of national borders, such

as that between the United States and Mexico, and the tensions that surrounded their creation and still surround their patrol. With the Rubin exhibition, and with his art over the past three decades, Ježik invited us to question why things are the way they are and challenged us to change them for the better by means other than brutality and aggression.

# 12

## Atherton|Keener

### *Light Lines*
### 2011

In early August 2010, I marked the halfway point on the twelve-hour drive from Los Angeles to El Paso with a stop for a bite to eat and a quick visit to the Scottsdale Museum of Contemporary Art, just a few miles from Phoenix. Unexpected pleasures mark my memory of that reprieve from the road: a lunch of mozzarella and tomato on thick sourdough and *90 Days Over 100°* by Atherton|Keener, an exhibition by artists-trained-as-architects Jay Atherton and Cy Keener. The walls of the hallway leading to the gallery supported text about the extreme heat and dryness in the Phoenix area. At the entrance hung a dimensional curtain crafted from tall panels of felt—each about nine inches wide—that insulated the dim room from the exterior elements. A structure that looked like a tall, roofless tunnel with the profile of a bottle towered to the ceiling. Its interior was lined with Tyvek, a semi-glossy material that repels moisture. Thin veins of water dripped from the top of the open form, hugged the curves of Tyvek as they skidded along its surface, and finally pooled in a shallow thigh-level gutter. To enter this structure was to retreat from the blaze of the Arizona summer.

Back in the car, I reflected on what I had just experienced. I liked this idea of a cool escape from the heat. Marketing material in the museum community sometimes focuses on air-conditioned galleries as an attractive place to spend summer leisure

*Facing:* Atherton|Keener, *90 Days Over 100°*, 2010, Scottsdale Museum of Contemporary Art. Photograph by Bill Timmerman.

Atherton | Keener, *90 Days Over 100°*, 2010. Installation view.
Photograph by Bill Timmerman.

time; this show took that promotional tool to the next level because intolerably warm temperatures were its subject. At the time, the Rubin's largest gallery was unscheduled for the May-September 2011 cycle, and I was eager to decide. It takes at least nine months for exhibition-specific campus connections to solidify, teaching applications to incubate, economic support to accumulate, and audience excitement to build. A year or more lead time is better. I still needed to settle on a few options and propose them to the faculty selection committee; I was running behind and *90 Days Over 100°* might be the solution. It would follow in the lineage of the 2007 exhibition *Hydromancy* by SIMPARCH with Steve Rowell (Chapter 3), which explored water use and conservation, and *Snagged* by Tom Leader Studio (Chapter 9), which reminded us of the moral complexities and obligations we undertake when we irrigate farmland. I contacted Cassandra Coblentz, associate curator at the Scottsdale Museum, to find out more. Would it be possible to travel the exhibit to El Paso?

Possible, yes. Advisable, no. *90 Days Over 100°* was designed specifically for that gallery in that museum. A block of ice rested at the top of the structure, just underneath a skylight. The twelve-hundred-pound block melted at a slow, steady pace, the source of the

*Facing:* Atherton | Keener, *90 Days Over 100°*, detail of water on Tyvek, 2010. Photograph by Bill Timmerman.

trickles of water on the Tyvek skin. I had not picked up on this important detail during my somewhat hurried visit. The results would not be the same at the Rubin, which has clerestory windows but no skylights. Plus, El Paso's summer temperatures are not as extreme as those in the Phoenix area. Its location in the foothills of the Franklin Mountains places it at about thirty-seven hundred feet above sea level, compared to Phoenix's elevation of eleven hundred feet. In the minds of Coblentz and the artists, the premise of the exhibition would fall flat. I agreed.

Coblentz recommended the artists highly, provided me with their contact information, and explained that Jay Atherton and Cy Keener are principals of the design firm known as Atherton | Keener. Each earned a graduate degree in architecture from the University of California, Berkeley. Their credits to date were that they designed Meadowbrook House, the home that they share in Phoenix, and successfully completed *90 Days Over 100°*. They were at the very beginning of their careers. Based on the success of *90 Days Over 100°*, they would be capable of designing an artwork for the Rubin. This seemed promising to me and I placed the call.

The artists and I scheduled an appointment for them to make a site visit in September. They financed this trip on their own and arrived right on time, an early indicator that they were motivated and committed. Both artists measured their words. During our first meeting, Keener did most of the talking, though that role shifted back and forth between the two of them at various stages of the project. We toured the facility and its corner of the campus. I told them about the opening in the exhibit schedule during summer 2011 and about our procedure for reviewing exhibit proposals. Though I needed to fill the May-September slot, I assured them that exhibiting at that time was not a requirement; an acceptable proposal was. They shared with me the tome that they had compiled for *90 Days Over 100°*, which included detailed CAD drawings of the structure. I told them that a similar document would be sufficient. Keener said that they wanted to push for May 2011; I stipulated an October 15, 2010, proposal deadline. I continued to consider other exhibition options, but nothing intrigued me as much as what I imagined the Atherton | Keener proposal would be.

## Taking a Risk

The proposal, which was an overview of how architects and artists have manipulated light throughout history, arrived on the due date, but without specifics about what the exhibition would consist of and without a CAD rendering.

I asked for more detail and they responded immediately with a loose sketch. The gallery was to be reshaped by walkways made from a yet-to-be-determined material suspended from the ceiling. Light reflected from mirrors installed in the landscape surrounding the building would be directed through the windows of the gallery. The summertime days are the longest of the year and these points of reflected brilliance would shift as each day progressed and as the summer marched on. The number of mirrors was not finalized, though they designated that one be installed in Juárez in order to embrace and involve our cross-border community. The many windows of the Rubin's historic structure were covered during its renovation in 2004 in order to create wall space for the hanging of artwork. The windows are evident on the exterior of the building, but inside they are masked in sheetrock. Atherton | Keener requested that two of the windows, one on the east side and one on the west, be revealed for the emission of light from the outside.

In the seven-year history of the Rubin, none of the windows in any of the galleries had been exposed from the inside. The windows are six feet high and four feet wide, with inserts constructed exactly like the interior walls: ⅝-inch sheetrock backed by ¾-inch plywood. Each insert weighs about two hundred pounds, and it would require several people and a forklift to move the inserts safely under special circumstances such as this one, when the art would benefit from natural light. For *90 Days Over 100°*, Atherton | Keener had collaborated with lighting designer Claudia Kappl to manipulate artificial light to enhance the art. This time they were going to the other extreme and the essence of the artwork would be to let go of control and to celebrate natural light by directing it.

Though the proposal was loose, I shared it with the exhibition committee in early November. Time was short and I did not have any other attractive options for a show that would be within budget and also entail new research. The other two exhibitions scheduled for that period would be of existing work and I wanted at least one that was commissioned. I was vulnerable because the Atherton | Keener proposal was the only one on the table that I firmly believed in, which I revealed to the committee without undermining the quality of the proposal. I described in detail *90 Days Over 100°* and the Atherton | Keener visit to El Paso, and I then presented their ideas with my full support of their request to exercise our underused option of exposing the windows. This would capitalize on the flexibility of the space in an entirely new way.

UTEP had restricted university-related travel to Juárez due to the drug-related violence that wracked the city. With the exception of discouraging the Juárez-based mirror, the committee was supportive. My vulnerability neither

diminished the potential of the exhibition concept nor the committee's belief that, in the words of one of the committee members, Atherton|Keener "would not fail." I sent the artists a contract in mid-November and by December, it was fully executed. The Rubin promised them an honorarium, a materials budget, and lodging during the two weeks leading up to the exhibition. We also promised to reveal some of the windows in the largest gallery.

I planned to make the production of the piece a component of the exhibition practices course that I taught twice a year. I discussed this with Atherton|Keener during their first visit to El Paso; the opportunity to work with students was one of the reasons they were motivated to exhibit in May. UTEP's Maymester is an intensive semester when a three-credit course, which requires forty-five hours of in-class time, is fulfilled in two weeks rather than the typical fifteen. At five hours a day for nine days, Maymester was an ideal format for an exhibition practice class. Students are substantively involved in the intensity and focus of an exhibition installation and experience first-hand what is required of both the museum and the commissioned artists. Atherton|Keener verbally agreed to be present for the nine days that class was in session and to work with the students as their assistants; the exhibition would open on the final day of class. I began to think about appropriate requirements and reading material for the class.

In December, Atherton|Keener's Meadowbrook House was featured on the cover of *Dwell*, a high-profile monthly magazine about progressive residential architecture and interior design. This came as a complete surprise. The article served as an excellent marketing tool to generate support, including the donation of a temporarily vacant furnished home in a historic neighborhood within walking distance of the Rubin as a place for the artists to reside during the May installation period. I was also able to solidify interest in the exhibition on the part of the community of architects in El Paso, as well as of the El Paso chapter of the American Institute of Architects. The latter helped offset costs and also held one of its monthly meetings at the Rubin while the exhibition was on view. This may have happened even without *Dwell*: like any type of marketing, it is difficult to know the full magnitude of the article's impact. In 2008, the Rubin hosted two architecture exhibitions: *Numinous Space: Toward an Architecture of Spirit by William C. Helm III* and *Modernism for the Borderland: The Mid-Century Houses of Robert Garland and David Hilles*. Dozens of architects came out for both, eager for opportunities to discuss and think about their profession.

I had an opportunity to see Meadowbrook House for myself that same month. Atherton|Keener invited me to dinner while I was in the Phoenix area on other business. It was a quick visit, as I had a late evening flight back to El

Paso, just enough time for tabouli, hummus, and beer, all in one course. The house is a rectangle with a bedroom at each end, parentheses to the galley kitchen that opens out onto the great room that houses two tables, a big one for work and a small one for dining. Dyed-black plywood storage cabinets serve as room dividers. The walls are smooth, white, and bare and, though they are constructed from unremarkable sheetrock, they look like polished plaster and I wanted to touch them. On three sides of the exterior of the house, about three feet from the walls and windows, is a vertical sheet of material pulled taut. Its vernacular use is as a cover—for kids' playgrounds or for young plants in desert vegetable gardens—to shield from intense heat. From the exterior, it lends Meadowbrook House a look of physical softness. It also diffuses the light penetrating the interior. "We wanted to make something quiet enough to receive what's going on outside," explained Keener.[1]

In January, I prompted the artists to settle on an exhibition title so that we could begin the processes of creating a graphic identity for the exhibit and of promoting it. Keener responded: "Here are our ideas. We would like the title selection to be a collaborative process. Please forward your thoughts. I think we prefer the first title . . . Two-Way Mirror (the connotation of this is nice . . . interrogative; one person watching the other), Mirror Wall, The Mirror Plane, Light Destination, A Light Crossing, Light Lines." I wrote back: "I like Light Lines or Light Crossing best because I think the show has more to do with light than with mirrors. Mirrors are a method to reflect and manipulate light." The same day from Atherton: "Let's go with Light Lines."[2] This correspondence helped me to settle upon an approach to the contextualization of "Light Lines" for the class. I would focus on artists who have used mirrors and light and only touch upon land use issues and architecture.

## The Borderlessness of Air and Light

Atherton | Keener visited El Paso again in February 2011 and their thinking and our discussions focused on the border and its wall as a political and physical divide. We met with Carl Dirk, UTEP professor of chemistry, and Bill Hargrove, the director of the university's Center for Environmental Resource Management. Both meetings were formative. Dirk was involved in research on a light filter designed to reduce radiant energy transfer to artwork on display. He understands how arrays of mirrors function and the effects of reflected light. Hargrove agreed to market the exhibition to his constituents and shared with the artists his observation that in El Paso the sun rises in the United States and sets in Mexico.

That remark left an impression on them. They began to shift their focus from the border as a construct to how light responds to the built environment. "We were thinking," states Atherton, "too directly about construction; we were missing the big picture. Instead we wanted to ask questions about commerce and history and how light is a mixture of colors reflected from objects around us." Keener adds, "We did not really want to address architectural space but rather that which is not knowable."[3] They focused on the borderlessness of air and light.

Atherton | Keener made one more research trip to El Paso in April to meet with Jorge Villalobos and Luis Morales, UTEP's director and associate director of facilities services, about the mirrors and how they would be installed. We needed to pass muster with these key employees because they would be the ones to assure the university president that the mirrors would be safely and securely mounted and not be jarred loose by the spring winds, which can gust to more than fifty miles per hour. I had curatorial autonomy regarding the Rubin's exhibitions and programs, provided I met the expectations and needs of the faculty. But as soon as the art reached beyond the gallery's walls, many other people became involved. The campus is architecturally cohesive, so temporary additions, decorations, or elaborations on the exterior of the buildings or in the landscape require the approval of the university president. Facilities services managers either recommend approval or advise against it. Atherton | Keener were convincing. They were also commendably concerned about scarring the rock on the hillside, so they researched and proposed the least invasive method possible. The project moved forward.

In mid-April, Atherton | Keener settled upon a water jet cutting process to create the components for the steel armature for the mirrors, which were triangular because, as Atherton explained, "we wanted a geometric shape and there are fewer references in nature to the triangle than there are to circles and rectangles. We wanted the nonreferential."[4] The mirrors pivoted inside their frames making it possible to tweak them weekly so that they would function effectively over the course of the exhibition's three-month-plus run. When in the landscape, they looked like a hybrid of scientific instrument and long-legged insect.

It was not until early May, two weeks before installation was to begin, that Atherton | Keener decided on the materials for the interior component of the piece: $1/16$-inch galvanized carbon steel rope and plaster-impregnated fabric that is flexible until it is moistened. After that, it becomes stiff enough to hold a shape. The everyday use for this plaster gauze is for casts to set broken bones, but it is also marketed to hobbyist crafters. We ordered 5,000 feet of the rope,

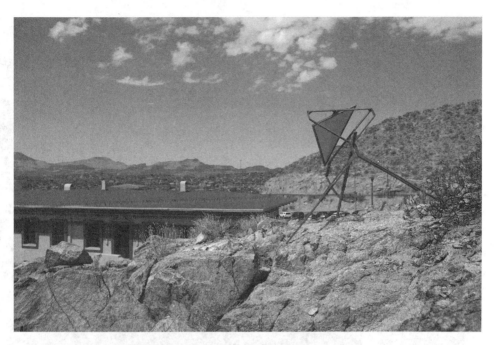

*Top:* Atherton | Keener, *Light Lines*, 2011. Mirror gimbal assembly. Photograph by Bill Timmerman. *Bottom:* Atherton | Keener, *Light Lines*, 2011. North exterior of the Rubin showing mirrors on mountain. Photograph by Bill Timmerman.

Atherton | Keener, *Light Lines*, detail of plaster-impregnated
fabric, 2011. Photograph by Bill Timmerman.

which looks like wire, and 13,825 feet of the 11-inch-wide fabric, which was
just shy of what we actually needed. We placed a second, smaller order a few
days before the show opened. I did not fully understand how these materials
would be employed. The CAD rendering that I expected back in October still
had not surfaced. I had not asked for it again after our first meeting; I had de-
cided to trust the artists.

The rendering arrived with the artists in May. Prior to this, the Rubin prepar-
ator Daniel Szwackowski removed three window inserts. (Atherton | Keener
added a north window to their original request of east and west so that light
could enter from three directions, just as it does at Meadowbrook House.)
For the first couple of days, they focused on positioning the anchors for the
mirrors. They had moved into the gallery by the first day of the Maymester
class, and, with some student assistance, they began attaching to the walls the
hooks that would hold the wire, placing them according to the specifications
on the CAD rendering. The wires stretched in horizontal lines, like multiple
taut clotheslines, eight inches apart, beginning twelve feet above the floor and
continuing to the baseboard. This process required a couple of days.

## The Class

During this time, the students and I met in the classroom to discuss the context of *Light Lines*. We began in the mid-1960s with artists Yayoi Kusama, Robert Morris, Robert Smithson, and others who used mirrors to situate the viewer within a broader interior environment. Smithson also executed several "mirror displacements" in the landscapes of Europe and the Americas that prompted reflection on the idea of Empire and on the "dialectic between inside and outside, visible and invisible, form and formlessness, determinacy and indeterminacy, centre and periphery—between Site and Nonsite."[5] For example, Smithson installed *Mirror Displacements (1–9)* in nine locations on a trail in Yucatán, Mexico, in 1969. Jacques Lacan's "mirror stage" was also a topic of discussion. So was Robert Morris's 1966 essay, "Notes on Sculpture," which was informed by phenomenology and Maurice Merleau-Ponty's focus on uninterrupted experience and sensation and the body. Unintended experience was apropos for *Light Lines* which, at the request of the artists, was without wall text or exhibition signage of any sort to create, in the words of Keener, "a singular experience."[6] The viewer's entire being became involved upon entering the art, which absorbed both body and mind.

The use of the mirror in *Light Lines* was set apart from these precedents because it connected environmental conditions with interior space, expanding the idea of cohesion by joining landscape to room to self. In addition, whereas Morris and the others used the mirror as a medium to reflect image, Atherton | Keener used it as a tool to direct light. Light, rather than the mirror, was their medium.

James Turrell, Olafur Eliasson, and Robert Irwin are some of the better-known artists to find meaning in the manipulation of light. Irwin has enjoyed a thirty-year-plus friendship with his biographer Lawrence Weschler, who credits his short note to Irwin asking, "Have you ever read Merleau-Ponty's *The Primacy of Perception*?" as the initiator of their relationship.[7] The message in part prompted Irwin to steep himself in the thinking of numerous philosophers. It also further supports the argument that light itself is a unifier and an exemplifier of Merleau-Ponty's point that existence is an interlocking of differentiated but not isolated components. Ambient natural light connects us because it is all around us. We cannot help but share it. Weschler's biography of Irwin was one of the assigned readings for the class. Others included articles about the use of natural light in architecture, light as a stylistic tool in Spanish and Italian Baroque art, reviews of exhibitions about mirrors in art, and essays about art on the U.S. / Mexico border.

## Rupture and Repair

On the entrance wall in the atrium, we posted a life-sized graphic of one of the mirrors above an abstracted map of the mirror locations in relationship to the building. Each of the nine mirrors was identified by the approximate time of day that it would reflect light into the gallery, which was ideally every hour on the half hour. Szwackowski was responsible for shifting the position of the mirrors in their frames over the course of the exhibit to make them as accurate as possible as the summer season progressed. The exhibition, like the light, would be ever changing, but visitors could attempt to time their presence in the gallery based on when the light would be most apparent and exciting.

Atherton│Keener, *Light Lines*, detail of plaster-impregnated fabric, 2011. Photograph by Bill Timmerman.

Atherton | Keener, *Light Lines*, 2011. North exterior of the Rubin showing reflected light from active mirror. Photograph by Bill Timmerman.

Student assistance came to bear most substantially with the preparation of the plaster gauze fabric. We created three production lines: one for cutting, one for folding, and one for hanging. Once hung, each square was misted and "crinkled." This imbued it with an individual personality and also produced an uneven surface to create high points for reflected light and low points for shadows. Each piece looked something like a three-dimensional topographic map of the neighboring mountains. Fragile but strong, the fabric permitted the transmission of light while also altering it. Because its standard use is for casts to heal broken bones, it alluded to repair, restoration, and survival.

The concept of rupture also linked to the border as an artificial and political divide, one currently in need of healing. Mirrors, too, are associated with survival tactics; they are used by the military to signal location and by surveyors in their quest to place us in relationship to others. The squares recalled Buddhist prayer flags in format and display method, a coincidental connection to the Bhutanese architecture of UTEP's campus, an additional link between architecture and art, and yet another reference to hope.[8] They abutted each other on all sides so the overall effect was that of a curtain connecting the pillars with the walls to divide the space into multiple open areas of monochromatic visual quietness.

In physical form, the interior component of *Light Lines* related more closely to *Running Fence*, by the artists Christo and Jeanne-Claude, than it did to works that produce and emit light. In 1976, Christo and Jeanne-Claude formed a billowing 24.5-mile fence of heavy white nylon along the Northern California coast. The large scale and literal connection to the landscape were two traits that *Running Fence* and *Light Lines* shared. Christo and Jeanne-Claude repeatedly denied that their projects contained any deeper meaning than to create aesthetic impact, joy, beauty, and new ways of seeing familiar landscapes. *Light Lines* also fulfilled these goals. In addition, it explored the properties of light and reminded us that there is still much that we do not understand. It brought to our awareness the incomprehensible.

## Museum as Sanctuary

Museums are sometimes referred to as sanctuaries, places to escape everyday concerns and to reflect upon larger subjects. *Light Lines* provided this reprieve. In addition, its intentional manipulation of light can be compared to that of Gothic cathedrals or that of more recent sacred spaces, such as Le Corbusier's *Notre Dame du Haut de Ronchamp* (1955) and Tadao Ando's *Church of the Light* (1989). The Rubin usually does not take the approach of museum-as-escape;

*Top:* Atherton | Keener, *Light Lines,* 2011. Photograph by Bill Timmerman. *Left:* Atherton | Keener, *Light Lines,* 2011. Steel and plaster-impregnated fabric. Photograph by Bill Timmerman.

most of our exhibitions tackle pressing issues in society and politics. *Light Lines* was a worthwhile exception to this curatorial focus. It was understated activism because it encouraged us to pay attention. It demanded time and concentration to experience the light as it shifted—and to appreciate its subtleties, such as the shadows on the floors and walls, the delicacy of the fabric, and the variance between one square and the next. One visitor described her experience as akin to entering an igloo. Another said it reminded her of the wings of a bird of prey. Yet another said that it made him aware that the earth was rotating on its axis.

In the successful union of the opposites of repetition and uniqueness, and in the intentional manipulation of natural desert light, *Light Lines* can be compared to Chinati Foundation's 100 untitled works in mill aluminum by Donald Judd, which still exist together exactly as they were installed between 1982 and 1986 in two former artillery sheds. Each of the 100 works has the same outer dimensions (41 × 51 × 72 inches), although the interior is unique in every piece.

The same could be said of the squares in *Light Lines*. The size and scale of the buildings at Chinati determined the nature of Judd's installation, just as the site and layout of the Rubin guided *Light Lines*. To visit Chinati Foundation in Marfa, Texas, is to make a pilgrimage. El Paso has the closest airport, and the three-hour drive south and east from here is endlessly open sky and land. Judd's art speaks in a different way when it commands views of the wide-open high desert than it does crammed into a big city museum. Marfa represents a quiet escape and is especially satisfying for those interested in the connection between landscape, architecture, and art. For the time that *Light Lines* was on view, the Rubin offered a similar (and unforgettable) experience. It also fulfilled the Rubin's curatorial mission of presenting new art that responds to the desert environment on the edge of two nations. The goals of *Light Lines* epitomized those of the Rubin. Art and institution united.

# Acknowledgments

Thank you to the following people for reading drafts of this manuscript and for providing valuable input:

Shelley Armitage
Sheila Black
Tim Cross
Kerry Doyle
William Eamon
Leslie Norton
Tyler Stallings
Stephanie Taylor
John Wright

# Notes

INTRODUCTION

1. Fernanda Canales, "From the Shop Window to the Laboratory," *Rufino*, Spring/Summer 2011, 39.
2. Thirty-three percent front and 67 percent back is recommended for museums, but because the Rubin is a noncollecting institution, it does not have the storage needs of a typical museum, so the 40 percent/60 percent arrangement of space is on point.
3. Many of the artists are familiar with one another and with each other's work. For example, Julio César Morales and Liz Cohen met in the Bay Area in the 1990s. Tania Candiani and Enrique Ježik became roommates several years after I met Candiani. Sarah Cowles is acquainted with Steve Badgett through the Center for Land Use Interpretation in Wendover, Utah. I do not discuss personal relationships between the artists because, to the extent of my knowledge, they do not significantly affect the conceptual bases of the art or the trajectory of the artists' practices.
4. Direct exhibition costs typically included artists' honoraria, travel, and lodging; exhibition supplies; marketing, including advertising and signage; and exhibition catalogue (essayists' and graphic designers' honoraria, photography, and printing).

ONE

1. Alejandro Almanza Pereda, Skype conversation with the author, October 14, 2010. All comments by Almanza Pereda quoted from this conversation unless otherwise noted.
2. For the first year of his university career, Almanza Pereda was a communications major, inspired by an alternative radio station in Mexico City. In 2003 and 2004, the

UTEP Annual Juried Student Art Exhibition took place in the Department of Art Gallery in Fox Fine Arts Center, where I was director. In 2005, at the first student exhibition at the Rubin, Almanza Pereda's *Untitled (Desk)* (2005) earned Best Sculpture.

3. Eva Diaz, "Alejandro Almanza Pereda: The Triumph of 'Kipple' in Alejandro Almanza Pereda's Sculptures," *Arte al Dia* (May 21, 2010). www.artealdia.com/International/Contents/Artists/Alejandro_Almanza_Pereda, accessed April 13, 2011.

4. Claire Bishop, *Installation Art* (New York: Routledge, 2005), 6.

5. Arthur Danto, "'Things Fall Together: An Introduction to the Sculptural Achievement of Sarah Sze," in *Sarah Sze* by Arthur C. Danto and Linda Norden (New York: Harry N. Abrams, 2007), 7.

6. José Luis Cortés Santander, *Alejandro Almanza Pereda: Works and Process* (New York: Magnan Projects, 2008), 28.

7. Interview with Alejandro Almanza Pereda, May 2009, as published in *LoDown Magazine* #66. http://magnanmetz.com/artists/press/158/LO66_ale_01.pdf, accessed April 28, 2011.

8. Ibid.

9. Irwin, for one, is well versed in phenomenology and committed to bodily and present experience. See Lawrence Weschler, *Seeing is Forgetting the Name of the Thing One Sees: Over Thirty Years of Conversations with Robert Irwin* (Berkeley: University of California Press, 2008).

10. Almanza Pereda's work brings to mind the famous phrase: "Everything is what it is, and not another thing," uttered by Joseph Butler (1692–1752), English bishop, theologian, and philosopher. This remark has become a philosophical commonplace since G. E. Moore used it as the epigraph for his *Principia Ethica* (1903), a standard text for modern ethics. Its source is Butler's *Fifteen Sermons Preached at the Rolls Chapel* (1726).

Other artists have incorporated exposed lightbulbs but few have been as consistently committed to this element as a material and a concept as Almanza Pereda. In November 2011, the Pace Gallery in New York hosted the exhibition *Burning, Bright: A Short History of the Light Bulb*, which addressed the subject and included artists such as Joseph Beuys, Alexander Calder, Felix Gonzalez-Torres, Robert Rauschenberg, and Lee Ufan. www.thepacegallery.com, accessed December 15, 2011.

Information about disconnecting the lightbulb from its metal housing, Alejandro Almanza Pereda, e-mail correspondence with the author, December 22, 2011.

11. www.nytimes.com/2007/06/03/magazine/03Style-skull-t.html, accessed December 15, 2011.

12. Eileen R. Doyle, "Art in the Mirror: Reflection in the Work of Rauschenberg, Richter, Graham and Smithson" (PhD dissertation, Ohio State University, 2004), 14. Jean Roussel published the first English translation of *The Mirror Stage* in *New Left Review* 51 (September/October 1968), 63–77. See www.english.hawaii.edu/criticalink/lacan/index.html.

13. Diaz, "Alejandro Almanza Pereda: The Triumph of 'Kipple'."

14. Izabel I. S. Gass, review of "Alejandro Almanza Pereda: *Andamio (Temporary Frameworks)*," *Art Lies* 54 (Summer 2007). www.artlies.org/article.php?id=1491&issue=54&s=1, accessed March 7, 2011.

15. Alejandro Almanza Pereda, interview with Elizabeth M. Grady, July 2008, as published in *Alejandro Almanza Pereda: Works and Process*, by José Luis Cortés Santander (New York: Magnan Projects), 16.

TWO

1. The artist is known as "ERRE," a name that he assigned to himself based on the Spanish pronunciation of the first letter of his surname.
2. Leah Ollman, review of insITE97, *Sculpture* 17, no. 2 (February 1998).
3. At the time of this writing, the most recent staging was insITE05 in 2005. Organizers Michael Krichman and Carmen Cuenca have claimed that there may be others in the future. The Rubin has drawn upon some of the same talent: ERRE, the artist collaborative SIMPARCH, Mark Bradford, and curator Beverly Adams have all contributed to both enterprises. Press materials described insITE05 as "a network of contemporary art programs and commissioned projects that maps the dynamics of permeability and blockage that characterize the liminal border zone," a statement that could easily describe many exhibitions at the Rubin. www.e-flux.com/shows/view/1517, accessed July 9, 2011.
4. W. E. B. Du Bois coined the term "double-consciousness" in 1903 to describe the mental situation of African American people, who are conscious of themselves as both black and not-white.
5. www.artistsrespond.org/exhibition/podcasts/artistinterviews/ERRE_Human_Nature_interviewFINAL.mp4, accessed April 1, 2011.
6. Ibid.
7. Marcos Ramírez ERRE, conversation with the author, summer 2006.
8. Marcos Ramírez ERRE, conversation with the author as published in *Sculpture* 25, no. 9 (November 2006), 26.
9. *Gardner's Art Through the Ages, Eleventh Edition* (Orlando: Harcourt College Publishers, 2001), 1063.
10. Placed at regular intervals along the wall at the same level as the red line on the eye chart below the photographs—about the eye level of a youth—were single words, some in English and some in Spanish, that described unpleasant emotions or states of being: *miseria* (misery), ignorance, *hambre* (hunger), stupidity, *envidia* (envy), cruelty, rage.
11. Marcos Ramírez ERRE, conversation with the author, August 3, 2010.
12. Ibid.
13. Toby Kamps, "Marcos Ramírez ERRE," in *Baja to Vancouver: The West Coast and Contemporary Art*, edited by Ralph Rugoff, et al. (San Francisco, CA: CAA Wattis Institute, 2004), 92.
14. The term "semiotics" was coined by Swiss linguist Ferdinand de Saussure. Anthropologist Claude Lévi-Strauss later applied these ideas to broader culture: language unlocks the hidden logic of an entire society, while also depriving us of "something fundamental," creating distance between individuals.
15. As quoted in Mike Davis, "The Artist Who Asked About the Contribution of Strategic Bombing to the American Way of Life," History News Network, George Mason

University, September 22, 2003. http://hnn.us/articles/1694.html, accessed April 1, 2011.

16. Marcos Ramírez ERRE, conversation with the author as published in *Sculpture* 25, no. 9, November 2006, 25.

17. Marcos Ramírez ERRE, conversation with the author, August 3, 2010.

18. Ibid.

19. http://artpace.org/.

20. ERRE credits the research of his brother, Juan Carlos Ramírez-Pimienta, in prompting him to reflect on this phenomenon. Ramírez-Pimienta specializes in the *narcocorrido*. *Narcocorridos* are ballads based on *corridos* (songs), polkas, and waltzes, featuring lyrics backed by accordions and brass bands. During the Mexican Revolution of 1910, hundreds of *corridos* were sung about legendary figures like Emiliano Zapata and General Francisco "Pancho" Villa. Today's *narcocorridos* feature individuals who run drug cartels. ERRE paraphrases Ramírez-Pimienta's research as revealing a *"fronterización,"* or "borderization," of the United States and Mexico. As ERRE states:

> This line that we see in the map can be as thin or as thick as the ballpoint pen that you use to mark it on the map. That line can be 100 kilometers wide. More and more the states of the north of Mexico, and then the states in the center, are becoming "bordered." The problematic that we had in the border five or ten years ago is spreading, like a cancer.

Marcos Ramírez ERRE, conversation with the author, August 3, 2010. Also see Juan Carlos Ramírez-Pimienta, *Cantar a los Traficantes: Origen e Historia del Narcocorrido* (Singing to the Traffickers: Origin and Development of Drug Trafficking Ballads) (Mexico: Editorial Planeta, 2011).

21. Emily Morrison and Lori Salmon, "International Artist-In-Residence, New Works 08.2, Marcos Ramírez ERRE, July 10–September 7, 2008," www.artpace.org/aboutThe Exhibition.php?axid=315&sort=artist, accessed February 17, 2011.

22. Chris Arsenault, "Invest in the World's Most Violent City," *Al Jazeera*, www.aljazeera .com/indepth/features/2011/03/201132622428384341.html, accessed March 31, 2011.

23. Ibid.

24. Marcos Ramírez ERRE, conversation with the author, August 3, 2010.

THREE

1. Henriette Huldisch, "Deborah Stratman," in *Whitney Biennial 2004* by Chrissie Iles, Shamim M. Momin, and Debra Singer (New York, NY: Whitney Museum of American Art, 2004), 240.

2. Matt Lynch, e-mail correspondence with the author, December 3, 2004.

3. Author, e-mail correspondence with Steve Badgett, December 23, 2004.

4. Author, e-mail correspondence with Steve Badgett, January 31, 2005.

5. Guy Debord, "Introduction to a Critique of Urban Geography," *Les Lèvres Nues* 6 (1955), http://library.nothingness.org/articles/SI/en/display/2, accessed February 21, 2011. The Situationists surface in my discussion of four other artists in this book:

Marcos Ramírez ERRE (Chapter 2), Tania Candiani (Chapter 8), and Ivan Abreu and Marcela Armas (Chapter 10).

6. Exhibitions by Tania Candiani (Chapter 8) and Atherton|Keener (Chapter 12) are two that also harnessed the beauty of the hillside.

7. Tania Ragasol, "Dirty Water Initiative," inSITE: Art Practices in the Public Domain, San Diego Tijuana, Interventions, 2005.

8. Clean Livin' is a project of Creative Capital, a national nonprofit organization offering financial and advisory support to artists pursuing adventurous projects in all disciplines. See www.creative-capital.org. The project was developed in part at the Illinois Institute of Technology by SIMPARCH and first-year architecture students.

9. Or twenty-five gallons per trip on a standard bicycle pulling a trailer.

10. Polly Ulrich, "SIMPARCH's Social Sculpture at the Wendover Air Force Base," Sculpture 23, no. 4 (May 2004), 25.

11. Gilles Deleuze and Felix Guattari, A Thousand Plateaus: Capitalism and Schizophrenia, trans. Brian Massumi (Minneapolis: University of Minnesota Press, 1987), 243.

12. Jay Griffiths, "Let Them Drink Coke," Orion (January/February 2011), 13.

13. Steven Badgett e-mail correspondence with the author, December 12, 2006.

14. Exhausted (2009) at Open Satellite in Bellevue, Washington, is an example of a work that was conceptualized and realized by Badgett and Lynch alone.

15. David Gissen, Subnature: Architecture's Other Environments (New York: Princeton Architectural Press, 2009), 100.

16. After the exhibition closed, we relocated the solar stills to one of these neighborhoods, specifically to La Cooperativa Esperanza/Cooperative of Hope, which assists and empowers women who are victims of poverty and/or domestic violence.

17. John Vidal, "Blue Gold: Earth's Liquid Asset," Guardian, August 22, 2002.

18. Griffiths, 12–13.

19. Steve Badgett, conversation with the author, El Paso, Texas, July 14, 2010.

20. Chon Noriega, "Godzilla and the Japanese Nightmare: When Them! is U.S." Cinema Journal 27, no. 1 (Autumn 1987).

21. Abigail Guay, exhibition brochure for Exhausted (Bellevue, WA: Open Satellite, 2009).

22. Steve Badgett, statement at artist preliminary concept meeting for Tornillo Border Station, November 18, 2010, as recorded in meeting minutes by U.S. General Services Administration Art in Architecture Program, distributed via e-mail on January 19, 2011.

23. Ibid.

## FOUR

1. Adrian Esparza, conversation with the author, July 23, 2010. All comments by Esparza quoted from this conversation unless otherwise noted.

2. Adrian Esparza, interview with Rita Gonzalez, as published online at http://live.glasstire.com, accessed March 14, 2008.

3. Esparza's use of commercially cast ceramics is a modest tribute to a grandmother who taught decorative ceramic craft classes at a local detention center when he was growing up.

4. Esparza had carried a *serape* with him to Cal Arts as a graduate student to use as a blanket, but then used it within a painting "as a symbol." (Adrian Esparza, conversation with the author, July 23, 2010.) However, *Here and There* was the first time he unraveled a *serape* and created something else from it. The dimensions are variable based on the space in which it is exhibited. Here I describe it as it was exhibited in *Come Forward*.

5. Adrian Esparza, interview with Rita Gonzalez.

6. www.festival.si.edu/about/mission.aspx, accessed August 7, 2011.

7. *One and the Same* is now part of the permanent collection of El Paso Museum of Art. See "Adrian Esparza" in *Texas 100: Selections from the El Paso Museum of Art* (El Paso, TX: El Paso Museum of Art, 2006), 48.

8. Esparza claims *Phantom Sightings* identified him as a "Chicano" artist, though the premise of the show was art by Mexican American artists working after the time of the Chicano movement. This conflict between the intention of the exhibit and Esparza's understanding of it reveals the looseness of the current definition of the term "Chicano." Margarita Cabrera, Nicola Lopez, and Julio César Morales were also among the thirty-one artists featured. The curatorial basis of *Phantom Sightings* and the mission of the Rubin overlap: both support progressive art by Mexican Americans.

9. Stephanie Taylor, "Handcrafts as Political Acts," in *Unknitting: Challenging Textile Traditions,* by Kate Bonansinga, Diana Natalicio, and Stephanie Taylor (El Paso: University of Texas at El Paso, 2008), 18.

10. Alexander Freeman, "International Artist-In-Residence: New Works 09.3, Adrian Esparza, El Paso, TX, November 19, 2009–January 10, 2010." http://artpace.org/about-the-exhibition/?axid=333&sort=title, accessed August 7, 2011.

11. Suzanne Weaver, "Are You Experienced?" in *Come Forward: New Art in Texas* by Suzanne Weaver and Lane Relyea (Dallas, TX: Dallas Museum of Art, 2003), 16. French philosopher Gilles Deleuze and Lacanian psychoanalyst Felix Guattari developed a theory of the rhizomatic nature of knowledge that, since its publication in *A Thousand Plateaus* in the 1980s, has been of interest to many artists. Today www.rhizome.org is a website "dedicated to the creation, presentation, preservation, and critique of emerging artistic practices that engage technology."

12. Becky Hendrick, "Adrian Esparza," *Art Lies* 40 (Fall 2003). www.artlies.org/article.php?id=182&issue=40&s=1, accessed May 12, 2011.

13. Esparza credits his interaction with community-oriented artists Adriana Lara and Mario Ybarra Jr., who were residents at Artpace with him, as prompting him to reflect on these questions.

14. www.marknewportartist.com/work/video.

FIVE

1. http://hirshhorn.si.edu/visualmusic/, accessed September 4, 2011.

2. Ramírez-Montagut subsequently has held curatorial posts at the Guggenheim Museum of Art (2006–2008), the Aldrich Contemporary Art Museum (2008–mid-2012), and San Jose Museum of Art (2012–2013).

3. Kate Bonansinga, "An Introduction to *Claiming Space,*" in *Claiming Space: Mexican Americans in U.S. Cities* (El Paso: University of Texas at El Paso, 2008), 7.

4. Latino Virtual Gallery is, at the time of this writing, known as the Latino Virtual Museum.

5. UNIVERSAL is a moniker that the artist adopted to emphasize the universal nature of the content and aesthetic of his artwork.

6. Nicola Lopez, conversation with the author, August 2008.

7. Noah MacDonald's mother's family name is Trujillo. His maternal grandparents, Estevan Henry Trujillo and Perla Josephina Vigil, married in Taos, New Mexico, in 1950. Both were of Mexican descent.

8. The group exhibits included *Hanging in Balance: 42 Contemporary Necklaces* (pectorals by artists from Europe and the United States); *Multiplicity: Contemporary Ceramic Sculpture* (large-scale works consisting of repeated, small-scale, cast forms that explored cloning, industrial production, and organic reproduction); and *Passing Through, Settling In: Contemporary Photographs of the Desert* (photographic interpretations of the American Southwest desert by twelve artists six of whom reside in the Southwest and six of whom visit to photograph the Southwest—with the goal of revealing the differences between the images produced by the two subgroups). The solo shows of new, commissioned work that responded to the border included *Hydromancy:* SIMPARCH with Steve Rowell and *Frontera: Current Work by Patricia Henriquez.* There have been many others in recent years.

9. Under my direction, the Rubin staff connected the solar panels to the light fixtures about a week before Villareal arrived on campus. I wanted to be as prepared as possible in order to maximize the artist's short time in El Paso. This was a mistake: the panels were drained of much of their power-generating capacity during that waiting period. Villareal decided to plug the fixtures into an electrical source with extension cords in case the solar panels had been compromised to the point that they would not provide adequate power. The cords were not distracting visually because we were able to hide most of them under plants, rocks, and dirt. But *Solar Matrix* was to be Villareal's first solar-powered piece, so this was a disappointment to the artist and to me.

10. Since the completion of *Solar Matrix,* Villareal has achieved several important permanent installations. The waterfront exterior of the Tampa Museum of Art glows with his illuminated color in *Sky* (2010). (It shares a title with the work at the El Paso Federal Courthouse.) *Multiverse* (2008) reinvents the once-dark concourse between the East and West Building at the National Gallery of Art in Washington, D.C., into an area of pulsing brilliance. Villareal embedded forty-one thousand LEDs into the existing reflective aluminum slats that clad the walls of the corridor. The effect is to "dematerialize the rectangular boundaries of the passageway," according to architectural writer Sara Hart in "Leo Villareal: Play of Brilliants," in *Leo Villareal* by Jo Anne Northrop (Osfildern, Germany: Hatje Cantz Verlag, 2010), 56. These are only two of Villareal's many high-profile projects that use light to reinvent the experience of an urban public space and to express the unknowable qualities of light.

11. Mike Davis, *Magical Urbanism* (New York: Verso, 2001), 63.

12. Julio César Morales, e-mail to the author, November 12, 2010.

13. Néstor García Canclini, *Latinoamericanos buscando lugar en este siglo* (Buenos Aires: Paidos, 2002), 41.

14. www.washingtonpost.com/world/americas/mexican-cartels-now-using-tanks /2011/06/06/AGacrALH_story.html, accessed June 9, 2011.

15. Noah MacDonald, conversation with Monica Ramírez-Montagut, August 11, 2008. Also see Monica Ramírez-Montagut, "Noah MacDonald with Keep Adding and Black Estate," in *Claiming Space: Mexican Americans in U.S. Cities*, ed. Victor Espinosa, Kate Bonansinga, and Monica Ramírez-Montagut (El Paso: University of Texas at El Paso), 33.

16. Monica Ramírez-Montagut, e-mail to the author, July 5, 2011.

17. Ramírez-Montagut, "Noah MacDonald with Keep Adding and Black Estate," 33.

SIX

1. Megan Irwin, "Hard Body: Liz Cohen's Infiltrating the Lowrider World—and Calling It Art," *Phoenix New Times* (October 5, 2006), 14–18, 22–29.

2. Liz Cohen, telephone conversation with the author, August 27, 2010. All comments by Liz Cohen cited here occurred during this conversation unless otherwise noted.

3. Cohen chose this title for the series of photos because it is the mantra of her mechanic mentor, Bill Cherry.

4. In late August 2010, Cohen was grappling with the fact that the car would not fit through the door of Salon 94 in New York City and was considering disassembling it and exhibiting it in parts on pedestals.

5. Daniel Chandler, "Notes on 'The Gaze'." www.aber.ac.uk/media/Documents/gaze /gaze09.html, accessed December 16, 2011.

6. Stephen Fry, "Lady Gaga Takes Tea with Mr. Fry," *FT Magazine* (May 27, 2011). www .ft.com/cms/s/2/0cca76f0-873a-11e0-b983-00144feabdc0.htmll#ixzz1QbnIEasH, accessed July 2, 2011.

7. Derek Blasberg, "Lady Gaga: The Interview," *Harper's Bazaar* (April 13, 2011). www. harpersbazaar.com/magazine/feature-articles/lady-gaga-interview, accessed July 2, 2011.

8. Liz Cohen, *Radical Mod* (Scottsdale, AZ: Scottsdale Museum of Contemporary Art, 2008).

SEVEN

1. Margarita Cabrera, gallery talk at the El Paso Museum of Art, August 28, 2011.

2. Margarita Cabrera, conversation with the author, April 18, 2010.

3. An international corporate entity is capable of distributing profits to individuals regardless of their citizenship or residency status.

4. The use of these personal narratives as visual elements differed from prior workshops of *Space in Between*.

5. Tyler Stallings, telephone conversation with the author, April 21, 2011.

6. The grant was from the University of California Institute for Mexico and the United States (UC MEXUS), an academic research institute dedicated to encouraging,

securing, and contributing to binational and Latino research and collaborative academic programs and exchanges.

7. Tyler Stallings, telephone conversation with the author, April 21, 2011.

8. Tyler Stallings, e-mail to the author, September 20, 2011.

9. Walter Maciel Gallery, "Margarita Cabrera." www.waltermacielgallery.com/mcabr era.html.

10. "[A]n art no longer distinct from the praxis of life but wholly absorbed in it will lose the capacity to criticize it, along with its distance." Claire Bishop, *Participation* (Cambridge: MIT Press), 49.

11. www.goodreads.com/author/quotes/8127.William_Morris, accessed December 14, 2011.

12. René Paul Barilleaux and Eleanor Heartney, *New Image Sculpture* (San Antonio, TX: McNay Art Museum, 2011), 49.

13. Margarita Cabrera, conversation with the author, April 18, 2011.

14. Walter Maciel, conversation with the author, August 21, 2011.

EIGHT

1. Tania Candiani, Skype conversation with the author, October 5, 2010. All comments by Candiani quoted from this conversation unless otherwise noted.

2. Kerry Doyle, conversation with the author, March 28, 2011. All comments by Doyle quoted from this conversation unless otherwise noted.

3. "Specs for Texas-Mexico Border Fence Finalized," Latina Lista, September 24, 2007. http://latinalista.com/2007/09/specs_for_texasmexico_border_fence_final/, accessed January 16, 2011.

4. Jo-Ann Wallace, "Where the Body Is a Battleground: Materializing Gender in the Humanities," HighBeam Research, September 22, 2001. www.highbeam.com/doc /1G1-90445821.html, accessed January 16, 2011. "Body as battleground" terminology has become nearly ubiquitous. Amnesty International, for example, uses it often to relay specific ways in which women's human rights are violated globally. "Our Bodies, Their Battleground" is the anchor for the homepage for IRIN (Integrated Regional Information Networks), the humanitarian news service launched in 1995 in response to the gap in humanitarian reporting exposed by the Rwandan genocide.

5. In her essay in the *Battleground* exhibition brochure, curator Kerry Doyle points to Rosler as a precedent.

6. Leah Ollman, "Liza Lou's American Dream," *Art in America* 86, no. 6 (June 1997), 98–101, 122. As quoted at http://linda.poling.com, accessed January 16, 2011.

7. Alison Hearst, "Tania Candiani and Regina José Galindo," *Art Lies* 62 (Summer 2009). www.artlies.org/article.php?id=1767&issue=62&s=1, accessed January 17, 2011.

8. Peggy Phelan, "The Returns of Touch: Feminist Performances, 1960–1980," in *Wack: Art and the Feminist Revolution*, edited by Lisa Gabrielle Mark (Los Angeles: Museum of Contemporary Art, 2007), 353.

9. Lisa Gabrielle Mark, ed., *Wack: Art and the Feminist Revolution* (Los Angeles: Museum of Contemporary Art, 2007), 267.

10. *Soft Gallery* was re-created in 2000 at Generali Foundation in Venice.

11. Tania Candiani, e-mail to the author, July 11, 2012.

12. Robert J. Yudell, "Body Movement," in *Body, Memory and Architecture*, edited by Kent C. Bloomer and Charles W. Moore (New Haven: Yale University Press, 1977), 57.

13. Carma R. Gorman, "Fitting Rooms: The Dress Designs of Frank Lloyd Wright," *Winterthur Portfolio* 30, No. 4 (Winter 1995), 259–277.

14. Juliet Kinchin and Aidan O'Connor, *Counter Space: Design and the Modern Kitchen* (New York: Museum of Modern Art, 2010), 20.

15. Pilar Viladas, "Now Showing: Sensate: Bodies and Design," *New York Times Style Magazine* (August 10, 2009). http://tmagazine.blogs.nytimes.com/2009/08/10/now-showing, accessed February 2, 2011.

16. www.alexschweder.com, accessed Feb. 13, 2011.

## NINE

1. "Historic Wendover Airfield," www.wendoverairbase.com/postwar, accessed August 12, 2011.

2. "Center for Land Use Interpretation." www.clui.org/about/index.html, accessed February 1, 2011.

3. "U.S. Customs and Border Protection: Securing America's Borders." www.cbp.gov/, accessed September 25, 2010.

4. As of January 22, 2010, CBP had completed roughly 643.3 miles of fencing (344.8 miles of primary pedestrian fence and 298.5 miles of vehicle fence) along the southwest border. www.globalsecurity.org/security/systems/mexico-wall.htm, accessed September 25, 2010.

5. Sarah Cowles, undated letter to the author.

6. Scott Nicol, "Wildlife at Risk along U.S.-Mexico Border Fence." http://nmsierraclub.org/Wildlife-at-risk-along-border-fence, accessed August 12, 2011.

7. Alan Smart, Skype conversation with the author, August 11, 2010. All comments by Smart quoted from this conversation unless noted otherwise.

8. "About Shelby Farms Park Conservancy." www.shelbyfarmspark.org/AboutHomePage.aspx?pid=14, accessed January 31, 2011.

9. Sarah Cowles, Skype conversation with the author, August 21, 2010. All comments by Cowles quoted from this conversation unless otherwise noted.

10. Jason Kentner, ed., *Tom Leader Studio: Three Projects. Source Books in Landscape Architecture 6* (New York, NY: Princeton Architectural Press, 2010), 24.

11. "Teddy Cruz: University of Michigan Taubman College Future of Urbanism." www.youtube.com/watch?v=hJ_FxXZrcDE, accessed February 14, 2011.

12. Juanita Sundberg and Bonnie Kaserman, "Cactus Carvings and Desert Defecations: Embodying Representations of Border Crossings in Protected Areas on the Mexico-US border," *Environment and Planning D: Society and Space* 25 (2007).

13. "Calexico Port of Entry." www.tomleader.com/studio/projects/project_details.php?id_cat=3&id_proj=18, accessed February 1, 2011.

14. Smart continued, "I think there is something to be said for trying to adopt a scholarly distance on your own life instead of rolling in as an outside observer and commenting on someone else's life."

15. Sarah Cowles, e-mail message to the author, February 18, 2011, and Skype conversation with the author, August 21, 2010.

TEN

1. *Proyecto/Project 2010—First Draft*, memo to participating organizations, issued by the federal government of Mexico, p. 1.
2. June S. Beittel, "Mexico's Drug-Related Violence," Congressional Research Service, May 27, 2009. www.fas.org/sgp/crs/row/R40582.pdf, accessed June 25, 2011.
3. Los Zetas, for example, were a cartel formed by former Mexican elite commando-type soldiers and consisted mostly of former federal and local police.
4. In the years following the Mexican Constitution, the zeal for collectivism extended to the arts. The muralist movement led by Diego Rivera emerged as the preferred revolutionary art form in part because it was collectively produced and received. Ironically, the murals that Rivera supervised are identified with him and him alone: posterity misleadingly credits a collaborative effort to an individual name. This is true of many works of art, especially those that are highly complex, require a variety of talents to execute, or are of architectural scale. The lead artist makes history and the assistants are forgotten. See Ruben Gallo, "The Mexican Pentagon: Adventures in Collectivism during the 1970s," in *Collectivism after Modernism: The Art of Social Imagination after 1945*, ed. Blake Stimson and Gregory Sholette (Minneapolis: University of Minnesota Press, 2007), 166.
5. Ivan Abreu, *Cross Coordinates*, www.crosscoordinates.org/.
6. Both social practice art and new media art have a language to describe a participative relationship between artwork and viewers. Neither of these languages are part of the typical art lexicon. See Beryl Graham and Sarah Cook, *Rethinking Curating: Art after New Media* (Cambridge, MA: MIT Press, 2010), 119. Nicolas Bourriaud's "Relational Aesthetics" and Suzy Gablik's "Connective Aesthetics: Art after Individualism" also highlight many artists engaged in art social practice. Also see "History of Art and Social Practice." http://historyofartandsocialpractice.tumblr.com/post/502426905/connective-aesthetics, accessed July 9, 2011.
7. Guy Debord was a member of both groups.
8. Grant Kester, *Conversation Pieces: Community + Communication in Modern Art* (Berkeley: University of California Press, 2004), 8.
9. Doyle lived in Juárez in the 1990s and has many connections to community-based organizations there.
10. Internet2 is a U.S. networking consortium led by research-based universities, including UTEP, in collaboration with industry. See "Internet2," www.internet2.edu.
11. The Rubin's financial outlay totaled about nineteen thousand dollars in artists' honoraria and materials for these commissions. The total cash outlay for the exhibition was about forty-four thousand dollars. In-kind contributions were about forty thousand.
12. UTEP chemistry professor Russell Chianelli was instrumental in securing the five gallons of crude that we needed for *I-Machinarius*. Other suppliers made crude available

only in much larger quantities and were concerned about compromising public safety and were therefore less willing to cooperate.

13. Adriana Gómez Licón, "Nearly Half a Million Residents Flee Juárez's Drug Wars," *El Reportero* 21, no. 9, June 22–30, 2011. Reprinted with permission from *El Paso Times*. www.elreporterosf.com/editions/?q=node/4217, accessed June 25, 2011.

14. Radley Balko, "The El Paso Miracle," *Reason*, July 6, 2009. http://reason.com/archives/2009/07/06/the-el-paso-miracle, accessed June 25, 2011.

15. Katherine Harmon, *You are Here: Personal Geographies and Other Maps of the Imagination* (New York: Princeton Architectural Press, 2004), 133.

16. The exhibition *Mark Bradford: With That Ass, They Won't Look at Your Eyes* took place at the Rubin in summer 2012.

17. Marcela Armas, e-mail to the author, November 12, 2010.

18. Ibid.

19. Gallo, 171.

20. Nicolas Bourriaud, "Relational Aesthetics," in *Participation*, ed. Claire Bishop (Cambridge: MIT Press, 2006), 168.

### ELEVEN

1. David confided that she wanted to provide the finances and time for the artists to investigate Juárez and the border in a deep and substantive manner. She projected the duration of *Juárez: An International Art Project* to be twelve months at a total cost of about one hundred and seventy thousand dollars.

2. Enrique Ježik, e-mail to the author, October 20, 2010.

3. After the exhibition closed in March, the Rubin arranged for the plywood components (twenty sheets) to be shipped to Mexico City; *Lines of Division* was featured in Ježik's retrospective exhibition at Museo Universitario Arte Contemporáneo (MUAC), the contemporary art museum at the University of Mexico, in summer 2011. The Rubin had earned an American Recovery and Reinvestment Act (ARRA) grant of thirty-five thousand dollars from the National Endowment for the Arts. This covered the expense of hiring an international art shipper, as well as all of the other direct expenses associated with the exhibition.

4. Enrique Ježik, conversation with the author, January 25, 2011.

5. Enrique Ježik, e-mail to the author, November 16, 2010.

6. *www.youtube.com/watch?v=5AmpyiR6kj8*, accessed December 13, 2011.

7. This idea connects *Lines of Division* with Ježik's earlier works *Premiere of NATO*, *What comes from outside is reinforced from within*, and *Untitled (damage and repair)*.

8. Enrique Ježik, conversation with the author, January 25, 2011.

9. Octavio Zaya, "Interview: Octavio Zaya in conversation with Cai Guo-Qiang," in *Cai Guo-Qiang* by Dana Friis-Hansen, Octavio Zaya, and Takashi Serizawa (London: Phaidon Press Limited, 2002), 14. As quoted in Miwon Kwon, "The Art of Expenditure," in *Cai Guo-Qiang: I Want to Believe* by Thomas Krens and Alexandra Munroe (New York: Guggenheim Museum, 2008), 62.

10. Kwon, 67.

11. Mao Zedong, "On New Democracy," January 1940. www.morningsun.org/living/education/cp_maoquotes.html, accessed March 2, 2011.

12. Pilar Villela, *Enrique Ježik: Practice (200 12-gauge cartridges, 78 9-mm bullets) and Related Works* (Mexico City: Tlatelolco University Cultural Center, National Autonomous University of Mexico, 2009), 9.

13. Ibid., 11. This intervention was coordinated by Rodolfo Aguerreberry, Guillermo Kexel, and Julio Flores (Ježik's teacher in Buenos Aires).

## TWELVE

1. Jaime Gillin, "Startin' Spartan," *Dwell* (December-January 2011). www.dwell.com/articles/startin-spartan.html, accessed June 6, 2011.

2. Cy Keener and Jay Atherton, e-mail correspondence with the author, January 14, 2011.

3. Cy Keener and Jay Atherton, public presentation at the Stanlee and Gerald Rubin Center for the Visual Arts, May 26, 2011.

4. Ibid. Though the artists sought the nonreferential, I think that the reflective quality of the mirrors, regardless of their shape, connotes the small and unusual pockets of water at nearby Hueco Tanks State Park, where liquid pools in basketball-sized indentations in the sandstone outcroppings during infrequent but heavy rainstorms.

5. "Yucatan is Everywhere: On Robert Smithson's *Hotel Palenque*." www.robertsmithson.com/essays/palenque.htm, accessed August 15, 2011.

6. Cy Keener, conversation with the author, April 8, 2011. Because of the common focus on reflection and self-reflection, the theoretical bases for *Light Lines* were similar to those for Alejandro Almanza Pereda's sculpture that uses mirrors as a material (Chapter 1).

7. Lawrence Weschler, *Seeing is Forgetting the Name of the Thing One Sees: Over Thirty Years of Conversations with Robert Irwin* (Berkeley: University of California Press, 2008), 267.

8. Atherton and Keener also attribute plastic trash caught in desert cacti as inspiration for the suspended, white squares of fabric.

Altshuler, Bruce. *Collecting the New: Museums and Contemporary Art*. Princeton, NJ: Princeton University Press, 2005.

Andermann, Jens. *The Optic of the State: Visuality and Power in Argentina and Brazil*. Pittsburgh, PA: University of Pittsburgh Press, 2007.

Arsenault, Chris. "Invest in the World's Most Violent City." *Al Jazeera*, March 31, 2011. www.aljazeera.com/indepth/features/2011/03/201132622428384341.html, accessed March 31, 2011.

Bachelord, Gaston. *Poetics of Space*. New York: Orion Press, 1964.

Balko, Radley. "The El Paso Miracle." *Reason*, July 6, 2009. http://reason.com/archives/2009/07/06/the-el-paso-miracle, accessed June 10, 2011.

Barilleaux, René Paul, and Eleanor Heartney. *New Image Sculpture*. San Antonio, TX: McNay Art Museum, 2011.

Barker, Emma, ed. *Contemporary Cultures of Display*. New Haven, CT: Yale University Press, 1999.

Beittel, June S. "Mexico's Drug-Related Violence." Congressional Research Service, May 27, 2009. www.fas.org/sgp/crs/row/R40582.pdf, accessed June 25, 2011.

Bishop, Claire. *Installation Art*. New York, NY: Routledge, 2005.

———. *Participation*. Cambridge, MA: MIT Press, 2006.

Black, Graham. *The Engaging Museum: Developing Museums for Visitor Involvement*. New York: Routledge, 2004.

Blasberg, Derek. "Lady Gaga: The Interview." Harper's Bazaar, April 13, 2011. www.harpersbazaar.com/magazine/feature-articles/lady-gaga-interview, accessed July 2, 2011.

Bloomer, Kent C., and Charles W. Moore, eds. *Body, Memory and Architecture*. New Haven, CT: Yale University Press, 1977.

Bonansinga, Kate. "An Introduction to *Claiming Space*." In *Claiming Space: Mexican Americans in U.S. Cities*. El Paso, TX: University of Texas at El Paso, 2008.

―――. "Marcos Ramirez ERRE." *Sculpture* 25, no. 9 (November 2006): 20–27.

Bonansinga, Kate, Diana Natalicio, and Stephanie Taylor. *Unknitting: Challenging Textile Traditions*. El Paso, TX: University of Texas at El Paso, 2008.

Bourriaud, Nicolas. "Relational Aesthetics." In *Participation*, ed. Claire Bishop. Cambridge: MIT Press, 2006.

Buskirk, Martha. *The Contingent Object of Contemporary Art*. Cambridge, MA: MIT Press, 2005.

Canclini, Néstor García. *Latinoamericanos buscando lugar en este siglo*. Buenos Aires: Paidos, 2002.

Carbonell, Bettina Messias, ed. *Museum Studies: An Anthology of Contexts*. New York: Blackwell Publishing, 2004.

Chandler, Daniel. "Notes on 'The Gaze'" (June 7, 2000). www.aber.ac.uk/media/Documents/gaze/gaze09.html, accessed December 16, 2010.

Cohen, Liz. *The 5 P's: Proper Planning Prevents Poor Performance*. Paris: Onestar Press, 2007.

―――. *Liz Cohen Body Work*. Paris: Onestar Press and Galerie Laurent Godin, 2006.

―――. *Radical Mod*. Scottsdale, AZ: Scottsdale Public Art, 2008.

Cooper-Greenhill, Eilean. *Museums and the Shaping of Knowledge*. London: Routledge, 1992.

Cuno, James, ed. *Whose Muse? Art Museums and the Public Trust*. Princeton, NJ: Princeton University Press and Cambridge, MA: Harvard University Art Museum, 2004.

Danto, Arthur, and Linda Norden. *Sarah Sze*. New York: Harry N. Abrams, 2007.

Davis, Mike. *Magical Urbanism*. New York, NY: Verso, 2001.

―――. "The Artist Who Asked About the Contribution of Strategic Bombing to the American Way of Life." History News Network, George Mason University, September 22, 2003. http://hnn.us/articles/1694.html, accessed April 1, 2011.

Dear, Michael, and Gustavo Leclerc. *Postborder City: Cultural Spaces of Bajalta California*. New York: Routledge, 2003.

Debord, Guy-Ernest. "Introduction to a Critique of Urban Geography." *Les Lèvres Nues* 6 (1955). http://library.nothingness.org/articles/SI/en/display/2, accessed February 21, 2011.

Deleuze, Gilles, and Felix Guattari. *A Thousand Plateaus: Capitalism and Schizophrenia*, translated by Brian Massumi. Minneapolis: University of Minnesota Press, 1987.

Diaz, Eva. "Alejandro Almanza Pereda: The Triumph of 'Kipple' in Alejandro Almanza Pereda's Sculptures." *Arte al Día International* (May 21, 2010). www.artealdia.com/International/Contents/Artists/Alejandro_Almanza_Pereda, accessed April 13, 2011.

Doherty, Claire, ed. *Situation*. London: Whitechapel Gallery and Cambridge, MA: MIT Press, 2009.

Doyle, Eileen R. "Art in the Mirror: Reflection in the Work of Rauschenberg, Richter, Graham and Smithson." PhD diss., Ohio State University, 2004.

Doyle, Kerry, Karla Jasso, Diana Natalicio, and Kate Bonansinga. *Contra Flujo: Independence and Revolution*. El Paso: University of Texas at El Paso, 2010.

Du Bois, W. E. B. *The Souls of Black Folks*. New York: Penguin Books, 1996. First published in 1903 by A. C. McClurg and Company.

Duncan, Carol. *Civilizing Rituals: Inside Public Art Museums*. New York: Routledge, 1995.

Espinosa, Victor, Kate Bonansinga, and Monica Ramírez-Montagut. *Claiming Space: Mexican Americans in U.S. Cities*. El Paso: University of Texas at El Paso, 2008.

Falk, John H. *Identity and the Museum Visitor Experience*. Walnut Creek, CA: Left Coast Press, 2009.

Fox, Claire F. "The Portable Border: Site-Specificity, Art, and the U.S.-Mexico Frontier." *Social Text* 41 (Winter 1994). Durham, NC: Duke University Press.

Freeman, Alexander. "International Artist-In-Residence: New Works 09.3, Adrian Esparza, El Paso, TX, November 19, 2009–January 10, 2010." http://artpace.org/about -the-exhibition/?axid=333&sort=title.

Friis-Hansen, Dana, Octavio Zaya, and Takashi Serizawa. *Cai Guo-Qiang*. London: Phaidon Press Limited, 2002.

Fry, Stephen. "Lady Gaga Takes Tea with Mr. Fry." *FT Magazine*. May 27, 2011. www .ft.com/cms/s/2/0cca76f0-873a-11e0-b983-00144fcabdc0.htmll#ixzz1QbnIEasH, accessed July 2, 2011.

Gablik, Suzy. "Connective Aesthetics: Art after Individualism." In *Mapping New Terrain: New Genre Public Art*, edited by Suzanne Lacy. Seattle, WA: Bay Press, 1995.

Gallo, Ruben. "The Mexican Pentagon: Adventures in Collectivism during the 1970s." In *Collectivism after Modernism: The Art of Social Imagination after 1945*, edited by Blake Stimson and Gregory Sholette. Minneapolis: University of Minnesota Press, 2007.

Gass, Izabel I. S. Review of "Alejandro Almanza Pereda: *Andamio (Temporary Frameworks)*." *Art Lies* 54 (Summer 2007). www.artlies.org/article.php?id=1491&issue=54&s=1, accessed April 10, 2011.

Gillin, Jaime. "Startin' Spartan." *Dwell* (December-January 2011). www.dwell.com/articles /startin-spartan.html, accessed June 6, 2011.

Gissen, David. *Subnature: Architecture's Other Environments*. New York: Princeton Architectural Press, 2009.

Gómez Licón, Adriana. "Nearly Half a Million Residents Flee Juárez's Drug Wars." *El Reportero* 21, No. 9. Reprinted with permission from *El Paso Times*. www.elreporterosf .com/editions/?q=node/4217, accessed June 25, 2011.

Gonzalez, Jennifer A. *Subject to Display: Reframing Race in Contemporary Installation Art*. Cambridge, MA: MIT Press, 2008.

Gonzalez, Rita. "Interview with Adrian Esparza." *Glasstire* 2 (March 2007). http:// glasstire.com/2007/03/02/interview-with-adrian-esparza/, accessed March 14, 2008.

Gonzalez, Rita, Howard N. Fox, and Chon A. Noriega. *Phantom Sightings: Art after the Chicano Movement*. Los Angeles: University of California Press, 2008.

Gorman, Carma R. "Fitting Rooms: The Dress Designs of Frank Lloyd Wright." *Winterthur Portfolio* 30, No. 4 (Winter 1995).

Graham, Beryl, and Sarah Cook. *Rethinking Curating: Art after New Media*. Cambridge, MA: MIT Press, 2010.

Greenberg, Reesa, Bruce W. Ferguson, and Sandy Nairne, eds. *Thinking About Exhibitions*. New York: Routledge, 1996.

Griffiths, Jay. "Let Them Drink Coke." *Orion* (January/February 2011).

Harmon, Katharine. *You are Here: Personal Geographies and Other Maps of the Imagination*. New York: Princeton Architectural Press, 2004.

Harrison, Charles, and Paul Wood, editors. *Art in Theory 1900-1990: An Anthology of Changing Ideas*. Oxford, UK: Blackwell Publishers, 1992.

Hearst, Alison. "Tania Candiani and Regina José Galindo." *Art Lies* 62 (Summer 2009). www .artlies.org/article.php?id=1767&issue=62&s=1, accessed January 17, 2011.

Heinrich, Christoph. *Embrace!* Denver, CO: Denver Art Museum, 2009.

Hendrick, Becky. "Adrian Esparza." *Art Lies* 40 (Fall 2003). www.artlies.org/article.php ?id=182&issue=40&s=1, accessed May 12, 2011.

Holo, Selma, Gustavo Leclerc, and Michael J. Dear. *Mixed Feelings*. Los Angeles: Fisher Gallery, University of Southern California, 2002.

hooks, bell. *Art on My Mind: Visual Politics*. New York: New Press, 1995.

Hung, Shu, and Joseph Magliaro, eds. *By Hand: The Use of Craft in Contemporary Art*. New York: Princeton Architectural Press, 2007.

Iles, Chrissie, Shamim M. Momin, and Debra Singer, eds. *Whitney Biennial 2004*. New York: Whitney Museum of American Art, 2004.

Irwin, Megan. "Hard Body: Liz Cohen's Infiltrating the Lowrider World—and Calling It Art." *Phoenix New Times* (October 5, 2006).

Johnstone, Stephen. *The Everyday*. London: Whitechapel and Cambridge, MA: MIT Press, 2008.

Karp, Ivan, Christine Mullen Kreamer, and Steven D. Lavine. *Museums and Communities: The Politics of Public Culture*. Washington, D.C.: Smithsonian Institution Press, 1992.

Karp, Ivan, Corrine A. Kratz, Lynn Szwaja, and Tomás Ybarra-Frausto. *Museum Frictions: Public Cultures/Global Transformations*. Durham, NC: Duke University Press, 2006.

Karp, Ivan, and Steven D. Lavine, eds. *Exhibiting Cultures: The Poetics and Politics of Museum Display*. Washington, D.C.: Smithsonian Institution Press, 1991.

Kentner, Jason, ed. *Tom Leader Studio: Three Projects. Source Books in Landscape Architecture* 6. New York: Princeton Architectural Press, 2010.

Kester, Grant. *Conversation Pieces: Community + Communication in Modern Art*. Berkeley: University of California Press, 2004.

Kinchin, Juliet, and Aidan O'Connor. *Counter Space: Design and the Modern Kitchen*. New York: Museum of Modern Art, 2011.

Kirshenblatt-Gimblett, Barbara. *Destination Culture: Tourism, Museums, and Heritage*. Berkeley: University of California Press, 1998.

Krens, Thomas, and Alexandra Munroe. *Cai Guo-Qiang: I Want to Believe*. New York: Guggenheim Museum, 2008.

Lacy, Suzanne, ed. *Mapping New Terrain: New Genre Public Art*. Seattle, WA: Bay Press, 1995.

Lord, Barry, and Gail Dexter Lord, eds. *The Manual of Museum Exhibitions*. Walnut Creek, CA: AltaMira Press, 2001.

Mark, Lisa Gabrielle, ed. *Wack: Art and the Feminist Revolution*. Los Angeles: Museum of Contemporary Art, 2007.

Marstine, Janet. *New Museum Theory and Practice: An Introduction*. New York: Blackwell, 2006.

McShine, Kynaston. *The Museum as Muse*. New York: Museum of Modern Art, 1999.

Medina, Cuauhtémoc, ed. *Enrique Ježik: Obstruct, Destroy, Conceal*. Mexico City: University Museum of Contemporary Art, National Autonomous University of Mexico, 2011.

Morrison, Emily, and Lori Salmon. "International Artist-In-Residence, New Works 08.2, Marcos Ramírez ERRE, July 10–September 7, 2008" (July 2008). www.artpace.org /aboutTheExhibition.php?axid=315&sort=artist, accessed February 17, 2011.

Mosquera, Gerardo, and Jean Fisher, eds. *Over Here: International Perspectives on Art and Culture*. New York: New Museum of Contemporary Art, 2004.

Noriega, Chon. "Godzilla and the Japanese Nightmare: When *Them!* is U.S." *Cinema Journal* 27: 1 (Autumn 1987).

Northrop, JoAnne. *Leo Villareal*. Osfildern, Germany: Hatje Cantz Verlag, 2010.

Obrist, Hans Ulrich. *A Brief History of Curating*. Zurich: JRP Ringier and Les Presses du Reel, 2011.

———. *Everything You Always Wanted to Know About Curating but Were Afraid to Ask*. Berlin: Sternberg Press, 2011.

O'Doherty, Brian, and Thomas McEvilley. *Inside the White Cube: The Ideology of the Gallery Space*. Berkeley: University of California Press, 1999.

Ollman, Leah. "Liza Lou's American Dream." *Art in America* 86, No. 6 (June 1997).

———. Review of insITE97, *Sculpture* 17, No. 2 (February 1998).

Orer, Bige, Jens Hoffman, and Adriano Pedrosa. *The Companion to the 12th Istanbul Biennial*. Istanbul: Istanbul Foundation for Culture and the Arts and Yapi Kredi Publications, 2011.

Pedrosa, Adriano, and Julie Dunn, eds. *Farsites: Urban Crisis and Domestic Symptoms in Recent Contemporary Art*. San Diego, CA: San Diego Museum of Contemporary Art and Tijuana, MX: Tijuana Cultural Center, 2005.

Phelan, Peggy. "The Returns of Touch: Feminist Performances, 1960–1980." In *Wack: Art and the Feminist Revolution*, edited by Lisa Gabrielle Mark. Los Angeles: Museum of Contemporary Art, 2007.

Pollock, Griselda. *Encounters in the Virtual Feminist Museum: Time, Space and the Archive*. New York: Routledge, 2007.

Prieto, Antonio. "Border Art as Political Strategy." *Information Services Latin America*, 1999. http://isla.igc.org/Features/Border/mex6.html, accessed November 10, 2010.

Ragasol, Tania. "Dirty Water Initiative." insITE: *Art Practices in the Public Domain, San Diego Tijuana, Interventions*. San Diego, CA and Tijuana, MX: insITE, 2005.

Raley, Rita. *Tactical Media*. Minneapolis: University of Minnesota Press, 2009.

Ramírez, Mari Carmen, and Héctor Olea, eds. *Inverted Utopias: Avant-garde Art in Latin America*. New Haven, CT: Yale University Press, 2004.

Ramírez-Pimienta, Juan Carlos. *Cantar a los Traficantes: Origen e Historia del Narcocorrido (Singing to the Traffickers: Origin and Development of Drug Trafficking Ballads)*. Mexico: Editorial Planeta, 2011.

Rand, Steven, and Heather Kouris, eds. *Cautionary Tales: Critical Curating*. New York: Apexart, 2010.

Reese, Becky Duvall, Ben Fyffe, Christian J. Gerstheimer, Amy Grimm, Kimberly Mc-Carden, Nicholas Munoz, Amy Beth Paoli, Michesse Dyan Ryden, and Michael A. Tomor. *Texas 100: Selections from the El Paso Museum of Art*. El Paso, TX: El Paso Museum of Art, 2006.

Rugoff, Ralph. *Baja to Vancouver: The West Coast and Contemporary Art*. San Francisco: CAA Wattis Institute, 2004.

Santander, José Luis Cortés. *Alejandro Almanza Pereda: Works and Process*. New York: Magnan Projects, 2008.

Serrell, Beverly. *Judging Exhibitions: A Framework for Assessing Excellence*. Walnut Creek, CA: Left Coast Press, 2006.

Sleeper-Smith, Susan, ed. *Contesting Knowledge: Museums and Indigenous Perspectives*. Lincoln: University of Nebraska, 2009.

Staniszewski, Mary Anne. *Believing is Seeing: Creating the Culture of Art*. New York: Penguin Books, 1995.

Stimson, Blake, and Gregory Sholette, eds. *Collectivism after Modernism: The Art of Social Imagination after 1945*. Minneapolis: University of Minnesota Press, 2007.

Stockebrand, Marianne. *Chinati: The Vision of Donald Judd*. Marfa, TX: Chinati Foundation and New Haven, CT: Yale University Press, 2010.

Sundberg, Juanita, and Bonnie Kaserman. "Cactus Carvings and Desert Defecations: Embodying Representations of Border Crossings in Protected Areas on the Mexico-US Border." *Environment and Planning D: Society and Space* 25 (2007).

Thea, Carolee. *On Curating: Interviews with Ten International Curators*. New York: D.A.P./Distributed Art Publishers, 2009.

Ulrich, Polly. "SIMPARCH's Social Sculpture at the Wendover Air Force Base." *Sculpture* 23, No. 4 (May 2004).

Vidal, John. "Blue Gold: Earth's Liquid Asset." *Guardian* (August 22, 2002). www.guardian.co.uk/environment/2002/aug/22/worldsummit2002.earth2, accessed May 9, 2011.

Viladas, Pilar. "Now Showing: Sensate: Bodies and Design." *New York Times Style Magazine* (August 10, 2009). http://tmagazine.blogs.nytimes.com/2009/08/10/now-showing, accessed February 2, 2011.

Villela, Pilar. *Enrique Ježik: Practice (200 12-gauge cartridges, 78 9-mm bullets) and Related Works*. Mexico City: Tlatelolco University Cultural Center, National Autonomous University of Mexico, 2009.

Wagner, Sandra. "Negotiating Boundaries: Artists Explore the Tijuana-San Diego Border." *Sculpture* 17, No. 2 (February 1998).

Wallace, Jo-Ann. "Where the Body is a Battleground: Materializing Gender in the Humanities." HighBeam Research (September 22, 2001). www.highbeam.com/doc/1G1-90445821.html, accessed January 16, 2011.

Weaver, Suzanne, and Lane Relyea. *Come Forward: New Art in Texas*. Dallas, TX: Dallas Museum of Art, 2003.

Weil, Stephen. *Making Museums Matter*. Washington, D.C.: Smithsonian Institution, 2002.

Weschler, Lawrence. *Seeing is Forgetting the Name of the Thing One Sees: Over Thirty Years of Conversations with Robert Irwin*. Berkeley: University of California Press, 2008.

Yard, Sally, ed. *inSITE97: Private Time in Public Space*. San Ysidro, CA: Trucatriche, distributor, 1998.

Yudell, Robert J. "Body Movement." In *Body, Memory and Architecture*, edited by Kent C. Bloomer and Charles W. Moore. New Haven, CT: Yale University Press, 1977.

# Index